Chinese Brush Painting:

flowers

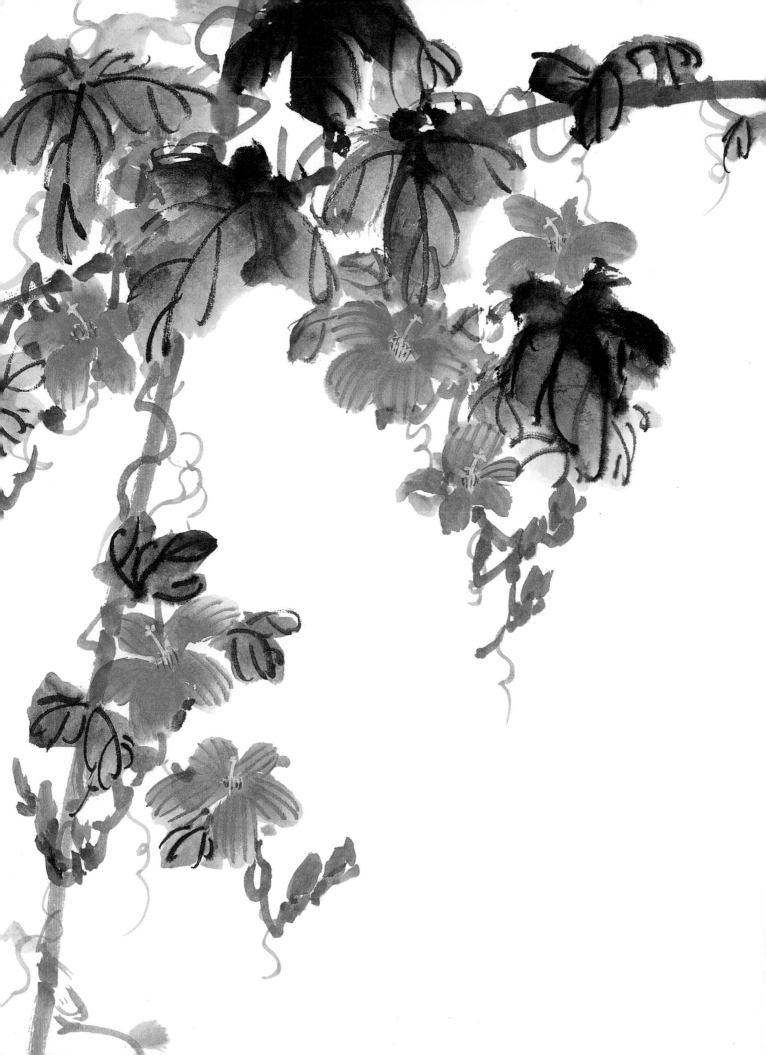

Chinese Brush Painting:
flowers

Joan Lok

A QUARTO BOOK

First edition for the United States
and Canada published in 2014 by
Barron's Educational Series, Inc.

All inquiries should be addressed to:
Barron's Educational Series, Inc.
250 Wireless Boulevard
Hauppauge, NY 11788
www.barronseduc.com

ISBN: 978-1-4380-0437-2
Library of Congress Control No: 2014939400

Conceived, designed, and produced by
Quarto Publishing plc
The Old Brewery, 6 Blundell Street
London N7 9BH

QUAR.CPF

Project Editor: Lily de Gatacre
Art Editor: Jackie Palmer
Designers: Jackie Palmer, Simon Brewster
Copy Editor: Clare Sayer
Photographer: Phil Wilkins
Proofreader: Chloe Todd Fordham
Indexer: Helen Snaith

Art Director: Caroline Guest
Creative Director: Moira Clinch
Publisher: Paul Carslake

Color separation in Singapore by
Pica Digital Pte Limited
Printed in China by
Hung Hing Printing Group Ltd

9 8 7 6 5 4 3 2 1

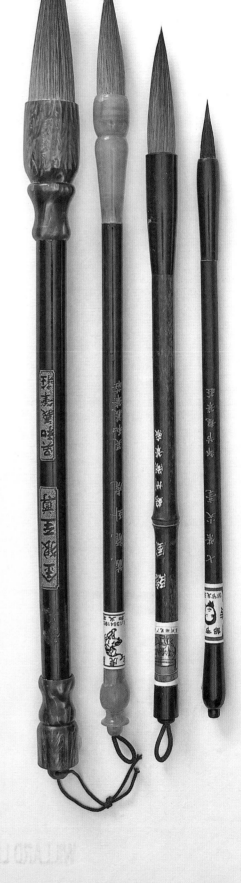

I dedicate this book to David, with whom
everything is better.

Joan Lok

Contents

Foreword

It is a great pleasure for me to write this short message for Joan Lok's book. I have known Joan since 1997 through the Sumi-e Society of America's activities and followed her artistic journey over all these years.

Joan has to be one of the most dedicated and hardworking artists I have known. I am profoundly impressed by her keen observation, strong sensibility, boundless creative energy, enormous motivation, excellent leadership quality, and absolute commitment to artistic pursuits!

Joan received solid training in the Lingnan School style; however, over the years living in the United States, she has explored and absorbed many new ideas and artistic nutrients to enrich her own visual statements.

To write a good instructional painting book, you need to be a good painter, experienced teacher, effective communicator, competent writer, and passionate professional. Judging from my personal experience with Joan, she possesses all these qualities. I truly cannot think of anyone else that I know who is more qualified to undertake such a task. This valuable book is the crystallization of her 30 years' creative and teaching experience, which, I am certain, will inspire many aspiring as well as well-established artists for many generations to come!

Cheng-Khee Chee

American Watercolor Society Dolphin Fellow
National Watercolor Society Signature Member
Transparent Watercolor Society of America Signature Member—Master Status
Associate Professor Emeritus, University of Minnesota

Introduction

Each stroke becomes a petal! The audiences at my Chinese brush painting demonstrations are often amazed by the astonishing beauty of finished artworks that are produced by quick and apparently simple brushwork. Chinese brush-painted flowers capture nature's allure with an economy of strokes and vibrant colors that many artists envy and admire. Chinese brush painting seems easy to learn, but beginners are often discouraged shortly after starting. The apparently simple brushwork conceals the demand for technical skills, thorough knowledge, and spiritual appreciation of the subject.

This book introduces the readers to a variety of types of brushwork and different floral painting techniques, and shows how to apply them to a diverse collection of flowers. In "Basic Brushwork" (see pages 16–20), I have covered how to hold the brush with both the right and left hand, as I encounter an increasing number of left-handed painters in my workshops. Each flower includes an introduction to the plant to increase the understanding of its form, and step-by-step procedures of how to paint it. There are also special details to ensure the mastery of specific techniques. For the more adventurous artists, I have included instructions on how to paint butterflies, honeybees, dragonflies, and birds. Knowing how to paint these small insects and birds is helpful to create your own design in your artwork. The section on composition (see pages 24–33) explains the fundamental design of painting flowers, as the aesthetic considerations are different in Chinese brush painting than in the Western arts. Finally, I have included a list of DOs and DON'Ts on the placement of signatures and seals, which will help balance the empty space in your composition without distracting from the design.

I hope this book will deepen your appreciation of Chinese brush painting. To capture the beauty and spirit of flowers, observe nature attentively, practice frequently, learn the classic strokes and composition theories but do not be confined by them. Experiment with new materials and supplies, and incorporate new subject elements to refresh and invigorate your own art. Embrace life and make the artistic experience your own. Follow your heart and have fun.

Enjoy the adventure.

Joan Lok

www.joanlok.com

Five Distinct Styles

There are five distinct styles in Chinese brush painting; each has its own unique qualities and artistic advantages. By examining these mainstream styles of Chinese brush painting, we also introduce the historic path of how Chinese brush painting has evolved with time. Let's explore these styles one by one.

Contour

Contour style is known as "White Sketch" in Chinese and dates back to the Han Dynasty (206 BC to AD 220), when the production of paper was invented. It is essentially a line drawing in black ink using a Chinese paintbrush. It emphasizes the use of graceful lines and is the foundation for all floral studies. However, Contour is more than merely a linear line drawing, like one might do with a marker pen. Practicing this style helps build a strong foundation for controlling the brushwork.

• A variety of thick and thin widths within the same line are produced by applying the flexible tip of a fine paintbrush with different pressures.

• The focus is on composition, controlling the thickness and thinness of lines, and the graceful application of lines on the paper.

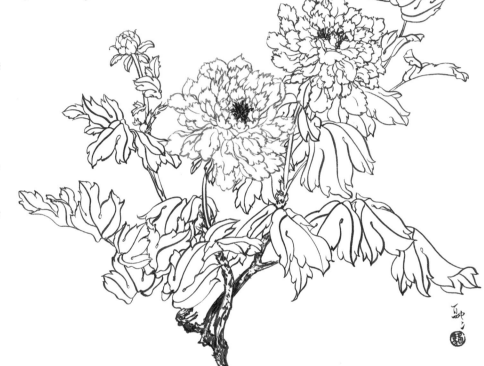

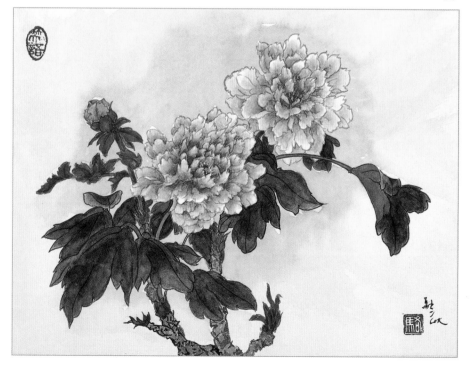

Detail

Detail style is known as "Fine Brush" in Chinese. It reached its height in popularity during the Song Dynasty (AD 960–1279) when the Emperors established the Academy of Painting in the imperial court system and artists were employed by the court to produce ornamental paintings to glorify the beauty of the royal garden and the lives in the palace. Detail style is also known as "Meticulous style" because of the laborious drawing and thin washes required to create the rich hues and intense colors. The process is time-consuming and requires a lot of patience. Artists need to study their subjects carefully before and during the process.

• Layers of color washes are added to a Contour style painting to build up the colors of the finished artwork.

• This slow building of colors enhances the transparency of light in the subject and builds up the radiance of the colors.

• The focus is on composition, anatomy, colors, and values of the subjects.

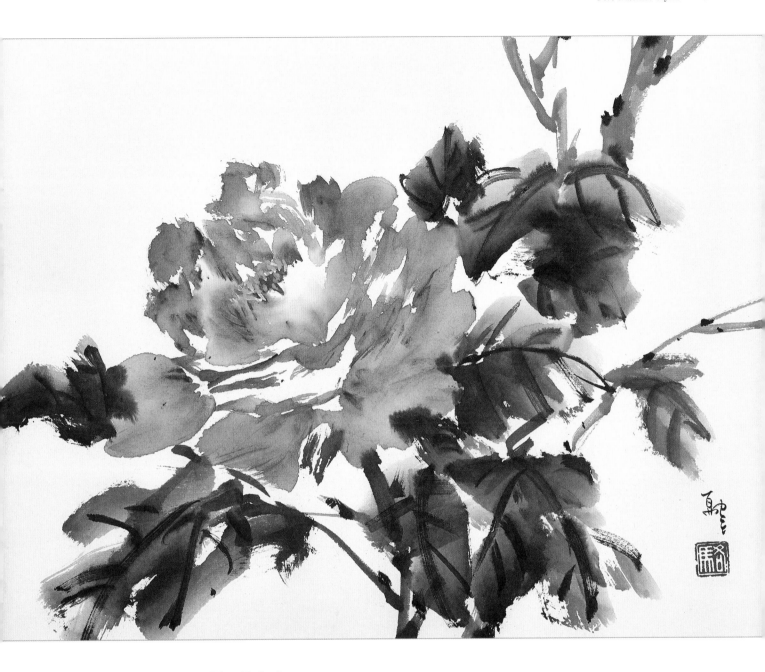

Idea Painting

With the imperial system honoring the art of painting in the Song Dyansty, many artists explored new ways to refine their art. Mo-Ku, meaning "no bone," is an expansion of Contour style, in which brushwork is manipulated to denote surfaces instead of contours of the subject. The introduction of the no-bone techniques paved the way for the development of Idea Painting style.

Idea Painting is known as "Writing of Idea" in Chinese. The painting captures the spirit of the subjects and the free spirit of the artists. It was widely practiced during the Yuan Dynasty (AD 1279–1368) by literati, educated scholars, and lovers of culture who rejected formal structures and sought freedom of expression in arts. Idea Painting style is commonly translated as "Spontaneous style," which is a misunderstanding of the style, as this word only captures the brushwork technique but neglects the spiritual importance of its development.

• Artists do not usually sketch on the paper before starting to paint. Instead, brushwork is applied directly onto the paper, and the composition is spontaneously adjusted during the painting process.

• Since the style focuses on the expressive strokes and somewhat impressionistic approach, anatomic accuracy may sometimes be compromised.

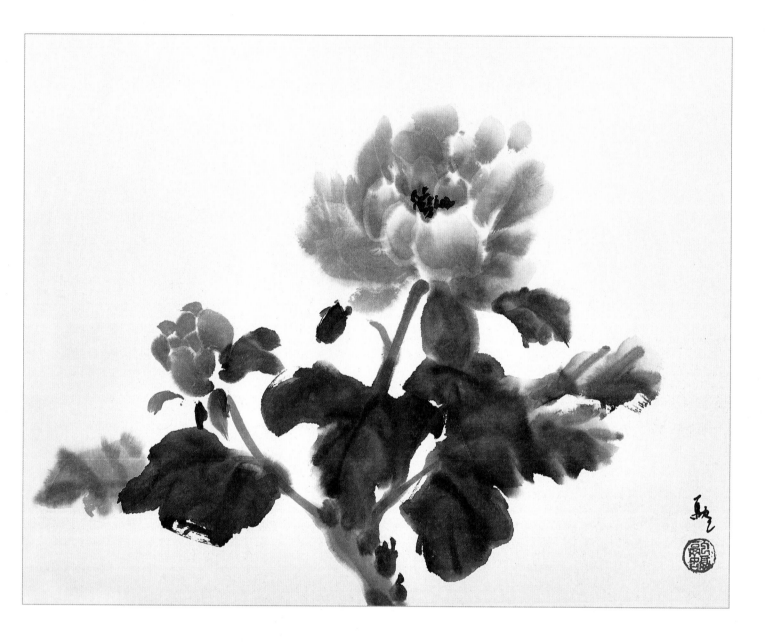

Monochrome Ink

With the development of Mo-Ku, painting moved toward a more spiritual enrichment as China went through an extended period of suffering, with a weak ruling dynasty, social upheavals, warfare, and aggression from neighboring countries. The Song Dynasty was succeeded by the Yuan Dynasty (AD 1279–1368) with Mongolians, not Han-Chinese, as the ruling party. Many literati felt the hopelessness in their environment and sought spiritual refuge in poetry, calligraphy, music, and painting. Since many of the literati were scholars with little art training, they drew from their calligraphic knowledge. The expression of ideas was strong, but the accuracy of subjects suffered due to their amateur approach to art. The somber mood and feelings of oppression also led them to favor the use of black ink, with little or no color in their works. Art is merged with calligraphic principles to produce Monochrome Ink paintings with strong symbolism, and as an expression of artists' silent protest against political and ethnic tensions.

• Besides undiluted black ink and the white of the paper, artists use mid-value ink in different shades of gray to represent colors.

• Focuses on tones, values, and composition without the distraction of colors.

• The absence of color creates a classic artwork unparalleled in impact.

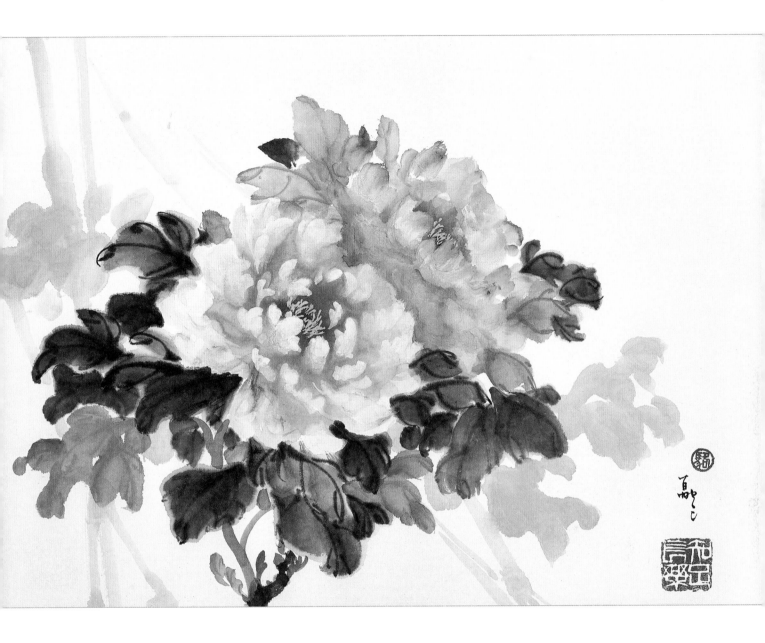

Combination

Often called "Half-Detail-Half-Spontaneous," the Combination style incorporates the refined structure of a Detail style painting with the spirit of the Idea Painting. The artists seek accurate representation of the subject through precise and spirited brushwork. Combination style is exemplified in the Lingnan School of Painting, which started in the late nineteenth century with influences from Japan that absorbed the elements of Western arts into Asian arts. The Lingnan School of Painting merges ink and colors, and adds Western painting elements, such as the use of value and light source.

Some artists misunderstood that Combination style is the mixing of Detail style and Idea Painting in one piece of artwork, such as combining a bird done in Idea Painting style with flowers done in Detail style. Idea Painting style needs raw rice paper to best present the spontaneity of the Mo-Ku brushwork, but Detail style typically requires sized rice paper to withstand the challenge of using multiple layers of paint. The Combination style alleviated the use of Mo-Ku, with the artists' profound comprehension of the subject and directness of expressive brushwork. It is much more than merely mixing Detail style with Mo-Ku brushwork in one artwork.

• Combines spirited brushwork with subject precision and accuracy.

• Usually created without a sketch and the composition is adjusted as the paintings proceed.

• Attention is paid to the accurate rendering of the subject's anatomy, color, value, and the light source.

Choosing Materials and Colors

The fundamental differences between Western art materials and those of Chinese brush painting can be overwhelming. Artists wanting to learn the art of Chinese brush painting were once discouraged by the difficulty in obtaining supplies outside Asia. With the advancement of Internet commerce and the ease of global trading, it is now much easier to locate quality Chinese brush painting supplies. Paper, brush, ink, and ink stone are collectively honored as the "Four Treasures" in Chinese brush painting.

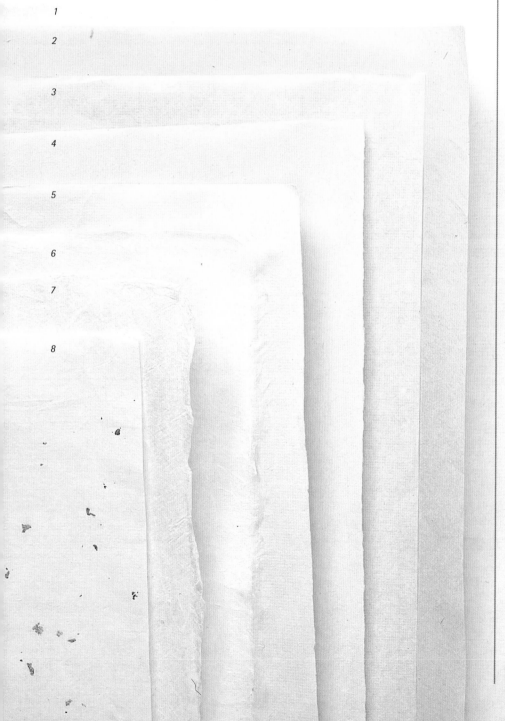

Paper

Rice paper is not made of rice. It probably obtained its name in the 1900s, when Europeans mistakenly took the paper made from the pith of the rice paper plant (*tetrapanax papyrifer*) as paper made from rice grains. Instead, the common ingredients for the paper used in Chinese brush paintings are reeds, elm, hemps, mulberry, bamboo, grass, and cotton, resulting in a variety of thicknesses. Rice paper is usually very lightweight, translucent, and absorbent (2).

Raw paper

Untreated rice paper is called "raw." It usually comes in single (one-ply) or double (two-ply) sheets. Single paper is thin and is great for monochromic ink painting, since all the movement of the brush is captured in the responsive rice paper. Double paper is thicker by comparison and works well to show the rich colors of flowers. The most popular rice paper is called Shuen. Because of the dialectic difference in pronunciation, sometimes, the word is translated as Shuen, Shuan, or Xuan (1), but these terms are essentially referring to the same kind of paper. Shuen paper is mainly made of the bark of elm, with additions of rice, bamboo, and mulberry. Shuen is not the name of the material but the name of a town famous for producing the best rice paper in ancient China. The name is now unanimously used for rice paper. Sometimes, decorative elements are added in the paper-making process to enhance the appearance. An example is Gold Fleck Xuan (8).

Sized paper

Rice paper (4) can be sized by applying a layer of alum, gelatin, or similar chemicals on its surface. The application reduces the paper's immediate absorbency of water and colors. A sized piece of paper allows the ink and colors to remain on the surface and dry slowly, thus permitting the manipulation of paint and texture for special art effects. It also allows the building up of layers of colors, creating a potent brightness and vitality. An example of sized rice paper is Cicada Wing (3), which has the addition of finely grounded mica in the sizing to produce a shine.

Semi-sized paper

Semi-sized paper (5) refers to rice paper that is either treated with a light application of sizing materials on the surface, or has water-repellent fibers added to the ingredients to reduce the absorbency of ink and colors during the painting process. A semi-sized paper is absorbent enough to show the beauty of gestural brushwork, yet allows some ink and color to rest on the surface to enable manipulation of texture and color transition. Two examples of semi-sized rice paper are Ma (6), made of long hemp fibers, and Dragon Cloud (7), made with long mulberry fibers.

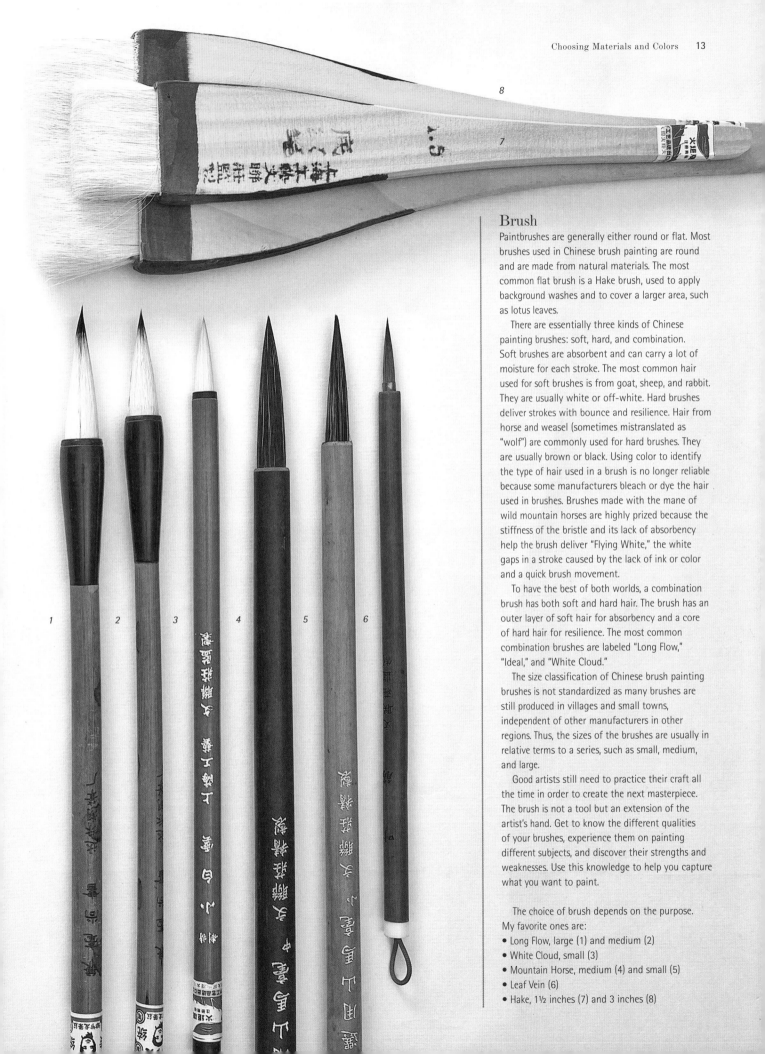

Brush

Paintbrushes are generally either round or flat. Most brushes used in Chinese brush painting are round and are made from natural materials. The most common flat brush is a Hake brush, used to apply background washes and to cover a larger area, such as lotus leaves.

There are essentially three kinds of Chinese painting brushes: soft, hard, and combination. Soft brushes are absorbent and can carry a lot of moisture for each stroke. The most common hair used for soft brushes is from goat, sheep, and rabbit. They are usually white or off-white. Hard brushes deliver strokes with bounce and resilience. Hair from horse and weasel (sometimes mistranslated as "wolf") are commonly used for hard brushes. They are usually brown or black. Using color to identify the type of hair used in a brush is no longer reliable because some manufacturers bleach or dye the hair used in brushes. Brushes made with the mane of wild mountain horses are highly prized because the stiffness of the bristle and its lack of absorbency help the brush deliver "Flying White," the white gaps in a stroke caused by the lack of ink or color and a quick brush movement.

To have the best of both worlds, a combination brush has both soft and hard hair. The brush has an outer layer of soft hair for absorbency and a core of hard hair for resilience. The most common combination brushes are labeled "Long Flow," "Ideal," and "White Cloud."

The size classification of Chinese brush painting brushes is not standardized as many brushes are still produced in villages and small towns, independent of other manufacturers in other regions. Thus, the sizes of the brushes are usually in relative terms to a series, such as small, medium, and large.

Good artists still need to practice their craft all the time in order to create the next masterpiece. The brush is not a tool but an extension of the artist's hand. Get to know the different qualities of your brushes, experience them on painting different subjects, and discover their strengths and weaknesses. Use this knowledge to help you capture what you want to paint.

The choice of brush depends on the purpose. My favorite ones are:
- Long Flow, large (1) and medium (2)
- White Cloud, small (3)
- Mountain Horse, medium (4) and small (5)
- Leaf Vein (6)
- Hake, 1½ inches (7) and 3 inches (8)

Ink and Ink Stone

Ink sticks (1) are made of soot from burning wood chips (mostly pine with paulownia) and plant oils (mostly rapeseed with paulownia and sesame). The process includes burning the wood or plant oils over a moderate flame and allowing the smoke to deposit as soot on the chimneys. The soot is then collected, blended together with animal bone glue, and kneaded to a dough-like consistency. The dough is put into molds and left to dry very slowly for a few months to avoid breakage. The ink stick is cleaned, polished, and decorated before going to the market.

Ink stone (2) is a piece of nonporous slate carved to a circular or rectangular well with a slope to provide a reservoir for ink. The most famous ink stone is made of slate from Tankei in China.

Ink is made by grinding an ink stick against an ink stone with a small amount of water. Grinding ink is a physical and mental exercise. Hold the ink stick perpendicular to the ink stone and rub calmly in a circular motion. Use the whole surface so the ink stick will wear down evenly. Grinding ink has a calming effect, which puts the artist in a frame of mind to paint. Ready-to-use bottled ink is available but do not substitute Chinese black ink with India ink or black watercolor paint. India ink produces a solid black coverage for graphic works and does not produce a great gradation of grays. Black watercolor may contain color ingredients that dilute into hues of blue and red. Only Chinese black ink can produce the gradual gradation effect on rice paper that black watercolor and India ink cannot duplicate.

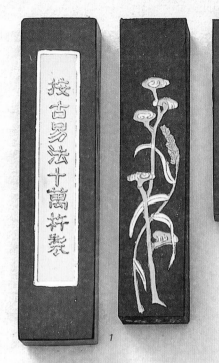

1

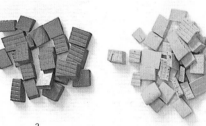

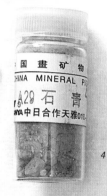

3

4

7

8

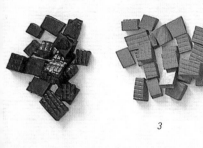

6

2

5

Additional Supplies

Besides colors and the "four treasures," the following supplies are also valuable to have on hand when practicing Chinese brush painting.

- A piece of felt or wool can absorb excess moisture and protect the tabletop. It provides an air space between the paper and the table to allow the ink and color to expand on the rice paper on contact. It also helps the paper dry faster.

- When using watercolors, the mixing is done in the center of the palette. In Chinese brush painting, the mixing is done on the brush itself and when the brush is applied to the surface of

the paper. Thus, the use of small dishes for each color is preferred. You can pick up each individual color with the brush.

- Use white plates (5) or a white butcher tray for mixing colors.

- Protect your brushes by rolling them in a slatted bamboo mat (6) to store them.

- Use a paperweight (7) to hold down the paper.

- A spray bottle can be used for background washes.

- Many artists enjoy signing their Chinese brush painting with a red seal, so you may need a seal (8) and a red ink pad. (For more on seals, see "Composition," pages 24–33.)

Color

Chinese colors are traditionally made from mineral and plant pigments. Stone Green is made from malachite, and Stone Blue is made from azurite. The colors from these semiprecious gems are vibrant but expensive. Traditional Chinese colors come in chip (3), chunk, powder (4), cake, and stick varieties sold in small packets or boxes. The chips, chunks, and powders need to be softened with a small amount of water before use. Some mineral colors also need to be mixed with glue as a binding agent. Synthetic Chinese colors in tube form became available in the last 50 years. Poor packaging and inconsistent color standards have discouraged many artists, but manufacturers have made significant improvements in both areas since.

Many Western watercolors carry the same hues as traditional Chinese colors. For vibrantly colored flowers, add more Western watercolors beyond the hues of the Chinese colors. See right for a chart of Chinese colors and their watercolor equivalents.

All the colors in the left column of the chart are classic hues that many watercolor manufacturers carry, including Winsor and Newton, Holbein, and Daniel Smith. Stone Green is used as accent color in flower painting and is used sparingly. Antique Opal Green by Holbein's Irodori Antique Watercolor is a great Stone Green. You can also make Stone Green by combining white gouache with Viridian or Hooker's Green. White gouache in a jar, such as Dr. Martin's Bleed Proof White, is easier to use than that from a tube. Transparent green and violet hues do not exist in the Chinese colors. The green of the leaves in flower painting are created by mixing Indigo with Rattan Yellow. Violet is created by mixing Indigo and Rough Red. For transparent green, use Sap Green but also consider including Olive Green in the palette. Cobalt Violet is great for flowers with a purple hue that you cannot get by merely mixing blue and red. You may also add more colors to your spectrum for a greater selection to capture the beauty of certain flowers. For example, Green Gold is a great color to use when painting the section where the flower petals are connected to the receptacle.

Basic Hue	Chinese Color	Watercolor Equivalents	Additional Watercolor Selections
Red	Rouge Red	Permanent Alizarin Crimson	Quinacridone Rose, Opera Rose
	Carmine	Vermilion Medium	
	Cinnabar	Vermilion Deep	
	Vermilion	Vermilion Light	Cadmium Orange
Brown	Yellow Ocher	Yellow Ocher	
	Burnt Sienna	Burnt Sienna	Quinacridone Gold
Yellow	Rattan Yellow	Gamboge Yellow	Cadmium Yellow Medium, Cadmium Yellow Pale
Green	Stone Green (Malachite) Level 2	Viridian	
	Stone Green (Malachite) Level 3	Antique Opal Green	Hooker's Green + white gouache
	Indigo + Rattan Yellow	Sap Green	Green Gold, Olive Green
Blue	Indigo	Indigo	
	Stone Blue (Azurite) Level 1	Manganese Blue	Cobalt Blue
	Stone Blue (Azurite) Level 2	Prussian Blue	
Purple	Indigo + Rouge Red	Indigo + Alizarin Crimson	Cobalt Violet, Permanent Violet
White	White	White gouache	
Black	Sumi-e ink	Sumi-e ink	

Basic Brushwork

Mastering brushwork takes practice. Brush painting is very much like performing art. You practice the same strokes multiple times until it becomes second nature to you. Then, with one deep breath and a bold move, you successfully put down a stroke onto the paper. Keep painting and keep exploring.

Good brushwork is created based on the six essential techniques:

- The grip (how to hold the brush)
- The angle between the brush and the paper
- The pressure of the stroke
- The movement of the brushstroke
- The speed of the movement
- The load (the amount of ink, water, and color on the brush)

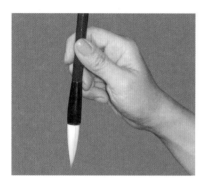

Basic grip, right hand.

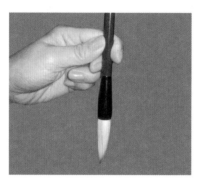

Basic grip, left hand.

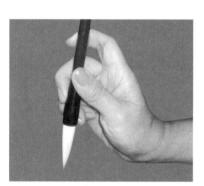

Calligraphy grip, right hand.

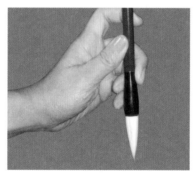

Calligraphy grip, left hand.

How to Hold the Brush

The brush is an extension of your hand; a proper grip can produce brush movements that balance control and flexibility.

Basic Grip

Hold the brush upright between the index and middle finger. Anchor the brush with the thumb. Move the index and middle fingers together and the brush will move with them. You can control the movement of the brush easily with this grip.

Modification for Calligraphy and Detailed Contours

To increase stability, slide the brush down between the middle and ring finger. This will provide a lock-in grip with the highest control for a steady line. This grip is great for practicing calligraphy and for drawing detailed contours. For maximum control for very detailed work, move the index finger higher to let the brush handle rest on it. You can make very steady lines with this grip.

Modification for Painting Shapes

To increase mobility, hold the brush between the index finger and the thumb, with the brush handle resting against the middle finger. You can rotate the brush along its axis by rolling it with your thumb. You can also move and point the brush up and down and around with your thumb. When combined with different pressure, the grip allows the brush to make different patterns in a variety of angles and shapes.

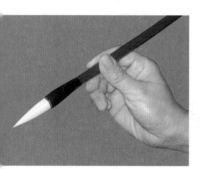

Grip that allows rotation of the brush with the right hand.

Grip that allows rotation of the brush with the left hand.

How to Load the Brush

Grind ink with water and an ink stone, or pour a small amount of bottled ink in a small dish. If you are using colors, prepare each color in separate small dishes. Squeeze a small amount of fresh watercolor from the tube and add a few drops of water to it. The color should have the consistency of honey, not too diluted but more fluid than fresh paint from a tube. Never dip a dry brush into color or ink. Wet the brush with clear water and then get rid of the excess water by scraping it on the side of the water container or tapping the brush on a blotting paper in the direction of the bristles. Now you are ready to load with color.

To Load with Ink or One Color

Dip two-thirds of the brush hair into the ink or color. Get rid of the excess color or ink by scraping it on the side of the ink dish. This will help work the color and ink into the body of the brush. Do not apply pressure, which will force the mixing of the water on the heel and the color/ink too early. The brush is now ready for painting.

HOW TO LOAD A BRUSH

Never dip a dry brush into color or ink. Always start by wetting the brush in clear water.

Get rid of excess water by scraping the brush on the side of the water container or the edge of a plate.

TO LOAD WITH INK ONLY

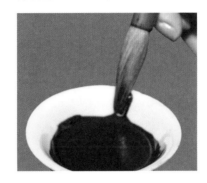

Wet the brush and get rid of excess water. Dip two-thirds of the brush hair into ink.

Brush loaded with water and two-thirds black ink.

To Load with Two to Three Colors

Load the brush with the first color, covering two-thirds of the brush hair. Pick up the second color and let it cover one-third of the hair. Get rid of excess color by scraping it on the side of the color dish. Roll the brush on a plate to let the first and second colors blend slightly. Do not overwork the blending; you want the different colors to be visible within the stroke on the paper.

Dip the very tip, about one-eighth of the brush, in the third color, which is usually an intense hue of the second color in a thicker consistency. To keep the intensity, do not roll the brush again. The brush is now ready for painting.

AUTHOR'S TIP: Always keep the heel of the brush (the third closest to the handle) free of color or ink. Water at the heel will migrate to the tip of the brush during the painting process, creating variation of values in the strokes.

TO LOAD WITH THREE COLORS

Wet the brush and get rid of excess water. Load two-thirds of the brush with the first color (Cadmium Yellow is shown here).

Load one-third of the brush with the second color (Vermilion is used here).

Roll the brush on a plate to let the first and second colors blend slightly. Do not overwork the blending.

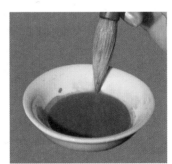

Dip the very tip (about one-eighth) of the brush in the third color (Permanent Alizarin Crimson, here).

Brush loaded with three colors.

Basic Strokes

By varying the angle, pressure, movement, and speed of the brush you can produce a variety of strokes. You can paint different contours and surfaces by using them in different combinations.

Center Stroke

The angle and pressure between the brush and the paper determine their contact. The center stroke is also known as the vertical stroke. Hold the brush perpendicular to the paper in an upright position so only the tip of the brush is touching the paper; this will create a thin line when you move down. If you increase the downward pressure, the width of the line will increase. By keeping the amount of pressure the same, you can draw a line with the same width throughout.

The brush in an upright position is responsive to the slightest variance in pressure, creating the breadth and shape of a stroke. More pressure will create a wider width while less pressure will create a narrower stroke. With the change of pressure, you can create wide and narrow shapes in the same stroke.

PRACTICE STROKES

Since the grip in Chinese brush painting is different from how we usually hold a pen or paintbrush, let's practice a few fundamental strokes. Newsprint is an affordable substitute for rice paper for practice strokes. Load a round brush with ink. Practice different kinds of center stroke movements: upward, downward, sideways, diagonal, and circular. Like clearing your throat before singing, the process is also a great way to clear your mind before painting.

Basic center stroke practice with the same pressure.

Start with the tip of the brush touching the paper, increase pressure as you pull down, and then decrease pressure before lifting the brush off the paper. The result is a stroke that resembles a classic bamboo leaf.

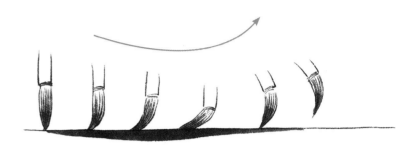

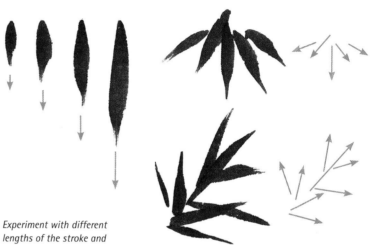

Experiment with different lengths of the stroke and see how the strokes mimic short baby leaves to long willow leaves.

Try the same stroke in different directions: upward, downward, and sideways. This will increase your flexibility in making the strokes with ease when painting.

Instead of swift movement in one direction, vary the pressure and draw a large semicircle. The stroke will create a graceful arch that resembles a long grass twisted in the wind. This is the stroke of a classic orchid leaf. Practice starting from the right and arching to the left and vice versa.

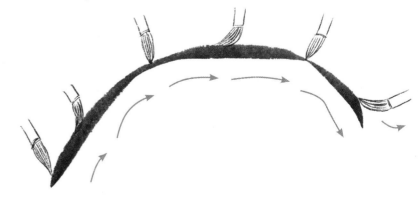

Side Stroke

The side stroke is also known as the horizontal stroke or the slanted stroke. Hold the brush at an angle so it is no longer perpendicular to the paper, thus increasing the contact of the brush with the paper. The amount of contact of hair with paper depends on the angle of the brush. The side stroke is great in showing the gradation of the ink or colors in the same stroke. Practice with a variety of angles and direction of movement to discover the wonders of the side stroke.

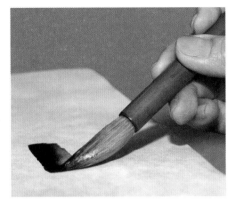

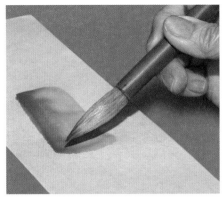

Painting a wide surface with a side stroke in black ink and water. Notice the slanted angle between the brush and the paper.

Painting a wide surface with a brush loaded with three colors. The gradation of the colors is visible on the paper in one single stroke.

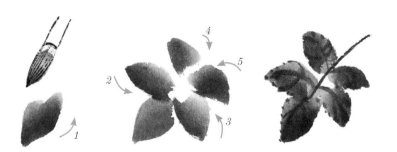

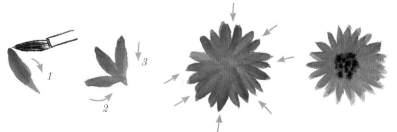

Side strokes in ink only and multiple colors. The stroke on the left is a center stroke, in which the brush is perpendicular to the paper. The rest are side strokes at varying angles to the paper. The more slanted the brush, the more visible the gradation of colors in the brushwork.

Different Ways to Start a Stroke

Since a complete petal or leaf can be formed with a single stroke in Chinese brush painting, let's work on the different ways to start a stroke to maximize the effect. The start of the stroke can be pointed, flat, or round.

Pointed Top

The tip of a good round brush always gathers to a point. Starting a stroke with the tip of the brush in the initial upright position will always give you a pointed top. Combine it with a side stroke to give you a wide leaf. Combine it with a center stroke to make a narrow flower petal.

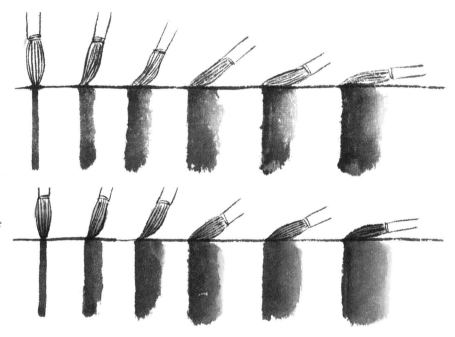

Pointed top side strokes make a group of rose leaves.

Pointed top center strokes in a circle make a daisy.

Nail Stroke (Flat Top)

To create a distinctly flat beginning of a stroke, start with resting the tip of the brush on the paper, then pull the brush down to finish the line. The resting of the tip creates the "Nail Head." Nail strokes have a calligraphic property that adds to the beauty of the contours in a painting. Use a small brush for contours of small blossoms, and use a medium brush for larger flowers.

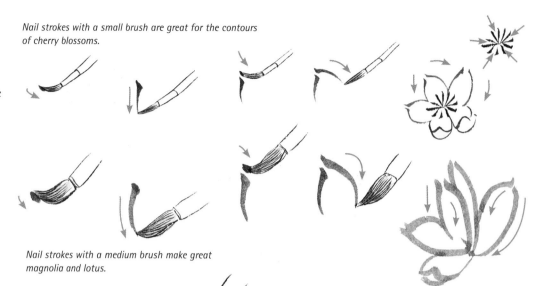

Nail strokes with a small brush are great for the contours of cherry blossoms.

Nail strokes with a medium brush make great magnolia and lotus.

Tuck-in Stroke (Round Top)

Many petals and leaves have rounded tips, instead of pointed ones. In order to hide the pointed tip of the brush, pull the brush in the reverse direction slightly before pulling it in the desired direction. The quick yet subtle reverse motion will "tuck-in" the pointed tip of the brush, making the start of the stroke round. Because the brushwork covers the initial starting mark, the pointed tip is no longer visible. Practice this stroke in repetition on newsprint to train the hand on this brush motion. Tuck-in strokes are great for the petals of many flowers.

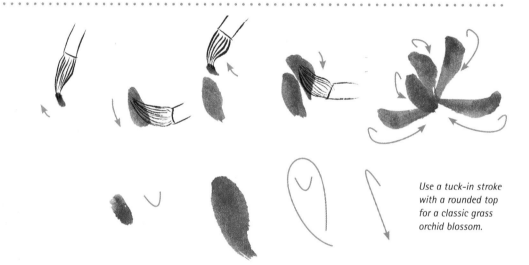

Use a tuck-in stroke with a rounded top for a classic grass orchid blossom.

Dry Stroke

By altering the amount of moisture on the brush and changing the speed of the brush movement, you can create a different texture in the brushwork. When the brush is relatively dry, or the movement is swift, only a portion of the brush is in contact with the paper, while some portions of the brushstroke remain unpainted. This is called the "Flying White," which represents the rough texture of tree bark and the stiffness of branches. The dryness of the brush can occur naturally when most of the colors are used up in the painting process. You can also create it by drying the brush against a paper towel before using it on the painting. Use a hard brush to deliver the dry strokes as it is less absorbent than a soft brush.

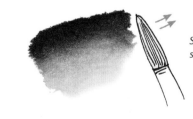

Side stroke with a soft brush.

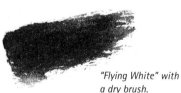

"Flying White" with a dry brush.

"Flying White" drawn with a hard brush.

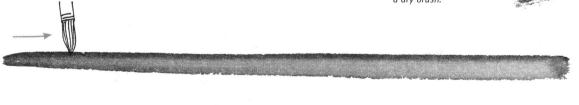

Center stroke with a soft brush.

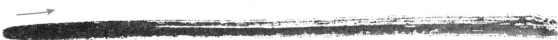

"Flying White" with a dry brush or drawn with a hard brush.

Leaves, Stems, and Branches

A good flower painting is not complete without supporting elements, including the leaves, stems, and branches.

Herbaceous Stems

There are two kinds of stem, herbaceous and woody. Herbaceous stems die down in cold weather and regrow when it is warm. The stems are generally upright but have a delicate, flexible quality. Paint herbaceous stems with a combination brush (Long Flow) loaded with two-thirds green and one-eighth Burnt Sienna on the tip. Use center strokes in a slightly curved motion. Straight lines look stiff and unnatural for stems. Some flowers with herbaceous stems are tulips (see pages 42–43), begonias (see pages 76–77), lotuses (see pages 94–98), and herbaceous peonies (see pages 122–124).

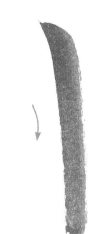

Center strokes for a lotus stem—notice the slight curve.

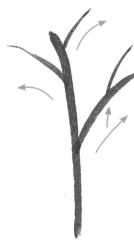

Stems for a herbaceous peony. Start with a center stroke from the top down for the main stem. Add smaller stems out from the main stem in slight curves in center strokes with decreasing pressure (see page 18).

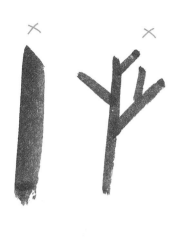

Do not use straight lines as they will make the stems too stiff.

Woody Branches and Trunks

Woody branches and trunks are coarse, as they survive the seasons and develop rough barks on the surface. Use a hard brush (Mountain Horse) loaded with two-thirds Burnt Sienna and one-eighth black ink on the tip to paint woody branches. Use a paper towel to dry the brush before painting. Examples of flowers with woody branches and trunks are pear blossoms (see pages 62–64), cherry blossoms (see pages 65–69), magnolias (see pages 90–93), and roses (see pages 116–119).

Begin the main branch with an assertive center stroke using a relatively dry, hard brush.

Use center strokes for the main branch, then add smaller branches to the side.

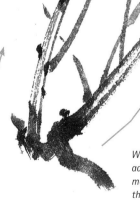

Without reloading the brush, add smaller branches in swift motions. Add dots of ink along the branches. The speed and the dryness create "Flying White" and convey the uneven texture of woody branches.

Draw the lower part of a thick trunk in a side stroke and "Flying White" using a relatively dry, hard brush.

Continue to draw the top of the trunk with the same brush using a center stroke.

Complete the body of the trunk in short, broken center strokes to represent the rough texture of the large trunk.

Leaf Veins and Leaves

Leaves provide a different range of colors that usually contrast nicely with the flowers. Leaf veins, often rendered in black ink or dark shades, not only provide detail but also add a calligraphic element to your artwork, making the overall composition more interesting.

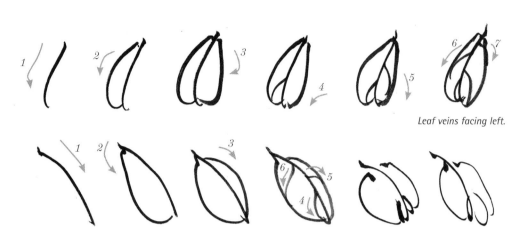

A longer leaf.

Leaf Veins

Load a fine hard brush (Leaf Vein) with black ink. Start with a nail stroke in the middle. Add an elongated "c" and reverse "c" on each side. From the middle, add downward nail strokes for the veins. Practice with leaves facing left and right, and draw longer leaves with the same steps. It takes practice to perfect the strokes for the veins, but you can use these veins for the leaves of most flowers.

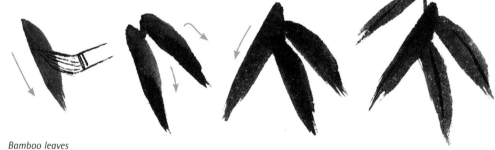

Leaf veins facing left.

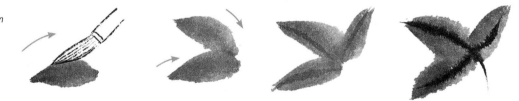

Leaf veins facing right.

Leaves

The vast variety of leaves may be summarized into a few major shapes. It is essential to match the correct type of stem, branch, and leaf shape with the right kind of flower. Practice painting them facing in different directions to help you in the design of your composition.

Leaves with a Narrow Body and a Pointed Tip

A simple center stroke will create a leaf with a narrow body and a pointed tip. Flowers and plants with this leaf shape are peach blossoms (see pages 60–61), wisteria (see pages 120–121), and bamboo.

Bamboo leaves

Shorter version for the leaves of the peach tree.

Leaves with a Round Body and a Pointed Tip

Apply a side stroke with a stroke that starts with a pointed tip, and you will have a leaf with a round body and a pointed tip. If you want a wider body, use two strokes side by side. Examples of flowers with this leaf shape are azaleas (see pages 88–89), magnolias (see pages 90–93), and roses (see pages 116–119).

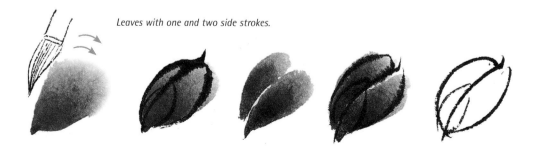

Leaves with one and two side strokes.

Leaves with a Long, Spear-Like Shape

A long side stroke creates the base of the leaf. Add texture by added "Flying White" with a hard brush and dark ink. Flowers with this leaf shape are daffodils (see pages 56–57), irises (see pages 72–73), orchids (see pages 78–79), jonquils (see pages 84–85), gladioli (see pages 106–107), and amaryllis (see pages 108–109).

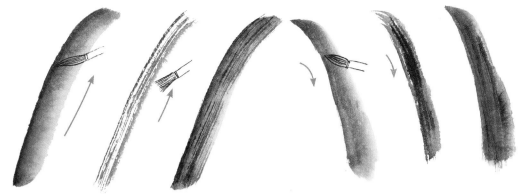

Leaves painted from the bottom up.

Leaves painted from the top down.

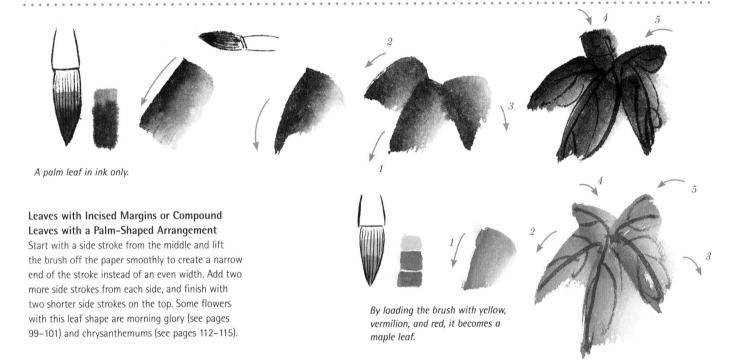

A palm leaf in ink only.

Leaves with Incised Margins or Compound Leaves with a Palm-Shaped Arrangement

Start with a side stroke from the middle and lift the brush off the paper smoothly to create a narrow end of the stroke instead of an even width. Add two more side strokes from each side, and finish with two shorter side strokes on the top. Some flowers with this leaf shape are morning glory (see pages 99–101) and chrysanthemums (see pages 112–115).

By loading the brush with yellow, vermilion, and red, it becomes a maple leaf.

Large Leaves

Combine two side strokes to create large leaves. For leaves with different top and bottom colors, use different colors for the strokes. You can also represent different kinds of leaves by altering the pattern of the veins. Examples of flowers with larger leaves are hydrangeas (see pages 52–55), hibiscus (see pages 70–71), sunflowers (see pages 74–75), and begonias (see pages 76–77).

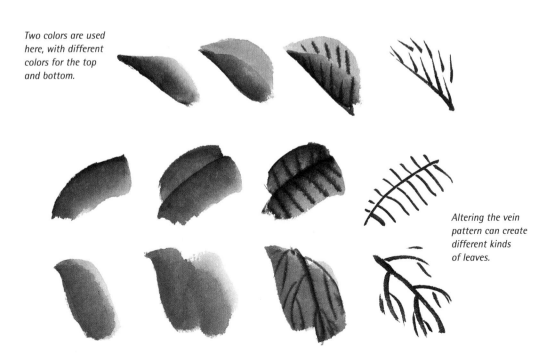

Two colors are used here, with different colors for the top and bottom.

Altering the vein pattern can create different kinds of leaves.

Composition

Composition is to a painting what a blueprint is to a building. It is an essential step in the creative process. A bad composition will ruin a painting, regardless of how sophisticated the brushwork or how skillful the techniques.

The aesthetic concepts of the East are quite different from those of the West; in Asian art the culture, the history of development, and the materials used all influence the way design and composition are treated. The development of Western art is deeply influenced by scientific discoveries; thus, traditional Western art emphasizes perspective, proportion, and realistic depictions of the subjects.

Chinese brush painting focuses on the artist's emotions and feelings, and pays attention to capturing the spirit of the subject rather than in attaining its realistic appearance. There are some unique elements in the composition of floral artwork in Chinese brush painting: flowers are mostly in their natural environment and not as cut flowers; branches create dramatic lines, affecting eye movement; the use of negative space; and the relationship between "Host" and "Guest." All these can be confusing to Western artists accustomed to having only one dominating element in an artwork.

While the concept of good composition can be very intangible, there are fundamental ways to help understand the concept. Here are ways to develop a strong composition in floral artwork in Chinese brush painting.

Select the Format and Content

Before you start, decide on the feeling and emotion that you are trying to capture. It may be the beauty of the spring, the solitude of winter, or the joy of having close friends. Then, select the subjects based on that emotion, and choose the format and basic design based on the physical attributes of the subjects.

Format

A visit to any major Asian art collection in a museum will reveal that Chinese brush painting has a very different format to that of Western art. Many traditional Western arts follow the "golden ratio" of 1 to 1.618, forming a rectangle in either the portrait (vertical) or the landscape (horizontal) format. This golden ratio is so imbedded in the Western aesthetics that many viewers reject the use of formats not conforming to it.

Chinese brush painting favors a more diverse selection of format. The designs are also more elongated than those using the golden ratio rectangle. Hanging scrolls designed to be hung from the top, hand scrolls and accordion books designed to be held in one's hands and viewed in portions rolling from right to left are often narrow and long. Besides rectangular formats, Chinese brush painting uses squares, ovals, circles, and even fan shapes. These unique formats not using the golden ratio make certain common Western composition rules no longer applicable. For example, the elongated rectangle format makes the "Rule of Thirds," which emphasizes the intersections in a nine-grid rectangle, not as practical for long, narrow paintings.

Rectangles in the golden ratio.

Using the Rule of Thirds in the rectangular format.

Basic Design

Consider the content you plan to paint in order to select between a vertical or horizontal orientation. Due to the popular natural setting of flower painting, branches are usually visible, forming dramatic lines in the composition. There are generally three basic designs:

SIDEWAYS: Flowers with outreaching branches suit a sideways design. Rambling roses that lean to the sides are an example.

DOWNWARD: A top-down design is ideal for painting climbers. Flowers like morning glory and wisteria, and fruit and vegetables including grapes and legumes are great in a downward design.

RISING UP: Trees with main trunks and plants with strong supporting stems are ideal for a rising up design. A blooming magnolia branch is an example.

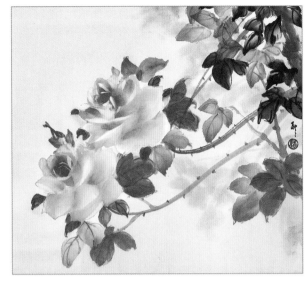

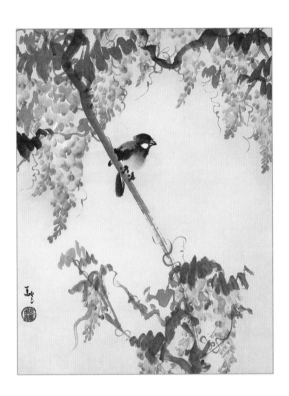

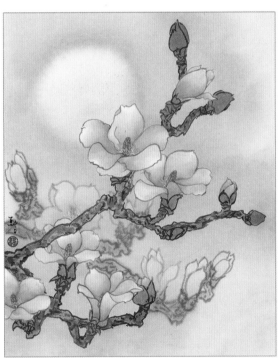

Above *Sideways design works for most plants with outreaching branches, including rambling roses that extend to the side.*

Far Left *Downward design is great for painting climbers like wisteria.*

Left *Rising up design fits nicely for most plants with flowering branches, including Mulan magnolia.*

Avoid Corners and Midpoints

In Western still life, where a glorious floral arrangement is the subject, the composition is very stable with symmetrically identical flowers on both sides of the painting. In Chinese flower painting asymmetry is preferred, providing a more dynamic composition to convey the feelings of the artist. To attain asymmetry, avoid all midpoints in the composition as the start of any key branches so the painting is not divided into halves horizontally or vertically. As well as the midpoints, avoid dividing the painting into equal halves diagonally by starting the key stem from the corners. Note the branches in the wisteria, magnolia, and roses above; they all avoid starting from corners and midpoints.

Avoid dividing the painting into halves vertically, horizontally, or diagonally.

Use of Negative Space

In Chinese philosophy, everything in the universe is composed of yin and yang, the negative and positive forces. These basic opposing forces represent the substance and void of all things. Harmony is achieved when yin and yang are in balance. The Tai Chi symbol represents the constant interaction of these two opposing forces to generate the vitality of nature. The contrast of opposing forces can be very interesting and is necessary for a successful painting. Contrast can be obtained through a variety of ways, including the use of shapes, value, color, texture, and size.

Negative space is the area that is left untouched in an artwork. The use of negative space is not only a visual representation but also a spiritual one. Irrelevant details are excluded, but the untouched area is not empty. It is filled with imagination and possibilities with the power of purifying the design. Leaving the area untouched allows room for the extension of ideas and movement. If the area is blocked with other subjects, it will block the energy of the flow of the main element, disrupting the harmony in the artwork.

Tai Chi symbol

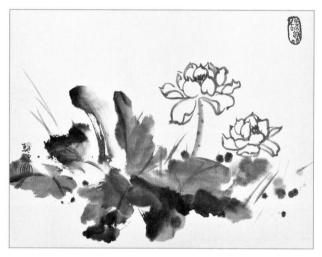

The blank background represents water in the pond.

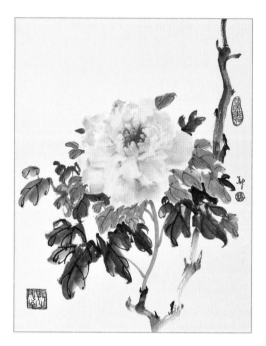

The blank background purifies the design, emphasizing the majestic peony.

Balance

Balance is sometimes misunderstood as having one side exactly the same as the other side. Although symmetry is calming, it lacks drama and easily leads to boredom in an artwork. The concept of balance is best illustrated with balancing a lever on a fulcrum. The lever operates by applying forces at different distances from the fulcrum. To balance a heavier weight, the force needs to be farther

away from the fulcrum. When designing the placement of elements in a painting, consider their relative weight. The weight is more than physical mass; it includes value, volume, brightness, complexity, and other artistic concepts. The placement of the butterfly and the bees in these examples create a visual balance with the canna lily and peonies.

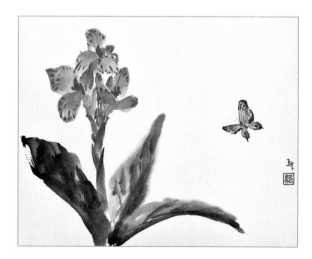

The butterfly is large and is farther away from the canna lily.

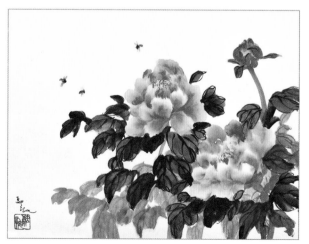

The bees are small and closer to the peonies. Notice the signature and seal also help balance the design.

"Host" and "Guest" and their Communication

Western art theories frequently discuss the use of dominance in composition. A similar concept is used in Chinese painting, but there are cultural influences that cannot be ignored. Instead of one's dominance over another, it is a reciprocal relationship of mutual support and respect. Like in a stage play, the host is the lead actor and the guests are the supporting actors. The role of the host is to be the center of attention and lead the telling of the story. The guests serve to accentuate the host and to give opportunities for the host to shine.

The host and guest interact and radiate a relationship similar to a friendship between two human beings. The host and guest communicate and show mutual respect to each other. The host has a more prominent presence, and the guest supports the host. There can be one host to one or multiple guests, or one guest to one or multiple hosts.

The morning glory are the hosts and the robin is the guest. The morning glory cascades down toward the robin, but the robin looks up and brings the attention back to the flowers. Flowers and birds are often humanized to communicate with each other.

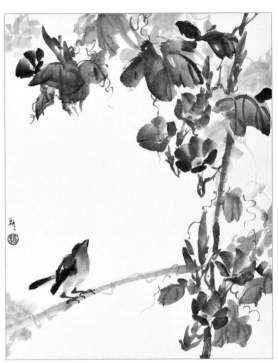

The sparrows are the host of the painting and the poinsettia the guests. The arrangement of the poinsettia forms a hollow circle, drawing the viewers to the sparrows.

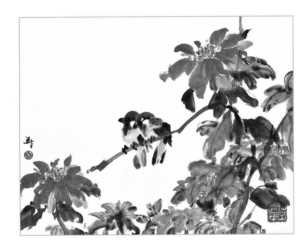

Top Left *Too closely grouped.*
Top Right *Too far apart.*
Bottom Left *Too uniform.*
Bottom Right *A better grouping.*

Grouping

Grouping of subjects is closely related to the concept of balance. How dense and how far apart the subjects are grouped can encourage eye movement throughout the painting. Elements too closely grouped confine the interest of the painting to only one location. Elements too far apart appear scattered and disconnected. Elements too uniformly distributed can appear unnatural and boring. Well-grouped elements encourage eye movement and give a dynamic energy to the artwork.

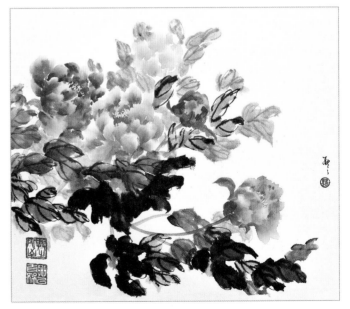

The grouping of peonies encourages eye movement and balances the composition. A single peony branching out makes a dynamic design.

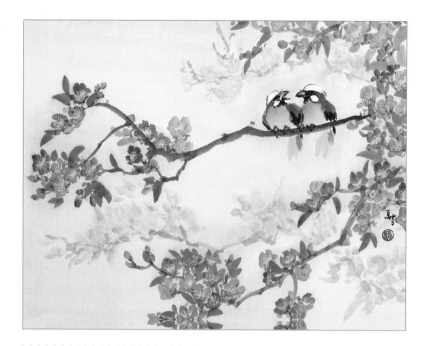

Rule of Odds

Odd numbers cannot be divided by two, thus avoiding the inadvertent even placement in the artwork. However, this concept is flexible in Chinese brush painting because of the popular use of symbolism. Birds usually come in pairs to symbolize a happy couple. Flower bundles may come in ten to symbolize perfection. Fish are depicted in groups of three, six, or nine to represent continuous good fortune. Avoid the use of four, as the number is considered unlucky in many regions of China.

A pair of white-headed bulbul with cherry blossoms is a symbol of a happy couple enjoying the return of spring.

The roses are arranged in a triangle in a circular vase.

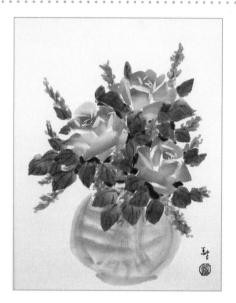

Classic Designs

There are several classic designs in flower paintings that are easy to follow. These basic geometric and linear designs are simple to understand and visually enticing.

Triangle

Three prominent subjects in the artwork form imaginary lines to create a triangle. The length of all sides of the triangle should be different. The outer shape of the painted substance may also form a triangular pattern that occupies two to three corners of the artwork, leaving one corner untouched as negative space. Triangles are unstable and dynamic in nature, making the artwork more energetic and lively.

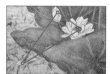

The fallen petal forms a triangle with the two lotus flowers on the right.

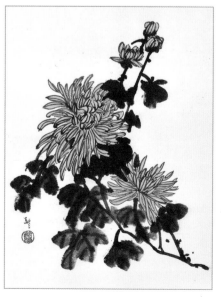

Beside the flower heads, the chrysanthemum also forms a triangular outer shape and occupies three corners of the artwork.

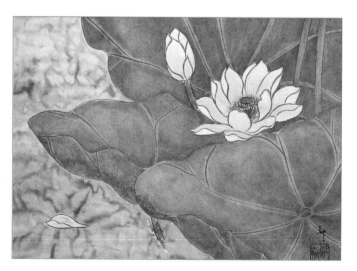

Cross

The Chinese character "Ten" is like a cross in the Western culture. This "Ten" design is popular for paintings of climbing plants, including wisteria, morning glory, and grapes. The supporting pillars form a cross that easily occupies the upper or lower corner of the painting, creating a pleasing asymmetric design.

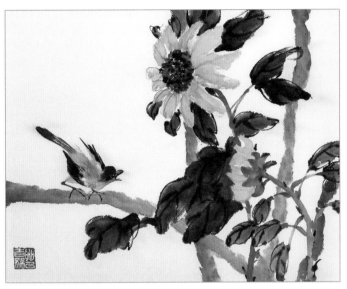

The sunflower and the bending stems form the basic cross design. Also notice how the sunflower and bird draw attention to each other in their guest and host relationship.

The trumpet creepers occupy the upper left. Notice a leisure seal (see page 30) in the lower right helps to balance the design, while the signature and name seal are hiding in the middle left.

"S" Shape

Commonly known as the "S" shape design in the West, this zigzag design is often used in larger, more elongated artworks to encourage eye movement. For branches extending from one side to another, the zigzag design introduces variety to the dominant direction. It invites the viewers to pay attention to different parts of the painting with their eyes traveling up and down the longer scroll artwork. This "S," or sometimes "Z," shape can have smooth or sharp turns, and may be composed of the same or multiple elements.

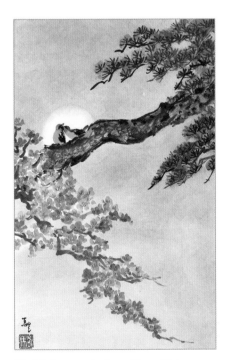

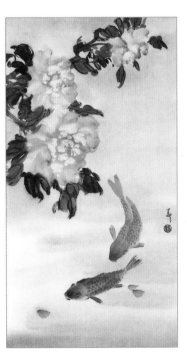

The "Z" shape can be formed by multiple elements, like the pine and blossoms shown here. The moon draws attention to the lovebirds on the pine branch.

The peonies and koi form a loose "S" shape that leads the eyes to travel across the painting.

Signatures, Seals, and Inscriptions

Chinese brush painting has a unique tradition in signing the artwork, which introduces the art of calligraphy, poetry, and seal carving into the painting. Artists usually sign with one or more seals and sometimes add an inscription.

Signatures

A signature may include more than the name of the artist. In ancient China, people had more than one given name based on a variety of traditions and cultural rituals. The artist's hometown, title (earned or self-proclaimed), age, and studio name are sometimes included as part of the signature.

Lok is my last name.

Pan is my maiden name.

Mei Lok is my given name. Mei means beauty and Lok means happiness.

Rong Rong is my pseudonym, which means harmony. Since the words are repeated, I usually sign the second one with two dots, representing "ditto."

Seals

Seals are carved in two different formats, Yang (positive) and Yin (negative). Yang seals have red words surrounded by blank space, and are lively and graceful. Yin seals have the words carved out so the surrounding area is red and the words are the color of the artwork, usually white. Yin seals appear heavy and substantial. Choose the carving style that matches the mood of the painting.

There are two types of seals: name seals, which are for the first name, last name, full name, or pseudonym of the artist; and leisure seals. Leisure seals, also known as supplemental seals or mood seals, help artists express their creative intent, and communicate their personal value of art and life. They may be the name of the studio, the official or self-proclaimed title of the artist, a personal motto, or a line from a poem. Leisure seals also balance the composition by adding weight to the corners of the artwork. Smaller, often irregular-shaped leisure seals are commonly used in the upper corners, and larger, block-shaped seals in the lower corners to add visual weight so the overall design will appear stable and balanced.

The seals for "Lok." The first two are Yang seals in a circular and a square shape, and the third one is a Yin seal in a square shape.

SOME OF JOAN LOK'S FAVORITE LEISURE SEALS

Left Converse with a smile. *Center* Mei Lok Studio. *Right* Lingnan native. *All are Yang seals.*

Left Tranquility reaches afar. *Center* Striving to live among the mist and cloud (longing for a hermit lifestyle). *Right* I am here (inside the artwork). *Left and center are Yin, right is Yang.*

Left Paint to my heart's desire. *Center* Favorite pastime. *Right* Happiness is treasuring what you already have. *Left is Yang, center and right are Yin.*

Inscriptions

Inscription is unique to Chinese brush painting. The most common inscriptions are poems and statements inspired by the subjects in the painting. Artists also express their feelings, creative intent, or the occasion for making the painting, such as a farewell to a friend, or a celebration of a birthday. The Chinese language is often written vertically from right to left. The style of calligraphy for the signature and inscription should correspond to the style of the painting to produce a unified artwork. Detail style artworks match well with the standard script while more free-spirited Lingnan style paintings work well with the running script.

In the past, collectors added their own seals and inscriptions to indicate artwork as part of their art collection. This practice is discouraged today as it permanently alters the artwork.

AUTHOR'S NOTE: The use of inscription is a personal choice. I rarely write inscriptions on my artwork because viewers who do not read Chinese cannot understand them. Translation is always needed, making the inscription a distraction instead of adding value to my art.

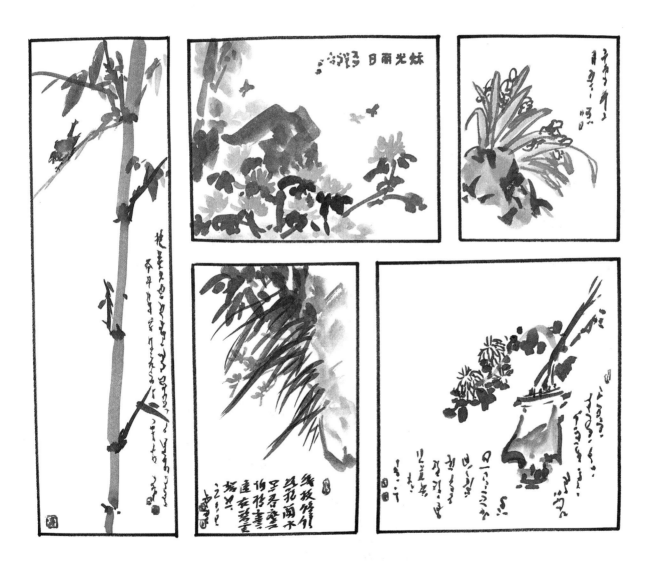

CLASSIC INSCRIPTION FORMATS

Left *Narrow, top-down inscription for long scrolls.* Top Middle *Larger inscription, usually with the title of the artwork, across the upper right on a horizontal centerpiece.* Top Right *Shorter, top-down inscription to balance the asymmetrical design.* Bottom Middle *Uniform, mostly rectangular, block-like inscription to fill the negative space at the bottom.* Bottom Right *Irregular, interwoven shape to enhance the shape of the subjects.*

Placement of Signatures and Seals

The placement of the signature and seal is very important to the overall composition of the artwork—the classic use of a black signature and red seals mean that both will stand out.

A well-placed signature and seal will enhance and balance the design, encourage eye movement, and improve the overall composition. When signing a painting, consider the following:

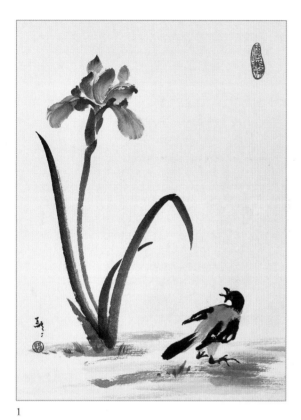

1

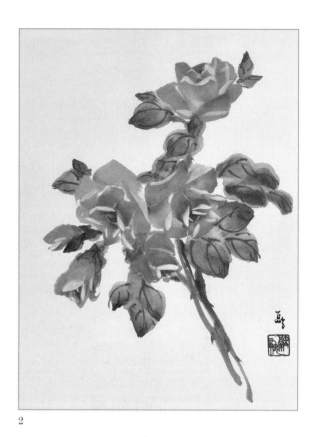

2

DO

• Use the signature and seals to encourage eye movement. A leisure seal on the upper right and the signature on the lower left encourages eye movement across the entire artwork. (1)

• Use a larger seal to stabilize a relatively floating design. A square-shaped Yang seal is airy, yet large enough to stabilize the design of the bouquet of roses without weighing down the composition. (2)

• Use an inscription to expand the viewer's attention to an easily ignored area in the painting. Note the running calligraphy style matches the free brushwork of the glass orchid. (3)

• Use the signature and seals to balance an asymmetric composition. The small signature and seal on the right are able to balance the roses on the left because the red seal and black signature repeat the colors of the roses and leaves. (4)

• If you are happy with the composition as it stands, place the signature and seal discreetly so they will not distract from the composition. The name and seal are small and placed among the cherry blossoms, so they are unnoticeable at a glance. (5)

3

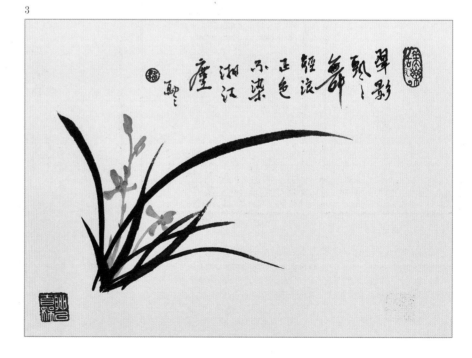

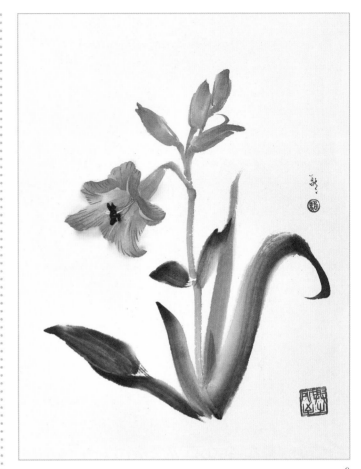

9

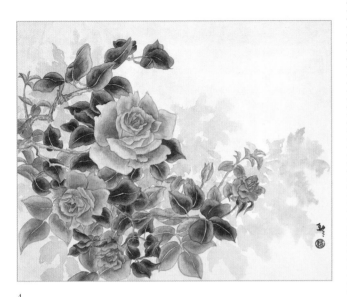

4

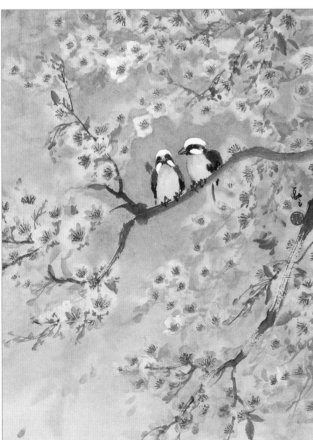

5

DON'T

• Do not block the flow of energy of the subjects by signing in the space where a plant is growing or where birds are flying to. (6)

• Do not sign where the signature and seals will create a continuous line with the key subject of interest in the painting. This will lead the eyes outside the artwork. (7)

A better way would be to use the signature and seal as a liaison between two key subjects. Here, the signature and seal add a third point of interest with the blooming daylily and its buds to form a triangle on the top half of the artwork. The square leisure seal adds weight to the lower right. (8,9)

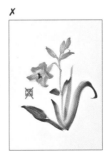

6

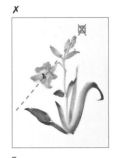

7

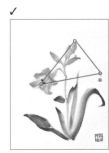

8

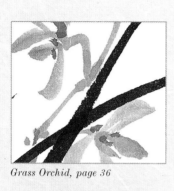
Grass Orchid, page 36

Bird of Paradise, page 38

Madonna Lily, page 40

Tulip, page 42

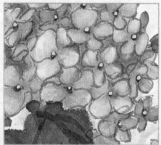
Hydrangea with Contour Lines, page 52

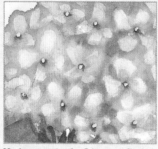
Hydrangea in the Lingnan Style, page 54

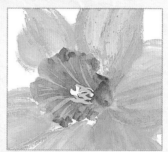
Daffodil, page 56

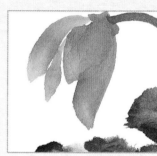
Cyclamen, page 58

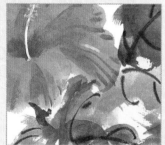
Hibiscus, page 70

Iris, page 72

Sunflower, page 74

Begonia, page 76

Azalea, page 88

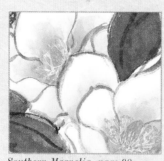
Southern Magnolia, page 90

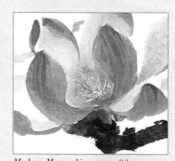
Mulan Magnolia, page 92

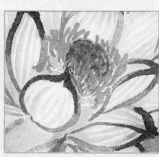
Lotus with Contour Lines, page 94

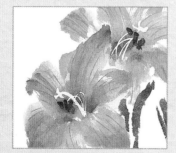
Gladiolus, page 106

Amaryllis, page 108

Hong Kong Orchid Tree, page 110

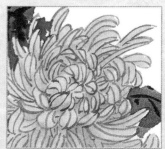
Chrysanthemum, page 112

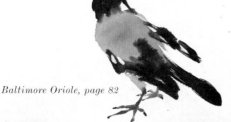
Baltimore Oriole, page 82

Directory of Flowers

Cockscomb, page 44

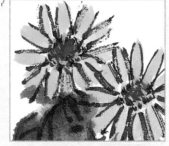
Black-eyed Susan, page 46

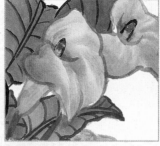
Calla Lily, page 48

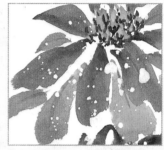
Poinsettia, page 50

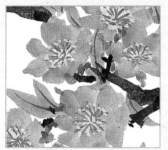
Peach Blossom, page 60

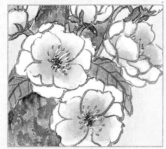
Pear Blossom, page 62

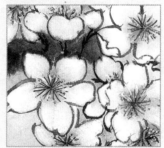
Cherry Blossom in the Detail Style, page 65

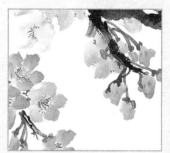
Cherry Blossom in the Lingnan Style, page 68

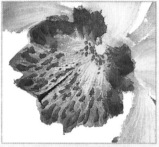
Orchid, page 78

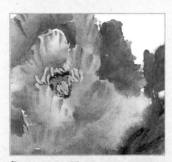
Poppy, page 80

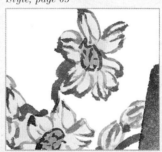
Jonquil, page 84

Daylily, page 86

Lotus in the Lingnan Style, page 96

Morning Glory, page 99

Purple Water Lilies, page 102

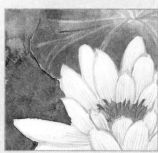
White Water Lilies, page 104

Rose, page 116

Chinese Wisteria, page 120

Herbaceous Peony, page 122

Tree Peony, page 125

Palette

 Gamboge Yellow

 [Green] Indigo +
Gamboge Yellow

 Vermilion

 Black ink

Cymbidium Grass Orchid

The grass orchid is honored as one of the "Four Gentlemen" in the Chinese culture. In ancient China, fragrant grass orchid grew only in the inaccessible forest, so the plant symbolizes serenity in obscurity. Scholars living simple monastic lives are described as having the spirit of grass orchid. Grass orchid has small flowers and long, grass-like leaves, making it an ideal subject for monochrome ink artwork. The flowers are painted with apparently simple-looking calligraphic strokes, but the true beauty of grass orchid painting is in the graceful rendering of the leaves with elegant brushwork.

The leaves

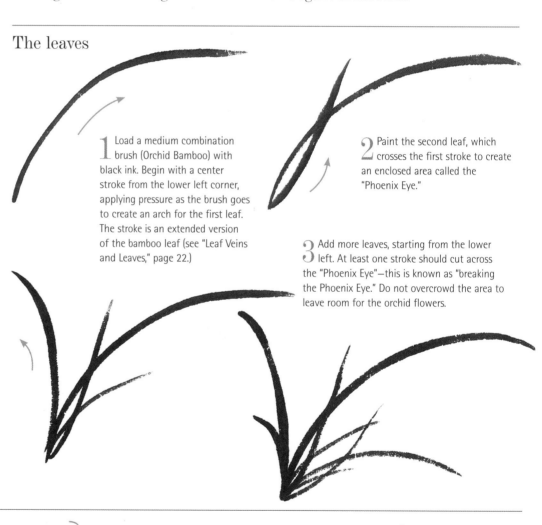

sequence
start to finish

Form a knot of leaves with the "Phoenix Eye" and "Breaking the Phoenix Eye" techniques using the steps described at right. Practice on newsprint as needed to attain the graceful brushwork and grouping. Next, paint a few flowers with tuck-in strokes in the spaces between the leaves (see page 20). Link the flowers to form 1–3 chains. Make sure the stems reach to the base of the knot of leaves. Finally, paint 3 tiny dots on each flower to represent the pollen cap and stigma once the petals are dry (see opposite).

1 Load a medium combination brush (Orchid Bamboo) with black ink. Begin with a center stroke from the lower left corner, applying pressure as the brush goes to create an arch for the first leaf. The stroke is an extended version of the bamboo leaf (see "Leaf Veins and Leaves," page 22.)

2 Paint the second leaf, which crosses the first stroke to create an enclosed area called the "Phoenix Eye."

3 Add more leaves, starting from the lower left. At least one stroke should cut across the "Phoenix Eye"—this is known as "breaking the Phoenix Eye." Do not overcrowd the area to leave room for the orchid flowers.

Paper
Double Shuen

Brushes
Orchid Bamboo, small and medium combination
Leaf Vein, fine hard

special details
forming chains

Some grass orchid flowers come in the form of one flower at the end of each stem, while some come in a chain of flowers in a single stem. The top two or three orchids are not yet open, so just paint them with two short tuck-in strokes. Link them with the rest of the orchids with center strokes.

Make sure that the stems reach right down to the base of the knot of leaves.

Orchid flowers in a variety of poses are shown for additional reference.

The flowers

1 Mix Indigo and Gamboge Yellow to create green. Load two-thirds of a small combination brush (Orchid Bamboo) with Gamboge Yellow and one-third with green. Paint two short tuck-in strokes, one with more pressure so one is thicker than the other to give the shape of the lip of the orchid flower.

2 Paint three additional tuck-in strokes from the left, right, and bottom toward the lip for three petals of the flower.

3 When the petals are dry, use a small hard brush (Leaf Vein) and paint three tiny commas in Vermilion to represent the pollen cap and stigma of the flower.

"Phoenix Eye" and "Breaking the Phoenix Eye" are two essential steps in painting orchid leaves to ensure the variety of crisscrossing and irregularity in the direction of the leaves.

special details calligraphic details

Note that grass orchid flowers are calligraphic, so these strokes are sufficient in representing the entire flower. See the drawing and the calligraphic brushwork side by side.

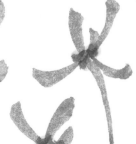

Strelitzia Reginae
Bird of Paradise

Palette

 Sap Green

 Cobalt Violet

 Cadmium Yellow Medium

 Vermilion

 Indigo

 Stone Green

 White gouache

The bird of paradise gets its name because the flower resembles the head of an exotic blue-headed bird with brilliant orange wings. It is available all year round in quality flower shops. It is often used in indoor flower arrangements because of its dramatic look. Bird of paradise have a unique shape that no other flower has. The flower stands erect on its stem, which is very strong, thick, long, and straight. It comes with very large, leathery leaves on long stalks.

sequence
start to finish

Begin by forming the base of the flower with a broad side stroke in Sap Green and Vermilion. Add overlapping petals in Cadmium Yellow Medium and Vermilion while leaving room for the "Blue-Headed Bird." Carefully paint 2–3 "Blue-Headed Birds" following the instructions at right. Load two-thirds of a large combination brush (Long Flow) with Sap Green and one-third Indigo and paint the leaves with side strokes. Before the leaves are completely dry, use a fine hard brush (Leaf Vein) loaded with Stone Green for the veins of the leaves.

Paper
Ma (semi-sized rice paper)

Brushes
Long Flow, large and medium combination
Leaf Vein, fine hard

The flowers

1 Load two-thirds of a large combination brush (Long Flow) with Sap Green and the tip with Vermilion. Paint the base of the flower in one side stroke by pulling from left to right.

2 Without washing the color off the brush, load one-third of the brush with Vermilion and complete the top edge of the base of the flower with a side stroke.

3 Load two-thirds of a medium combination brush (Long Flow) with Cadmium Yellow Medium and one-third with Vermilion. Paint the first petal in one stroke, pulling down toward the center of the base. Add additional petals, some overlapping, while leaving room for the "Blue-Headed Bird."

Add texture to the petals in Vermilion (see Daffodil, Step 4, page 57).

The "Blue-Headed Birds"

1 Load a fine hard brush (Leaf Vein) with Cobalt Violet and create the first portion by simply laying the side of the brush against the paper and sliding downward.

2 Repeat for the second portion.

3 When the colors are dry, add Cadmium Yellow Medium mixed with a small amount of white gouache for accent color at the tip of the "Blue-Headed Bird."

Adding a small amount of white gouache to Cadmium Yellow Medium will ensure it covers the Cobalt Violet for the head of the "Blue-Headed Bird."

While details are usually added when the colors have dried, leaf veins should be added when the colors are not completely dry so the veins merge with the rest of the leaves, instead of sitting on top of them.

For color variation in the leaves, add a small amount of Cobalt Violet to the Sap Green already in the brush. Vary the colors of each leaf by adding Vermilion, Cobalt Violet, and Gamboge Yellow to produce a variety of leaf colors.

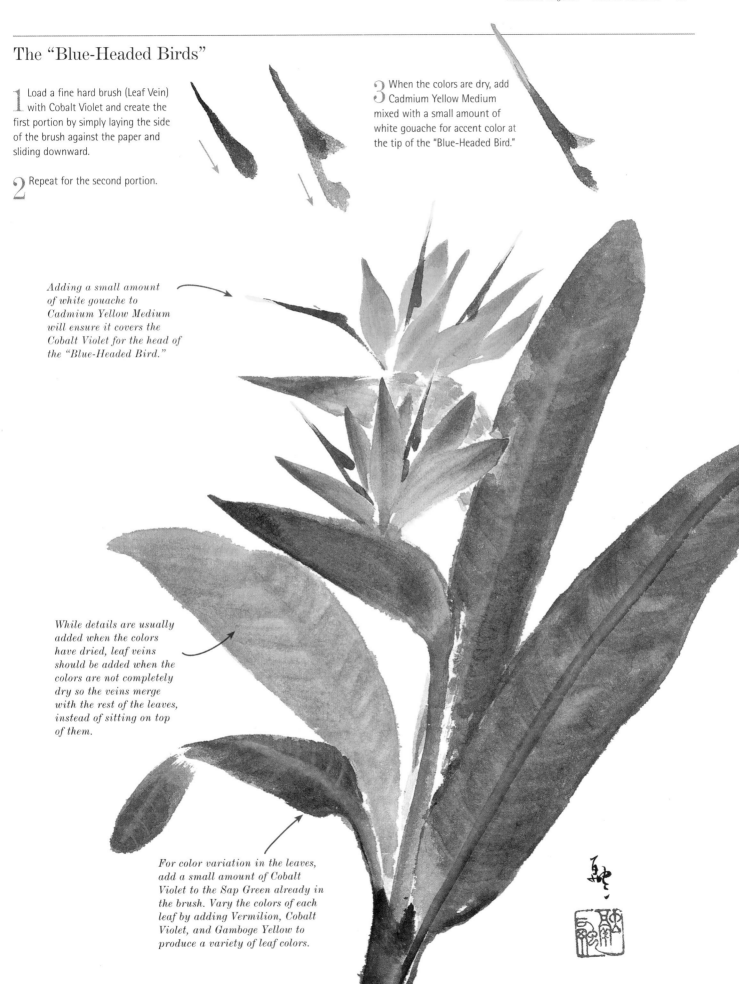

Lilium Candidum Madonna Lily

Palette

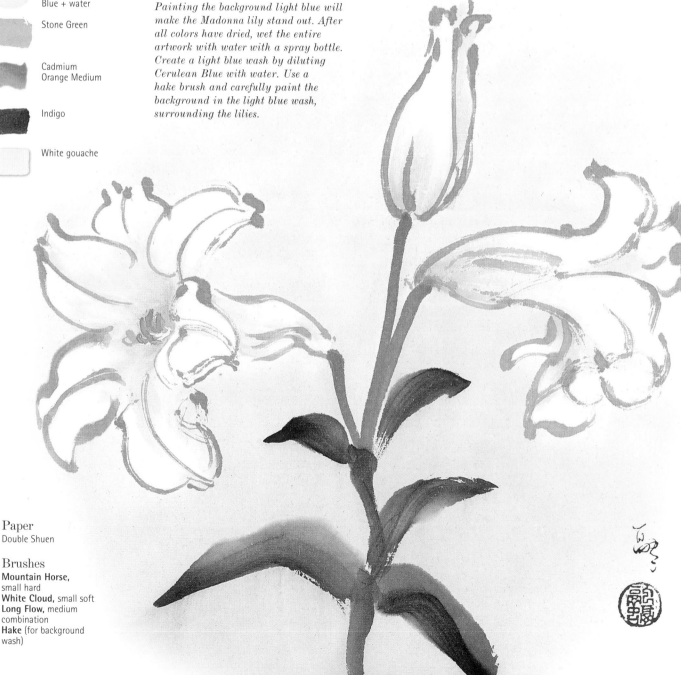

[Light Ink] Black ink + water

Sap Green

Black ink

Cadmium Yellow Light

[Light blue wash] Cerulean Blue + water

Stone Green

Cadmium Orange Medium

Indigo

White gouache

Elegant and sophisticated in appearance, the lily is also a versatile plant. Its Chinese name is "Works with a Hundred Things" as lily bulbs are used in soup and herbal drinks in China. The flower grows at the top of the stem and has six spreading petals, giving the flower a funnel shape. Lilies have yellow anthers, one stigma, and several stamens, and the leaves are dark green and glossy. White lilies are popular in pots or as cut flowers in spring. The white Madonna lily shown here is a good introduction to the use of white gouache in Chinese brush painting.

Painting the background light blue will make the Madonna lily stand out. After all colors have dried, wet the entire artwork with water with a spray bottle. Create a light blue wash by diluting Cerulean Blue with water. Use a hake brush and carefully paint the background in the light blue wash, surrounding the lilies.

Paper
Double Shuen

Brushes
Mountain Horse, small hard
White Cloud, small soft
Long Flow, medium combination
Hake (for background wash)

sequence
start to finish

First construct the contour of the Madonna Lily in assertive strokes. Practice on newsprint to attain the expressive brushwork. Color the center of the flowers Cadmium Yellow Light. Fill the outer edge of the petals with a thin layer of white gouache. Add stems and leaves in Sap Green and Indigo (see Stems, Leaves, and Branches, pages 21–23). Complete the flowers with the details of the stamen. Apply a light blue wash in the background using a hake brush.

The flowers

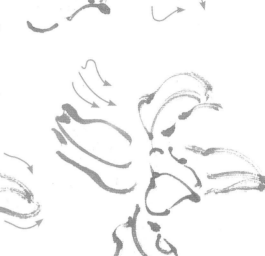

1 Create a light ink by diluting 1 part black ink with 5 parts water and use it to load a small hard brush (Mountain Horse). Tap the brush on a paper towel three times to absorb most of the light ink from the brush. The dryness of the brush will create the "Flying White" in the strokes. Start with drawing the petal closest to you. Use broken lines and purposely leave open space between them to create a more rustic look. Continue with the petal on the lower bottom, then the upper one. Now that the brush is pretty dry, continue to draw the tube funnel of the lily.

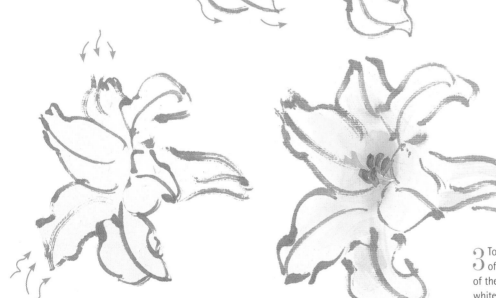

2 When the drawing has dried, load a small soft brush (White Cloud) with water and Cadmium Yellow Light. Roll the brush on a plate to ensure the yellow fades into the water in the brush. Roll the brush on the inside of the tube funnel of the lily.

3 To enhance the whiteness of the lily, fill the outer edge of the petals with a thin layer of white gouache.

special details stamens

1. Load a fine, hard brush (Leaf Vein) with Stone Green and draw three small dots that gather at a point in the trumpet. Draw a thin line from the three dots for the stamen.

2. Add five thin lines in white gouache for the filaments.

3. Add long dots of Cadmium Orange Medium over the filaments as pollen.

Tulipa Tulip

Palette

 Gamboge Yellow

 Vermilion

 Permanent Alizarin Crimson

 [Light green] Sap Green + Gamboge Yellow

 Sap Green

 Black ink

Paper
Double Shuen

Brushes
Long Flow, medium combination
Leaf Vein, fine hard

These widely cultivated flowers come in all colors except blue, as well as in many shapes. The most common shape is a single row of round petals forming a globular shape. The double ones resemble a rose or peony. There are also varieties that have pointed petals that resemble lilies and some have frilly or fringed petals. The stems are thick and stand up well to wind and rain. Because of their beauty and wide color range, tulips are popular in gardens and as cut flowers.

If desired, add a touch of green to the center of the tulip to create the depth of the globular shape. Green gold is a great color for the "inner" color of many flower petals.

A bent leaf adds visual interest to the composition. At the end of a leaf, paint its extension with two short side strokes.

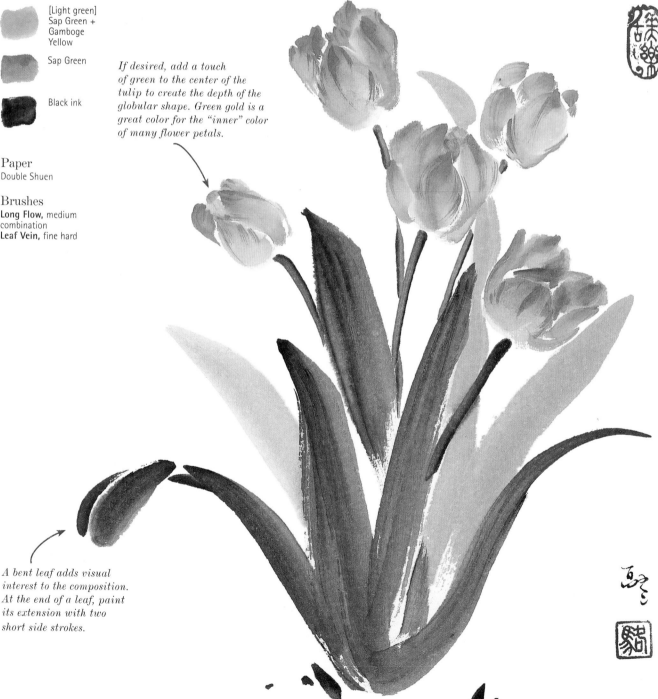

The flowers

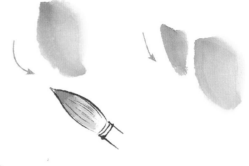

1 Load a medium combination brush (Long Flow) with two-thirds Gamboge Yellow, one-third Vermilion, and the tip with Permanent Alizarin Crimson. Create the first and second petals with a short side stroke, slightly curved to a letter "c."

sequence
start to finish

Starting with the petals, form the globular shape of the tulip with short, slightly curved side strokes (see right). Next, add vein details. Experiment with different colors as tulips come in many color combinations. Paint a stem from each bloom in Sap Green and black ink with a medium combination brush (Long Flow) using center strokes. Finally, add the leaves by following the instructions below.

2 Paint the third petal with a side stroke but this time curving toward the center as a reverse "c." Add the remaining petals on the top of the flowers.

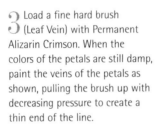

3 Load a fine hard brush (Leaf Vein) with Permanent Alizarin Crimson. When the colors of the petals are still damp, paint the veins of the petals as shown, pulling the brush up with decreasing pressure to create a thin end of the line.

The leaves

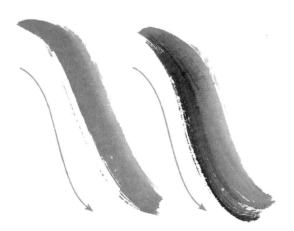

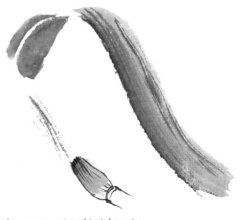

1 Mix Sap Green and Gamboge Yellow to create a light green. Load a medium combination brush (Long Flow) with two-thirds light green and one-third Sap Green. Use a side stroke to paint a leaf. Without washing the brush, reload the brush with light green and paint more leaves that are farther away from the flowers.

2 Tap the brush on a paper towel to take out a portion of the green color. The brush should be fairly dry but still have the color green on it. Load one-third of the brush with black ink. Dry the brush again on a paper towel. The brush should be relatively dry but still have a touch of black and green on it. Run the brush in the same side stroke motion over the leaves in the front. There is no need to add the texture details to the leaves in the background.

Palette

 [Light green]
Gamboge Yellow +
Indigo

 Cadmium Orange
Deep

 Permanent Alizarin
Crimson

 Gamboge Yellow

 Black ink

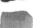 Sap Green

Celosia Cockscomb

Common in the wild in China, cockscomb earns
its name from its resemblance to the combs of a
rooster. Cockscomb has a contorted floral head,
which is reddish green with red veins. The plant
can grow pretty tall—the flower stands on long
but stiff stems. Most commonly found in bright
red, some come in a slightly lighter shade of red,
gold, and vibrant yellow. Because bright red is the
color of good luck, cockscomb is a common
ornamental plant in China.

TIP FOR FLOWER ARTISTS

Cockscomb is a showy flower.
When creating a painting
with two kinds of flowers,
choose one that is less
dominant in appearance for
visual contrast. Do not pick
another showy flower such as
a peony that competes with
the cockscomb (see
Composition, pages 24–33).

Paper
Ma (semi-sized rice paper)

Brushes
Long Flow, medium combination
Mountain Horse, large hard
Leaf Vein, fine hard

*Resist the temptation to fill in the white spots
created when rolling to make the comb, as these
will add visual interest. The best white spots are
those next to the intense Permanent Alizarin
Crimson, which has the strongest contrast.*

sequence
start to finish

Beginning with the base of the
flower, position two to three
blooms on the page (see opposite
page). Create the contorted floral
head by rolling the brush on its
side to resemble the comb of
a rooster. Paint the leaves in
bold side strokes following the
instructions opposite. Add vein
details while the colors on the
leaves are still damp.

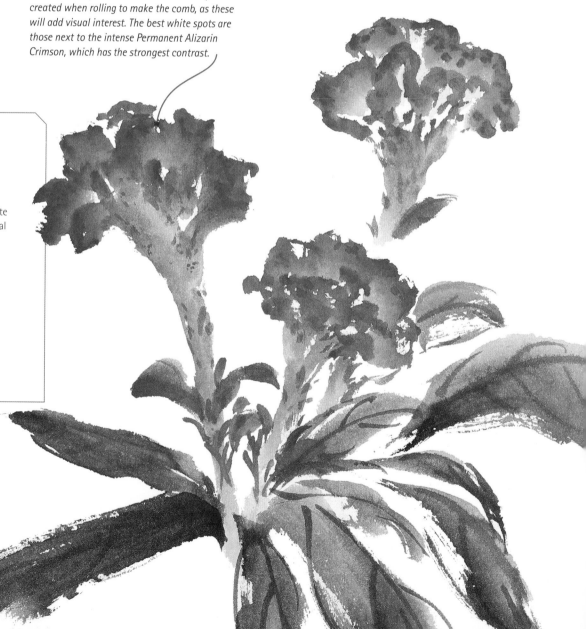

The flowers

1 Mix Gamboge Yellow and Indigo to create light green. Load a medium combination brush (Long Flow) with two-thirds light green and a touch of Cadmium Orange Deep. With a center stroke, paint the base of the flower in two strokes, like writing the letter "y."

2 Flatten the tip of the brush with your fingers to make it look like a fan brush. Pick up a touch of Cadmium Orange Deep with it. Add texture to the flower base with the fanned brush.

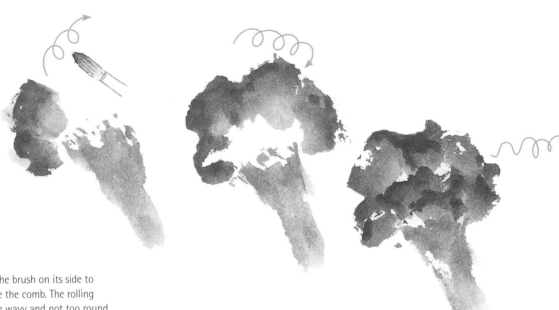

3 Load a medium combination brush (Long Flow) with two-thirds Gamboge Yellow, one-third Cadmium Orange Deep, and an intense amount of Permanent Alizarin Crimson on the tip. Do not roll the brush on the plate. Instead of a smooth mixing of colors, you want to see the three vibrant colors distinctly on the flowers.

4 Roll the brush on its side to create the comb. The rolling should be wavy and not too round to resemble the comb of a rooster.

The leaves

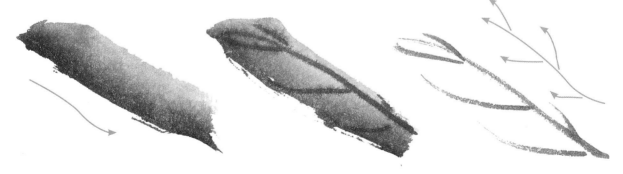

1 Load a large hard brush (Mountain Horse) with two-thirds Sap Green and one-third black ink. Paint the leaves with side strokes.

2 Before the colors on the leaves are completely dry, draw the leaf vein with Permanent Alizarin Crimson with a fine hard brush (Leaf Vein).

Palette

 Burnt Sienna

 Sap Green

Gamboge Yellow

 Vermilion

[Medium ink] Black ink + water

 Black ink

 [Dark brown] Burnt Sienna + black ink

Rudbeckia Hirta
Black-eyed Susan

The black-eyed Susan is also called the brown Betty, brown daisy, yellow daisy, and yellow ox-eye daisy. It is a yellow daisy with a dark, purplish-brown center. The flower is very easy to grow, producing a large color-mass of yellow and brown against a bed of green foliage. It blooms throughout summer and often into fall, cheering up the meadow with its brightly colored petals. The black-eyed Susan is designated as the state flower of Maryland in the United States.

TIP FOR FLOWER ARTISTS

Although it is easy to paint petals surrounding a dark center, do not make them too even—attempt to have a little irregularity in the petals to give a slightly shaggy appearance.

sequence start to finish

First load a medium combination brush (Long Flow) with Burnt Sienna and paint the bamboo fence in center strokes. Create and color the daisies and buds using the instructions at right. Paint the leaves with side strokes and add veins in center strokes (see right). To finish, connect the components with stems in center strokes (see Leaves, Stems, and Branches, page 21–23).

Paper
Double Shuen

Brushes
Mountain Horse, extra-small hard
Long Flow, medium combination
White Cloud, small soft

The flowers

1 Mix Burnt Sienna with black ink to create dark brown. Paint the oval center of the daisy in dark brown with a small soft brush (White Cloud).

2 Load an extra-small hard brush (Mountain Horse) with medium ink (1 part black ink to 3 parts water) and draw the contour of the petals. Start from the top center and work your way to both sides.

3 Finish all the petals on the bottom, also starting from the center, and work your way to both sides.

4 Load a small soft brush (White Cloud) with Gamboge Yellow and a touch of Vermilion and fill in the colors of the petals.

The leaves

1 Load a medium combination brush (Long Flow) with two-thirds green and one-third medium ink. Paint the leaves with side strokes.

2 Load the extra-small hard brush (Mountain Horse) with black ink, and paint the stems and veins with center strokes.

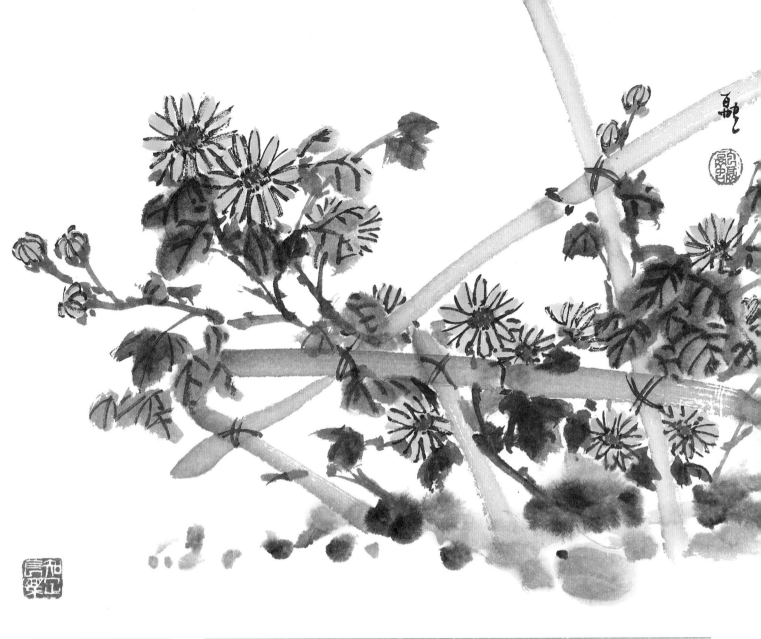

special details
daisy buds

Draw the petals as shown in medium ink. For a more natural look do not make the shape perfectly round. Fill in the colors with Gamboge Yellow and Vermilion.

An alternate way of drawing the flower

1 Use your fingers to flatten the hair tip of the brush to the appearance of a flat brush (instead of a round brush).

2 Load the brush with Gamboge Yellow and a touch of Vermilion. Use another brush loaded with medium ink to add medium ink to the sides of the brush.

3 Paint the petals surrounding the center using a short center stroke. Reload as needed. The outlines and colors of the petals are created in the same strokes. The same can be done for the buds as well.

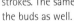
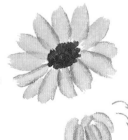

Zantedeschia Aethiopica
Calla Lily

Palette

[Light ink] Black ink + water

Cadmium Orange Medium

Alizarin Crimson

Olive Green

Cadmium Yellow Light

Black ink

White gouache

The calla lily's simple color and elegance has made it a favorite for weddings, interior design, and home decorations. Calla lily comes in a variety of colors: pure white, cream, yellow, pink, green, and some with stripes. It is shaped like a soft cone with a protruding spadix in its center—each stem has one flower. The foliage is light to deep green. Detail style best represents the graceful lines of calla lilies. Pay special attention to the tactful use of lines and brushwork.

TIP FOR FLOWER ARTISTS

Make sure you align the spike with the direction of the petal funnel. Not aligning is a common mistake, making the plant appear unnatural.

Paper
Double Shuen

Brushes
Leaf Vein, fine hard
White Cloud, medium soft

sequence
start to finish

Prepare a detailed sketch and resolve all compositional challenges prior to painting a complex flower arrangement. Use it as a reference for the painting. Draw the contours of the calla lilies in light ink and outline the yellow spikes in black ink. Form the leaves in black ink (see below). Pay attention to the overlapping composition. Color the calla lilies according to their individual colors. Adjust the overall design by adding pebbles in light and black ink.

special details
coloring non-white lilies

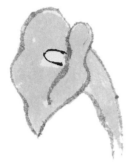

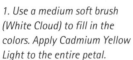

1. Use a medium soft brush (White Cloud) to fill in the colors. Apply Cadmium Yellow Light to the entire petal.

2. Wait 5 minutes to let the base color dry off a bit but not completely dry. Add color strips in Alizarin Crimson when the base color is still damp.

3. When the painting is dry, color the spike with Cadmium Orange Medium. Add tiny dots of white gouache to denote the texture of the spike.

The flowers

1 With a fine hard brush (Leaf Vein) and light ink (1 part black ink to 5 parts water), start from the center of the curled petal from left to right. Twist the tip of the brush at the end of each stroke. Apply slightly different pressure to the brush while drawing so the lines will attain a variety of thicknesses.

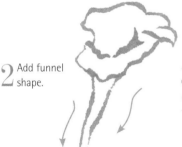

2 Add funnel shape.

3 Use black ink to draw the outline of the yellow spike in the center.

4 Use a medium soft brush (White Cloud) to fill in the colors. Dampen the middle of the petal with water. Apply Olive Green to the center and bottom of the funnel. Since the paper is damp, the color should fade into the petal smoothly.

5 Enhance the outer edge of the petal with a thin layer of white gouache.

6 When the painting is dry, color the spike with Cadmium Orange Medium. Add tiny dots of white gouache to denote the texture of the spike.

The leaves

1 Draw the contour lines in black ink with a hard fine brush (Leaf Vein).

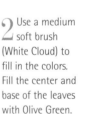

2 Use a medium soft brush (White Cloud) to fill in the colors. Fill the center and base of the leaves with Olive Green.

3 Apply Cadmium Yellow Light from the outer edge of the leaves toward the center.

4 Apply a thin wash of Olive Green to the entire leaf.

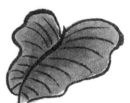

Palette

 Gamboge Yellow

 Vermilion

 Sap Green

 Cadmium Deep Red

 Burnt Sienna

 [Medium ink] Black ink + water

Black ink

[Blue wash] Cerulean Blue + water

White gouache

Euphorbia Pulcherrima
Poinsettia

Poinsettias are widely used as a decorative plant during winter, especially around Christmas and the winter holidays. Poinsettia has a cluster of yellow cyathia at the top of the stem, surrounded by layers of colored leaves, commonly in shades of red, white, cream, or pale green. These leaves are often mistaken as petals. Bright red poinsettia is called "Top Scholar Red" in Chinese, as the color is the same as the red robe of the top scholar in the governmental examinations.

sequence
start to finish

Beginning with the yellow cyathia at the center, position two blooms on the page. Then construct the colored leaves around the center cluster of each bloom using the instructions at right. Paint a stem from each bloom in medium ink with a medium combination brush (Long Flow). Add leaf veins while the leaves are still wet. Add more stems and leaves to balance the composition. Finish with a blue wash. Spatter white gouache as snowflakes after the wash has dried.

Paper
Double Shuen

Brushes
Leaf Vein, fine hard
Long Flow, medium and large combination

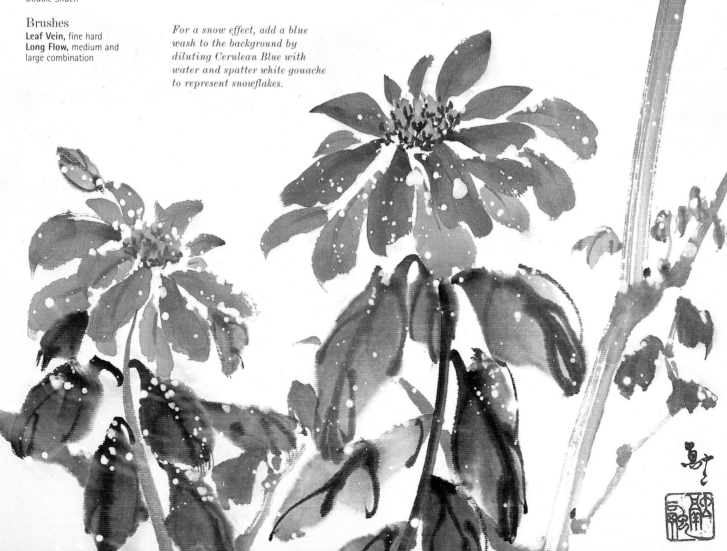

For a snow effect, add a blue wash to the background by diluting Cerulean Blue with water and spatter white gouache to represent snowflakes.

The colored leaves

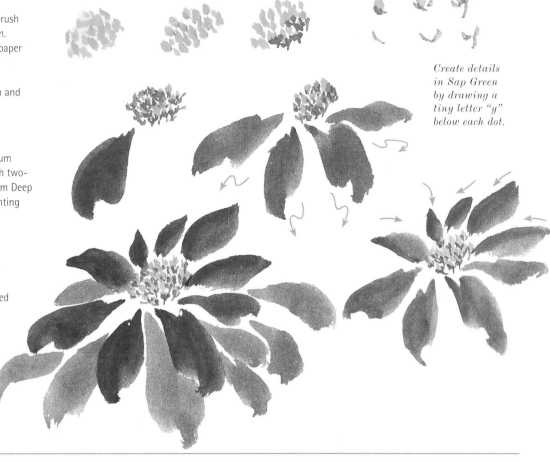

1 Load a fine hard brush (Leaf Vein) brush with Gamboge Yellow and Vermilion. Create cyathia by putting dots on the paper in the form of a cluster.

2 Load the fine brush with Sap Green and add the details of the cyathia.

3 For the colored leaves, load a medium combination brush (Long Flow) with two-thirds Vermilion and one-third Cadmium Deep Red. See *Special Details*, below for painting the red leaf.

4 Draw similar leaves in multiple directions surrounding the cyathia. Begin from the lower left and work clockwise to the lower right. Add the red leaves on the top with slanted strokes. If you want a bigger poinsettia, add a second layer of leaves.

Create details in Sap Green by drawing a tiny letter "y" below each dot.

The green leaves

1 Load a large combination brush (Long Flow) with two-thirds medium ink and a small amount of black ink at its tip. Paint the green leaves in a similar manner as the red leaves. The strokes are the same, but the size of the leaves should be bigger than the red ones.

2 Load a fine hard brush (Leaf Vein) with black ink and draw the veins while the ink of the leaves is still wet.

special details forming a red leaf

1. Start the stroke at a center stroke position, holding the brush perpendicular to the paper initially. Apply pressure as the stroke moves down, gradually turning to a slanted angle to the paper.

2. With the brush still touching the paper, pull the brushwork in an upward movement. Most of the hair of the brush is now touching the paper, as in a side stroke.

3. With the brush still touching the paper, change to a downward movement and gently lift the brush off the paper so that the stroke ends with a pointed hook. Note that the brush is touching the paper at all times in a continuous down-up-down zigzag movement. The stroke mark is that of a classic leaf shape.

Hydrangea Hydrangea

Hydrangea is a favorite garden shrub made up of clustered, tubular florets. Each floret has four to five petals, and together they form a sphere that resembles a pom-pom, earning hydrangea its Chinese name "Embroidered Ball." Most species of hydrangea are white, and the color of the flowers is determined by the acidity of the soil: acidic for blue hue and alkaline for pink hue. In order to capture the beauty of the changing colors of hydrangea, we will use two different techniques to paint it—one with contour lines and one with white gouache, in the Lingnan style.

Hydrangea with Contour Lines

Creating hydrangea in contour lines demands attention to the structure and placement of the florets and helps to build a strong foundation for an intuitive approach in the Lingnan style (see page 11).

sequence
start to finish

To begin, use light ink and draw florets in clusters using the instructions at right. After the contour lines are dry, fill in the colors in layers of Cobalt Blue and Permanent Violet. Wait about five minutes so the paper is still damp and not completely dry. Paint each petal of the floret with diluted white gouache. Repeat to build intensity. When the petals are dry, add dots of Permanent Violet at the center of each floret. Add another dot of Gamboge Yellow thickened with white gouache slightly to the right of each violet dot. Finish with leaves and stems in Cadmium Yellow Pale, Sap Green, and Yellow Ocher (see Leaves, Branches, and Stems, pages 21–23).

Palette

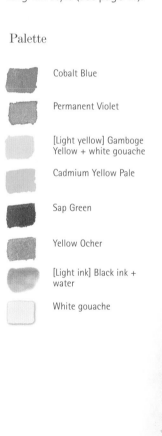

Cobalt Blue

Permanent Violet

[Light yellow] Gamboge Yellow + white gouache

Cadmium Yellow Pale

Sap Green

Yellow Ocher

[Light ink] Black ink + water

White gouache

Paper
Double Shuen

Brushes
Leaf Vein, fine hard
White Cloud, small and medium soft

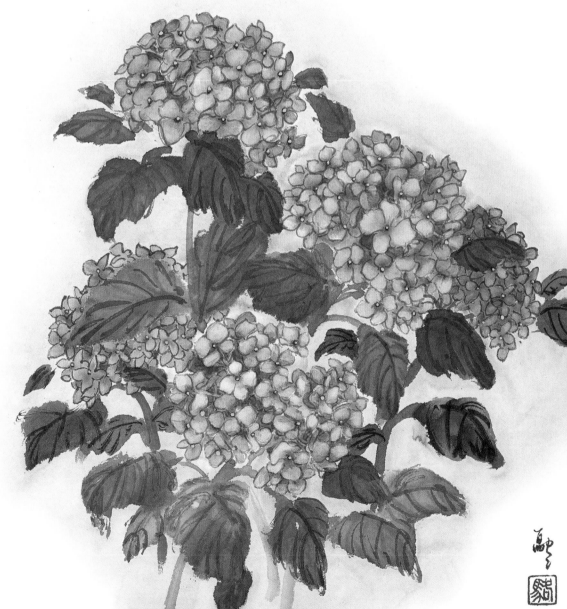

Creating a cluster of flowers

1 Load a fine hard brush (Leaf Vein) with light ink (1 part black ink to 5 parts water). Start with a dot, and draw four petals around it for the first floret. Build on the first two florets and expand below and above them. Vary the size of the florets slightly so some are bigger and some are smaller. Although the overall shape of the hydrangea is a sphere, do not make the shape too perfectly round—add irregularity to the shape.

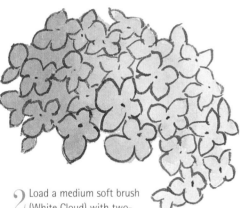

2 Load a medium soft brush (White Cloud) with two-thirds water and one-third Cobalt Blue. Fill in the hydrangea—one side of the flower should be lighter than the other side.

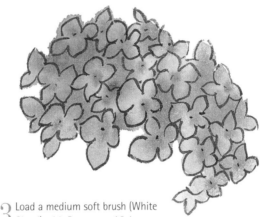

3 Load a medium soft brush (White Cloud) with Permanent Violet, and fill in the area between the florets within the hydrangea. This will create the illusion of depth and space between the florets.

TIPS FOR FLOWER ARTISTS

For the white gouache petals to hold on the background colors, wait at least five minutes to let the blue and violet color dry off a bit. The paper should be damp and not completely dry. Touch it with the palm of your hand; it should be cold to the touch.

✳

You can also use a hairdryer to speed up the drying but be careful not to overdry it. You are looking for a subtle effect for the layers of floret petals.

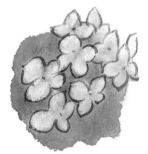

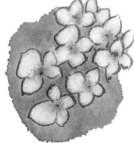

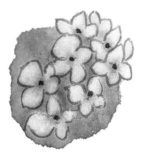

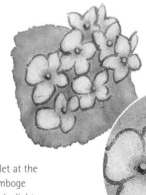

4 Load a small soft brush (White Cloud) with white gouache diluted with water (1:1 ratio), to the consistency of milk. Paint each petal of the floret with one tuck-in stroke from the outer edge to the inside of the floret. Continue for the whole hydrangea. Repeat the process two to three times to build up the intensity of the white.

5 Place a dot of Permanent Violet at the center of each floret. Mix Gamboge Yellow with white gouache to make light yellow. When the violet dots are dry, place a small dot of light yellow over the violet dot. Place the yellow one slightly to the right of the violet dot to give the illusion of depth and shadow.

Palette

 Cobalt Blue

 Green Gold

 Permanent Alizarin Crimson

 Cobalt Violet

 Gamboge Yellow

 Indigo

 Sap Green

 Burnt Sienna

 Black ink

 Yellow Ocher

Paper
Ma (semi-sized rice paper)

Brushes
Long Flow, medium and large combination
Mountain Horse, small hard
White Cloud, small soft

Hydrangea in the Lingnan Style

Lingnan style uses vibrant colors and spirited brushwork to express the beauty of hydrangea by contrasting florets in white gouache over a base of fused colors. It is recommended that you practice the hydrangea with contour lines (see pages 52–53) to learn the placement of the florets before beginning.

sequence start to finish

Create a patch of fused colors using Cobalt Blue, Green Gold, and Permanent Alizarin Crimson. Wait about five minutes so the paper is just damp, not completely dry. Draw florets in white gouache (see *Special Details*, right). Repeat 2–3 times to build up the intensity of the white. Add dots of Cobalt Violet at the center of each floret. When the painting is dry, add dots of Gamboge Yellow over the Cobalt Violet dots at the center of the florets. Finish with leaves and stems (see opposite).

TIP FOR FLOWER ARTISTS

White gouache should be applied in layers to build up the intensity. If the white gouache is too thick, the floret will look chalky.

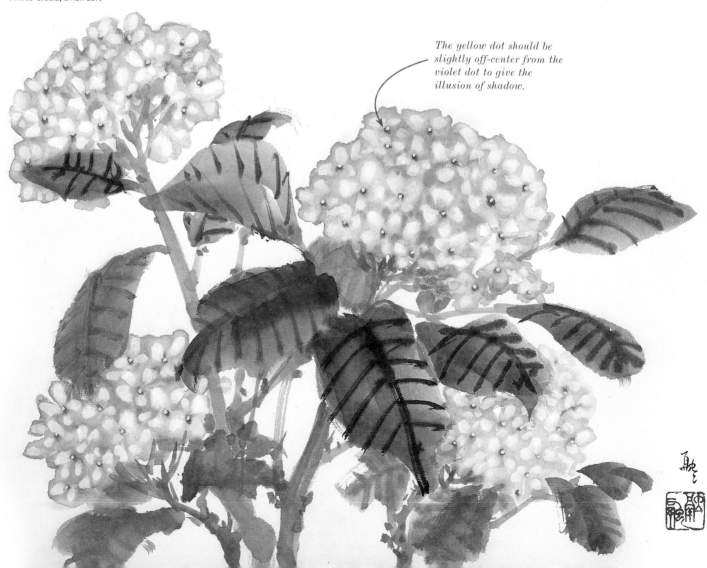

The yellow dot should be slightly off-center from the violet dot to give the illusion of shadow.

Creating a cluster of florets

1 With a medium combination brush (Long Flow), make a patch of Cobalt Blue on the paper. Add Green Gold and Permanent Alizarin Crimson. This will be the base for the hydrangea.

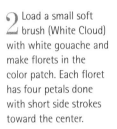

2 Load a small soft brush (White Cloud) with white gouache and make florets in the color patch. Each floret has four petals done with short side strokes toward the center.

3 Similar to the contour line hydrangea, apply the white gouache two to three times to build up the white florets.

4 Place a dot of Cobalt Violet in the center of each floret.

5 Add a Gamboge Yellow dot over the violet dot for the center of each floret.

The leaves

1 Load a medium combination brush (Long Flow) with two-thirds Indigo and Sap Green, and the tip with a small amount of black ink. Form big leaves with two bold side strokes.

2 Load a large hard brush (Mountain Horse) with black ink. Draw the veins in dry strokes.

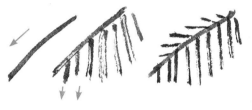

Use different amounts of Indigo, Sap Green, Burnt Sienna, and Yellow Ocher for each leaf, to produce a variety of shades.

special details forming the floret

Painting hydrangea with the contour lines before working on the Lingnan style will help you visualize the placement of florets in the hydrangea.

Narcissus Daffodil

From the narcissus family, daffodils are popular in gardens because they bloom early—a field of blooming daffodils is the sign of spring after a long winter. Most daffodils have cuplike trumpets with a ruff of delicate petals. The color ranges from white and cream to pale and rich yellow. Some trumpets and petals are of different colors. The blossoms grow on erect stems over medium green sword-like foliage.

Palette

Cadmium Yellow Pale

Cadmium Orange

Vermilion

Alizarin Crimson

Olive Green

Sap Green

Indigo

Black ink

White gouache

Paper
Double Shuen

Brushes
Long Flow, medium combination
Leaf Vein, fine hard
White Cloud, small soft

sequence start to finish

When painting daffodils, first paint the cuplike trumpets, then the surrounding petals following the instructions opposite. Add stems in Olive Green using center strokes and a White Cloud brush. Daffodils have long, spear-like leaves. Paint them in long side strokes (see page 23.)

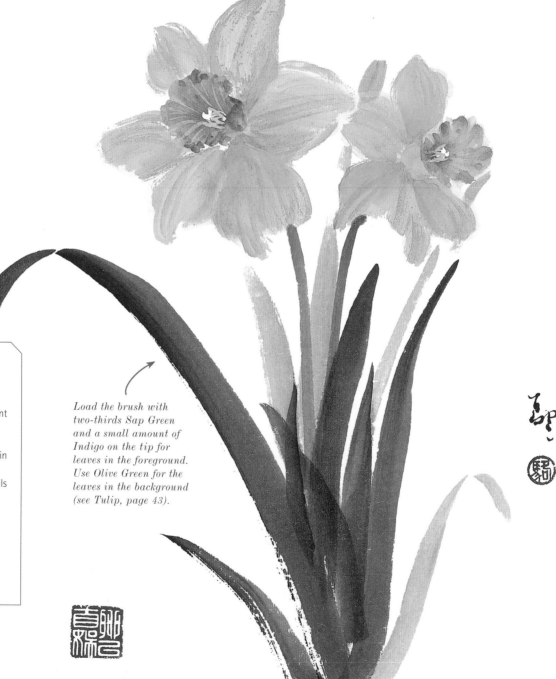

Load the brush with two-thirds Sap Green and a small amount of Indigo on the tip for leaves in the foreground. Use Olive Green for the leaves in the background (see Tulip, page 43).

The flowers

1 Load a medium combination brush (Long Flow) with two-thirds Cadmium Yellow Pale and one-third Cadmium Orange. Roll the brush on a plate to ensure the colors transition. Use the tip of the brush and pick up a small amount of Vermilion. Do not roll on the plate. The brush is ready. Roll the brush on the paper to create a small triangular shape for the center of the cuplike trumpet.

2 Use the tip of the brush and paint the edge of the trumpet with the tip of the brush.

3 Load a medium combination brush (Long Flow) with two-thirds Cadmium Yellow Pale and one-third Cadmium Orange. Roll the brush on a plate to ensure the colors transition. Paint the six petals surrounding the trumpet. Start the stroke at a center stroke position, holding the brush perpendicular to the paper initially. Apply pressure as the stroke moves down and gradually turn to a slanted angle to the paper (see Poinsettia, pages 50–51.)

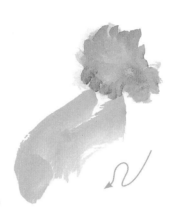

4 Use your fingers to flatten the hair of a small soft brush (White Cloud). Gently pick up a small amount of Vermilion with the fanned tip of the brush. Tap it on some paper towel to absorb some of the paint—the brush should be pretty dry. Draw the veins on the petals by quickly brushing the fanned tip over the petals. The quickness of the stroke with the dryness of the brush will create a "Flying White" effect of veins on the petals.

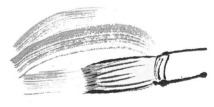

5 Load a fine hard brush (Leaf Vein) with white gouache and draw the stamens inside the trumpet. Draw three small dots that gather at a point.

6 Draw a thin line from the three dots for the stamen.

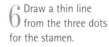

7 Add a few thin lines surrounding the stamen for the filaments.

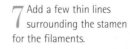

8 Add long dots of Cadmium Yellow Pale mixed with white gouache over the filaments as pollen.

Palette

 [Pink] Alizarin Crimson + white gouache

 Alizarin Crimson

 Permanent Violet

 Olive Green

 Sap Green

 Black ink

 Stone Green

Paper
Double Shuen

Brushes
Long Flow, medium combination
White Cloud, small soft

Cyclamen Persicum Cyclamen

Cyclamen's Chinese name is "Incoming Fairies." It is nicknamed "Rabbit's Ears" because of its upswept petals—the flower has five petals that bend upward but are connected at the base. Petals may be white, pink, or purple-red. Cyclamen creates a charming sight in a shaded area of a rock garden. The leaves come in different shapes depending on the variety. Some have round leaves, some kidney-shaped, while others are heart-shaped with pointed tips. Many species have intricately marbled foliage.

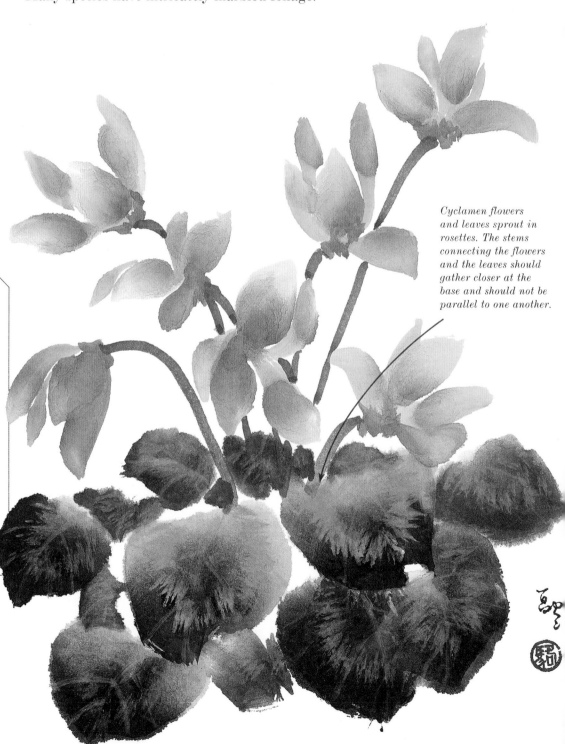

Cyclamen flowers and leaves sprout in rosettes. The stems connecting the flowers and the leaves should gather closer at the base and should not be parallel to one another.

sequence
start to finish

Begin with the flowers at the top of the composition and form them using the instructions opposite. Paint some flowers facing in various directions. Turning the paper sideways makes it easier to paint a flower facing downward. Form the leaves with bigger ones in the front and smaller ones in the back (see opposite). Draw the stems with a White Cloud brush in Olive Green and connect the flowers to the leaves using center strokes.

The flowers

1 Mix together Alizarin Crimson and white gouache to create pink. Load a medium combination brush (Long Flow) with two-thirds pink and one-third Alizarin Crimson. Roll the brush on a plate to ensure the smooth transition of colors in the brush. Paint the first upswept petal with a short slanted stroke.

2 Paint the second upswept petal and connect to the top of the first petal in the same short slanted stroke.

3 Add the rest of the petals in similar short slanted strokes. Vary the pressure of the brush so some petals are thinner while others are wider.

4 Add Permanent Violet to the tip of the brush and paint the base of the flower cup in four small center strokes.

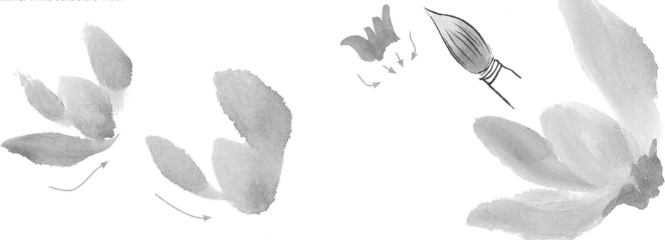

The leaves

1 Load a medium combination brush (Long Flow) with two-thirds Olive Green, one-third Sap Green, and black ink on the tip of the brush. Roll it on a plate to ensure smooth color transition. Paint the two halves of the leaf with two side strokes.

2 Fan up the tip of a small soft brush (White Cloud) and pick up some Stone Green. Tap the brush on the leaves to create interesting foliage patterns on the leaves. You can also use white gouache, Olive Green, or Stone Green to create the patterns on the leaves.

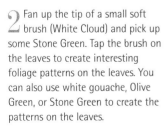

TIP FOR FLOWER ARTISTS

The tip of the leaf is darker. Since the darkest color is on the tip of the brush, the direction of the brushstroke is decided by the arrangement of the leaves. Instead of holding the brush at different angles, move the paper so that you can paint the leaves in any direction you want.

Prunus Persica Peach Blossom

Many Chinese folktales are tied to peach blossoms. There are legends of a paradise in a hidden valley with peach blossoms, and tales of short-lived romance with maidens blushing like peach blossoms. Peach blossoms come in shades of red, pink, and white. The leaves of peach blossoms are green with a tint of red, and arrive when the flowers are still in bloom.

Palette

 [Pink] Alizarin Crimson + white gouache

 Alizarin Crimson

 Black ink

 Olive Green

 Burnt Sienna

 [Light yellow] Cadmium Yellow Pale + white gouache

sequence start to finish

Beginning in the center, form a group of 2–5 pink peach blossoms using the instructions opposite. Fill the middle of each blossom with Olive Green before the petals are completely dry. Repeat and create more clusters of peach blossoms in various positions. Load a medium hard brush (Mountain Horse) with Burnt Sienna and a small amount of black ink at the tip of the brush. Connect the blossoms with assertive and quick center strokes to represent the branches.

Add leaves (see opposite) surrounding each group of blossoms to complete the clusters.

Paper
Double Shuen

Brushes
Long Flow, small combination
Leaf Vein, fine hard
Mountain Horse, medium hard
White Cloud, small soft

Differentiate peach blossoms and cherry blossoms (see pages 65–69) by the shape and number of leaves. There are more leaves on peach blossoms, and they are narrower. Cherry blossoms have fewer leaves when the flowers are blooming, and the leaves are rounder in shape.

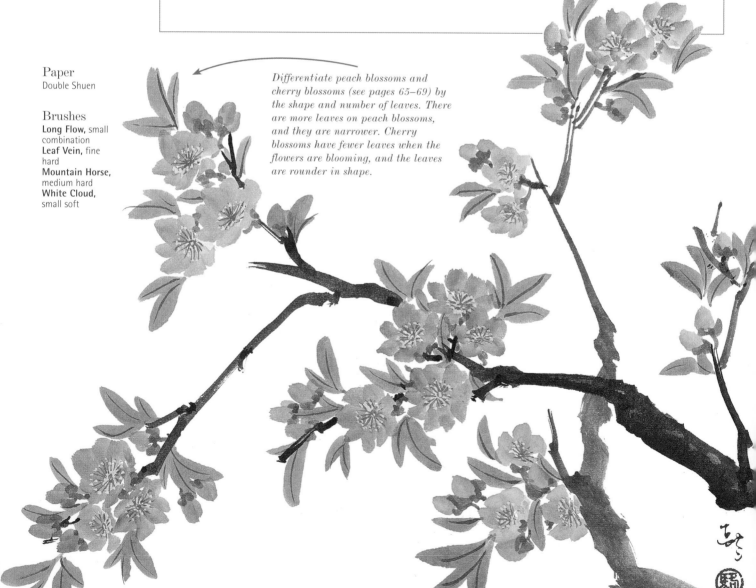

The flowers

1 Mix equal amounts of white gouache and Alizarin Crimson to create pink. Load a small combination brush (Long Flow) with two-thirds pink and a small amount of Alizarin Crimson at the tip. Paint the first petal with a short center stroke. Because peach blossom petals are more pointed than cherry blossoms, there is no need to tuck in the brush tip of the strokes.

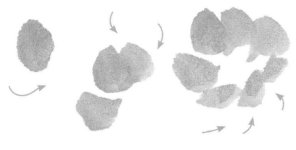

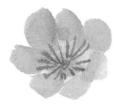
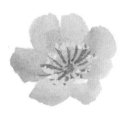

2 Continue with short strokes and paint several petals for each peach blossom. Flower buds are painted with one or two short strokes each.

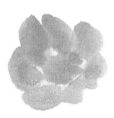

3 Load a small soft brush (White Cloud) with one-third Olive Green and fill in the middle of the blossoms before the petals are completely dry.

4 Mix Cadmium Yellow Pale with white gouache to make light yellow. After the painting has completely dried, use a fine hard brush (Leaf Vein) and add the details of the stamen and pollen in Alizarin Crimson and light yellow.

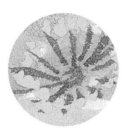

The leaves

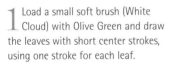

1 Load a small soft brush (White Cloud) with Olive Green and draw the leaves with short center strokes, using one stroke for each leaf.

2 Add a leaf vein in Alizarin Crimson in the middle of each leaf with a fine hard brush (Leaf Vein).

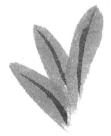
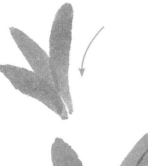
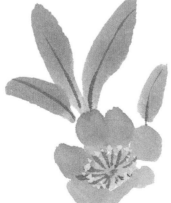

special details differentiating blossoms

Plum, cherry, pear, and peach blossoms all belong to the Rosaceae family and their blossoms look similar. Artists usually differentiate them by accentuating the differences in the petals.

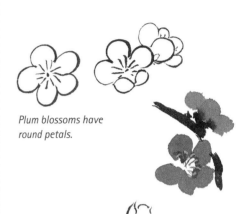

Plum blossoms have round petals.

Cherry blossoms have round petals with indented tips.

Pear blossoms have petals with more squared edges.

Peach blossoms have narrow petals with pointed tips.

Pyrus Calleryana Pear Blossom

Palette

 Green Gold

 Olive Green

 Stone Green

 Cobalt Violet

 [Light ink] Black ink + water

 Black ink

 White gouache

Pear blossoms are well-loved in Chinese art and poetry. Delicate pear blossoms in the spring rain are romantically compared to a maiden in tears for her parting lover. Pear blossoms are often white with five petals. The leaves are broad ovals and alternatively arranged. Since we have already painted single blossoms in the Rosaceae family, let's paint pear blossoms in doubles. We will use watercolor in Green Gold, which is not found in traditional Chinese colors. The introduction of new materials and colors keeps the art of Chinese brush painting refreshed.

The flowers

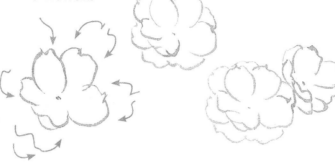

1 Load a fine hard brush (Leaf Vein) with light ink (black ink diluted 1:5 with water) to draw the contours of double pear blossoms. Start with the inner layer of petals. Draw each petal from its tip with two strokes. Reduce the pressure on the brush as you pull the stroke down, so the strokes end with a narrow tail.

2 Without reloading the brush, draw the outer layer of petals surrounding the inner layer. Draw the flower buds in light ink. For the leaves and petals, use medium ink instead of light ink for the contours.

3 After the contour drawing has dried completely, load a small soft brush (White Cloud) with Green Gold and fill the center of each blossom. Note that there is no need to draw a circle with water to avoid a water mark. The sizing on the paper reduces the absorption of colors on the paper.

sequence start to finish

Draw the contours of the pear blossoms in clusters of 3–6 in light ink. Add the contours of leaves and buds. Create the tree trunk (see *Special Details*, page 64). Next, fill the center of the blossoms with Green Gold. Add thin layers of white gouache from the outer edge of the petals toward the center. Repeat to build intensity. When everything is dry, finish the painting with filaments in the center of each blossom.

4 Fill in the petal from the tips toward the center with white gouache. Apply the white gouache in thin layers and repeat to build up the colors as desired.

5 While you have reached the desired intensity of whiteness in the blossoms, strengthen the center with Green Gold.

6 When all the colors are completely dry, load a fine hard brush (Leaf Vein) with Cobalt Violet and put tiny dots in the center of each blossom. Use white gouache to paint the filaments surrounding the center and use Cobalt Violet in tiny dots on the top of each filament.

Paper
Cicada Wing (sized rice paper)

Brushes
Leaf Vein, fine hard
White Cloud, small soft

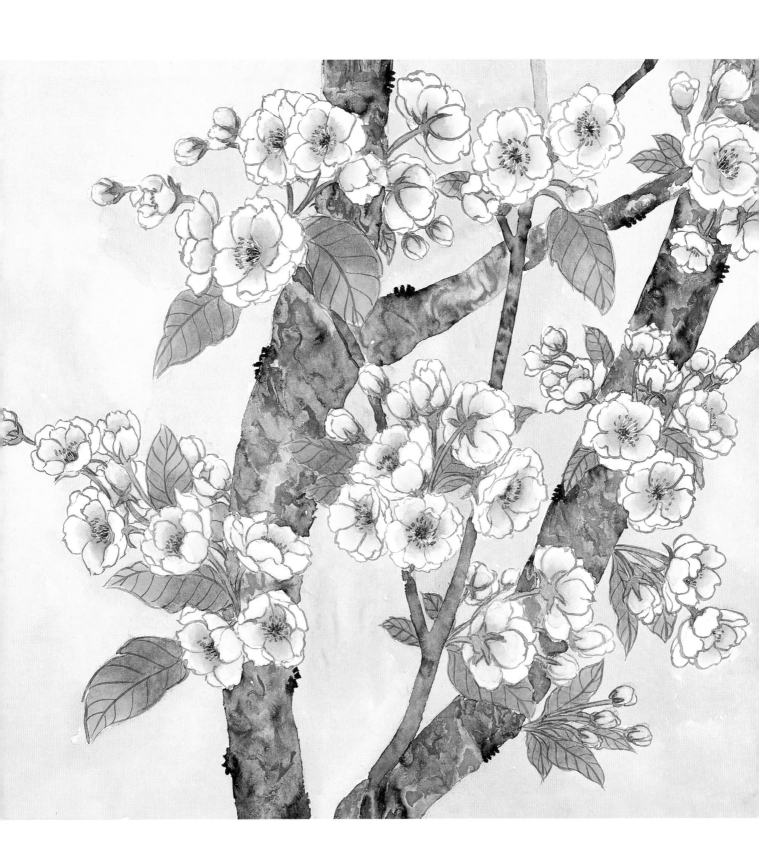

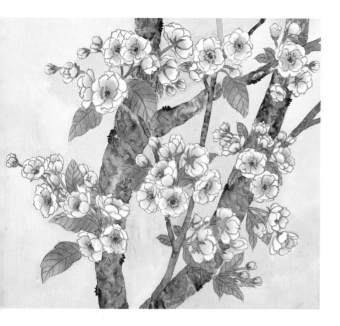

special details tree trunk

1. Sizing reduces the paper's readiness to absorb water and color. As a result, the moisture rests on the top of the paper, creating interesting effects. To create the texture of pear tree trunk, wet the entire area of the tree trunk with light ink. You will see a pool of light ink covering the tree trunk area.

2. Load the tip of a small brush with black ink and carefully touch the edge of the pool of light ink. The black ink will flow into the pool of light ink. Do not overdo it, or you will just have a pool of black ink.

3. Load the tip of a small brush with Stone Green and carefully touch the edge of the pool that has black ink. Stone Green is a very strong contrasting color, so take care not to overdo it.

4. Let the paint dry naturally on the paper lying flat on the table. The free-flowing and mixing of light ink, black ink, and Stone Green will create an interesting texture for the tree trunk. (For more demonstration of this technique, see Water Lily, page 105.)

The buds and leaves

1 Draw the buds in light ink and the leaves in black ink using a Leaf Vein brush.

2 Fill the buds with Green Gold and white gouache as on the flowers (see page 62).

3 Use Olive Green to color the base of the bud and the lower half of the leaf.

4 Repeat Steps 2 and 3 to build color intensity.

Palette

	[Light ink] Black ink + water
	Black ink
	Alizarin Crimson
	Olive Green
	Gamboge Yellow
	Burnt Sienna
	[Light violet wash] Permanent Violet + water
	White gouache

Prunus Serrulata Cherry Blossom

Cherry blossom festivals are popular in many cities. Cherry trees bloom in clouds of pink, but the blossoms usually only last for two weeks and are easily damaged by wind and rain. The flower's short but glorious life is a symbol of mortality and the ephemeral nature of life. Cherry blossoms mostly come in shades of light to deep pink. The flowers arrive before the leaves, which are pale green when the blossoms are in bloom. The leaves turn to a deeper green after the flower has withered. The tree has upright spreading branches with gray bark. Here the cherry blossom is shown in two styles: Detail style and Lingnan style.

Cherry Blossom in the Detail Style

The close-up portrait of the elegant yet fragile cherry blossoms is best represented in the Detail style, with graceful lines and delicate washes. The strokes of the branches and the background are kept to a minimum to avoid distractions from the blossoms.

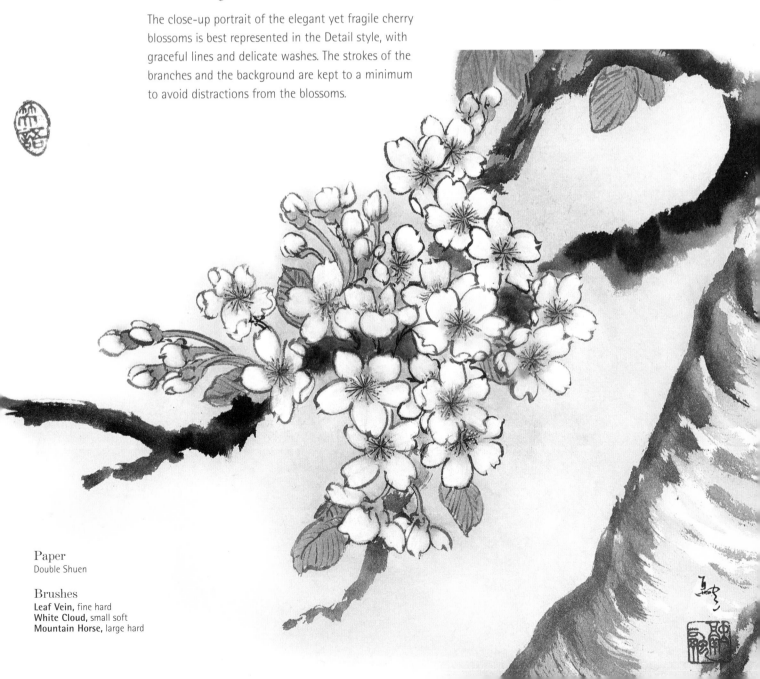

Paper
Double Shuen

Brushes
Leaf Vein, fine hard
White Cloud, small soft
Mountain Horse, large hard

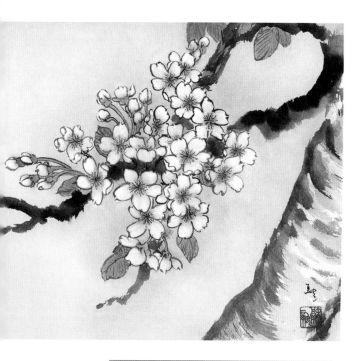

The blossoms

1 Load a fine hard brush (Leaf Vein) with light ink to draw the contour of the cherry blossoms. Draw each petal with two nail strokes, which are made by starting the stroke with significant pressure and lessening it as you pull the stroke down. The stroke will have a nail-like head that narrows to a pointed tip when it is done.

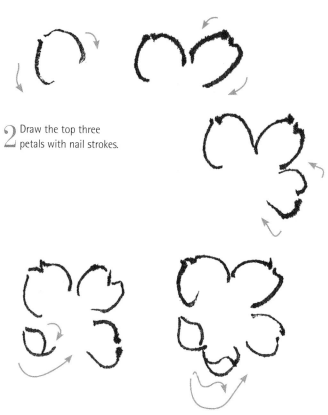

2 Draw the top three petals with nail strokes.

sequence start to finish

Starting off in the center, draw the blossoms following the instructions at right. Add blossoms with side views and buds near the cluster of cherry blossoms (see *Special Details*, opposite). After the contour drawing is dry, create a soft hue in the center of each blossom. Apply a thin layer of white gouache on the petals and repeat to build intensity. Complete the blossoms by adding stamens. Color the leaves in Olive Green. Draw the stems and trunk with the Mountain Horse brush in Burnt Sienna and black ink. Add a wash of light violet in the background to complete the piece (see Step 9, opposite).

3 For the bottom two petals, draw them sideways to create the illusion of petals extending out toward you.

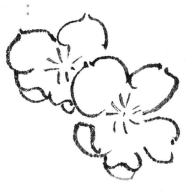

4 Put a dot in the center of the blossom and add short strokes surrounding it. Repeat and add more cherry blossoms as desired.

5 After the contour drawing is dry, load a small soft brush (White Cloud) with water and draw a small circle in the center of the blossoms. (Light blue has been used in the illustration for clarity, but only water should be used.)

6 Load a soft brush with Alizarin Crimson and drop a dot in the center of the blossoms. Because of the circle of water, Alizarin Crimson will spread into the circle, creating a soft hue in the center of the blossom with no hard edges.

7 Load the soft brush with white gouache and fill in the petal from the tips toward the center. Apply the white gouache in thin layers and repeat to build up colors as desired.

8 After the painting is dry, load a fine hard brush (Leaf Vein) with black ink and add more short strokes in the center of the blossoms for the stamens. Add tiny dots in a mixture of Gamboge Yellow and white gouache on the stamens to represent pollen.

9 To enhance the white blossoms, add a wash of light violet (made by mixing one part Permanent Violet to eight parts water) on the background.

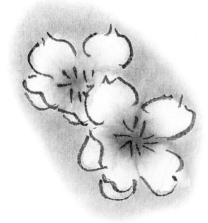

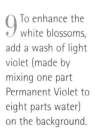

special details variations

For visual interest, when drawing the contour of the cherry blossoms, overlap some blossoms, add some with side views, and add bunches of buds, as shown here. This will accentuate the flower's delicate nature.

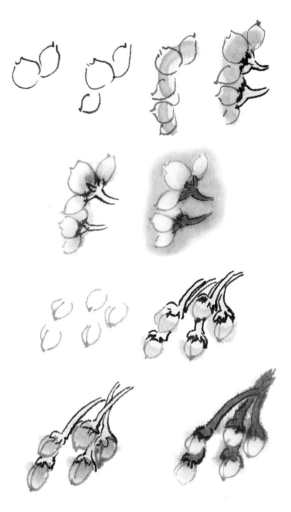

The trunk

For the body of the cherry blossom tree trunk, load a large hard brush (Mountain Horse) with two-thirds Burnt Sienna and one-third black ink. Tap the brush on a paper towel to absorb most of the ink in the brush. Create the tree trunk with successive side strokes.

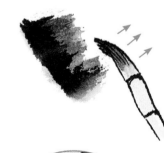

Do not fill in the "Flying White" created by the dryness of the brush. It represents the beauty of the trunk's texture.

Palette

Alizarin Crimson

Olive Green

Cadmium Yellow Pale

Burnt Sienna

Black ink

White gouache

Cherry Blossom in the Lingnan Style

Lingnan style uses expressive brushwork to capture the spirit of the subject. The cherry blossom's simple petal arrangement is ideal for beginners to learn to paint in Lingnan style. Each blossom is relatively easy to paint and the masses of blossoms encourage the artist to practice more.

Paper
Double Shuen

Brushes
Mountain Horse, medium hard
White Cloud, small soft
Leaf Vein, fine hard

sequence start to finish

Begin in the upper left of the page and draw two branches hanging down (see opposite). Using the instructions opposite, add clusters of 3–5 cherry blossoms with groups of buds in various places along the branches. Paint the filament and stamen in each blossom. Add blossoms in the distance in lighter colors (see *Special Details,* below). Remember to use lighter colors for the filament and stamens of the distant blossoms, as well. Use a White Cloud brush in Olive Green and add a few short, curved bamboo strokes for leaves. Finally, use diluted colors to paint the background landscape, if desired.

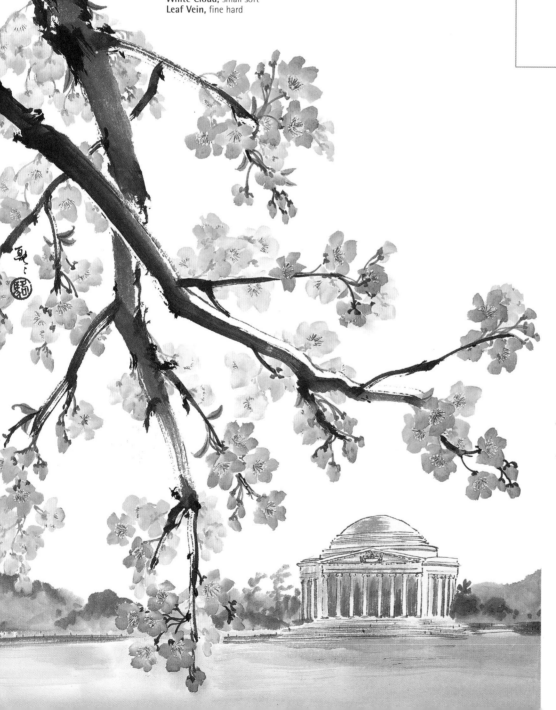

special details flowers in the distance

To add water to the brush without reloading colors: Use a second brush loaded with clear water and add water to the heel of the first brush that has colors. Since the water in the heel of the brush will continue to come down, the water will lighten the colors on the tip as you paint. The petals will be lighter, appearing to be farther away from the viewer.

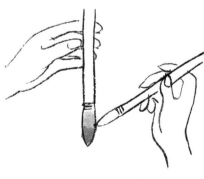

The blooming of cherry blossoms celebrates the return of spring around the world. The sample has the Jefferson Memorial and the Tidal Basin in Washington, D.C., in the background. Remember to use only light ink and softer, more diluted colors for the background to give the illusion of distant scenery.

The branches

The blossoms

1 Load a small soft brush (White Cloud) with two-thirds white gouache and one-third Alizarin Crimson. Roll the brush on a plate to ensure smooth color transition. Paint the first petal with a tuck-in stroke that starts in the opposite direction before moving the strokes back in the desired direction to tuck in the tip of the strokes—this creates a rounded starting edge.

2 Continue with tuck-in strokes and paint five petals for each cherry blossom. Do not reload the brush. The water and white from the heel and middle of the brush will flow down, creating a subtle variation in the petals. You can draw about six blossoms before reloading the colors.

3 For petals behind the branches and further away from the views, instead of reloading the brush, just add water. (See *Special Details*, opposite.)

4 Load a small soft brush (White Cloud) with one-third Olive Green and fill in the middle of the blossoms while the petals are still damp so the colors will merge.

1 In this Lingnan style painting, we start with the branches first. Load a medium hard brush (Mountain Horse) with two-thirds Burnt Sienna and a small amount of black ink at the tip of the brush. With assertive and quick strokes, draw two branches from the upper left with center strokes. The speed of the strokes will create "Flying White" at the end of the strokes as the brush becomes dry.

5 When the painting is dry, load a fine hard brush (Leaf Vein) with Alizarin Crimson and add short strokes in the center of the blossoms for the stamens.

6 Add tiny dots of Cadmium Yellow Pale on the stamens to represent pollen.

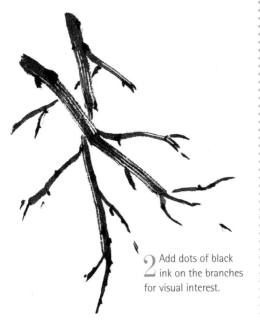

2 Add dots of black ink on the branches for visual interest.

7 For flower buds, paint them with a few tuck-in strokes, one for each flower bud. Load a small soft hair brush (White Cloud) with Olive Green and draw two dots at one end of the red buds.

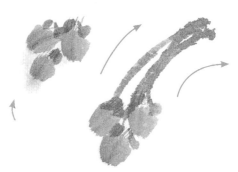

Palette

[Light yellow]
Gamboge Yellow +
white gouache

Gamboge
Yellow

Vermilion

Alizarin Crimson

Indigo

Black ink

[Light pink]
Alizarin Crimson +
white gouache

White gouache

Hibiscus Hibiscus

The hibiscus is adored by many cultures. Different varieties of hibiscus are the national flowers of Haiti, Malaysia, and South Korea. Hibiscus have an exotic appearance with long, branched stigma reaching out from a deep, velvety, cone-like center. Each flower has five or more petals forming a large trumpet shape. The flower comes in white, pink, red, orange, yellow, and purple. Hibiscus leaves are blue-green, and often have a toothed margin. Hibiscus attracts butterflies and honeybees, and is a favorite with hummingbirds. Besides painting hibiscus, we will paint little honeybees.

sequence start to finish

After practicing the strokes for the petals, begin with the hibiscus in the upper left of your painting. Add one or two more flowers, but do not overcrowd the composition. Add vein details on the petals. Paint the pistils in slightly curved center strokes when the petals are dry. Load a medium combination brush (Long Flow) with two-thirds Indigo and a small amount of black ink on the tip. Paint the leaves with bold side strokes. Add leaf veins in black ink (see Leaves, Stems, and Branches, page 22). Add in the honeybees (see *Special Details*, opposite) if you wish.

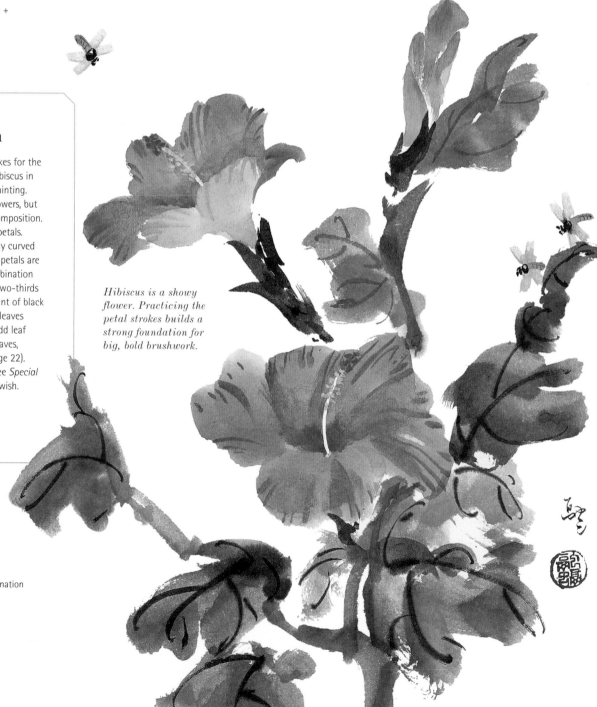

Hibiscus is a showy flower. Practicing the petal strokes builds a strong foundation for big, bold brushwork.

Paper
Double Shuen

Brushes
Long Flow, medium combination
Leaf Vein, fine hard
White Cloud, small soft

The flowers

1 Load a medium combination brush (Long Flow) with two-thirds Gamboge Yellow and one-third Vermilion. Roll the brush on a plate to ensure smooth color transition. Start the first petal with a side stroke and apply pressure to obtain a wider petal.

2 Add one more petal to the left of the first petal with a side stroke but do not apply extra pressure, so the petal is narrower. These are the backs of two petals that form the trumpet shape of the hibiscus.

3 Load a medium combination brush (Long Flow) with two-thirds Vermilion and one-third Alizarin Crimson. Roll the brush on a plate to ensure smooth color transition. Pull the third petal with a side stroke toward the middle of the hibiscus. Finish by lifting the brush when it reaches the center of the trumpet.

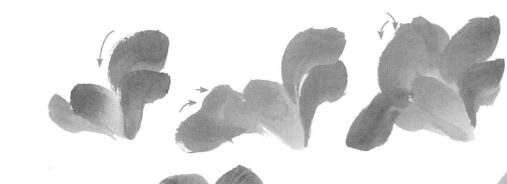

4 Repeat and paint two more petals from the outer edge to the center.

5 Mix small amounts of Alizarin Crimson and white gouache to create light pink. Use a fine hard brush (Leaf Vein) to draw the veins on the petals in light pink in the direction of the petals, toward the trumpet center.

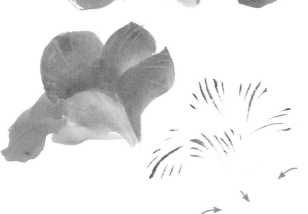

6 When the entire hibiscus is dry, draw the pistil in one stroke in light pink with a small soft hair brush (White Cloud). Make sure the line is slightly curved and not too straight. Add details in Alizarin Crimson and light yellow, made by mixing Gamboge Yellow and white gouache.

special details honeybee

Palette

 Black ink

 Gamboge Yellow

 [Light ink] Black ink + water

1. Load a small soft brush (White Cloud) with black ink. Start with a small rectangle to represent the thorax. The unpainted white in the middle will be the highlight.

2. Add the head and two big compound eyes.

3. Paint the abdomen in Gamboge Yellow. Dilute 1 part black ink with 5 parts water to make light ink. Add details in light ink.

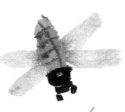

4. Flatten the tip of the brush with your fingers and pick up light ink. Brush the tip on a paper towel twice to let it absorb most of the moisture. Draw the wings of the honeybee from the outer edge toward the body, using one stroke for each wing.

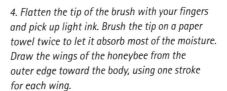

5. Use a fine hard brush (Leaf Vein) to add the antennae and legs.

Iris Iris

The iris comes in an enormous range of colors and combinations, earning its name because Iris is the name of the Greek goddess of rainbows. The iris has two sets of petals: three outer, downward-spreading ones called the falls, and three inner, upright ones called the standards. Some species are "bearded" with tufts of hair in colors that contrast with or match the colors of the falls. Irises have long, sturdy stems and green, sword-shaped leaves. The Chinese name for iris is "Kite-Tail" after its beautiful petals that look like kites dancing in the wind.

sequence start to finish

Beginning with the upright petals, position two blooms on the page, following the instructions below. Construct the falls around the upright petals of each bloom. Add veins to the petals (see *Special Details*, below right). Paint a stem for each bloom in Olive Green with a medium combination brush (Long Flow) using center strokes. Add the leaves (see right). Add background flowers and leaves in lighter colors to balance the composition.

Palette

- Permanent Violet
- Cobalt Blue
- Gamboge Yellow
- Sap Green
- Olive Green
- Black ink
- White gouache

Paper
Ma (semi-sized rice paper)

Brushes
Long Flow, medium combination
Leaf Vein, fine hard
Mountain Horse, medium hard

The flowers

1 Load a medium combination brush (Long Flow) with two-thirds white gouache and one-third Permanent Violet. Roll the brush on a plate to ensure smooth color transition. Before painting, use the tip to pick up a small amount of Cobalt Blue. Paint the upright petals in slightly curved center strokes.

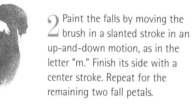

2 Paint the falls by moving the brush in a slanted stroke in an up-and-down motion, as in the letter "m." Finish its side with a center stroke. Repeat for the remaining two fall petals.

3 Add short tuck-in strokes for the curved varieties of the petals.

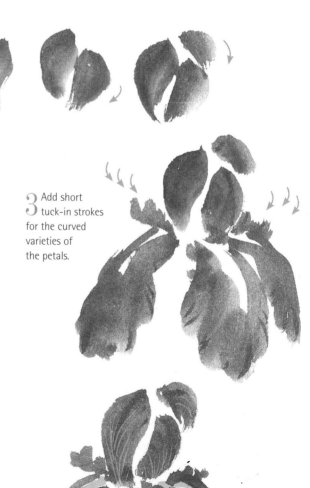

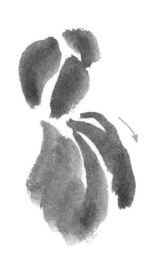

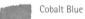

4 Load a fine hard brush (Leaf Vein) with Permanent Violet and add essence to the edges of the falls. Draw the details in white gouache diluted with water (1:1 ratio). Add Gamboge Yellow in the space between the "m" shape and the center strokes for color contrast.

The leaves

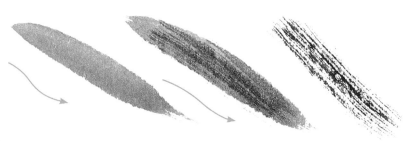

1 Paint the leaves with a medium hard brush (Mountain Horse) in Sap Green and add details in black ink. Try different combinations of Sap Green and Olive Green for a variety of shades.

2 For the black veins on the leaves, load the brush with black ink and brush two strokes on a paper towel so that most of the ink is absorbed. Then mark the leaves with the almost-dry brush. The dryness will create a "Flying White" texture on the leaves.

special details veins

The veins on the falls are not parallel lines. Draw them as shown in the sample.

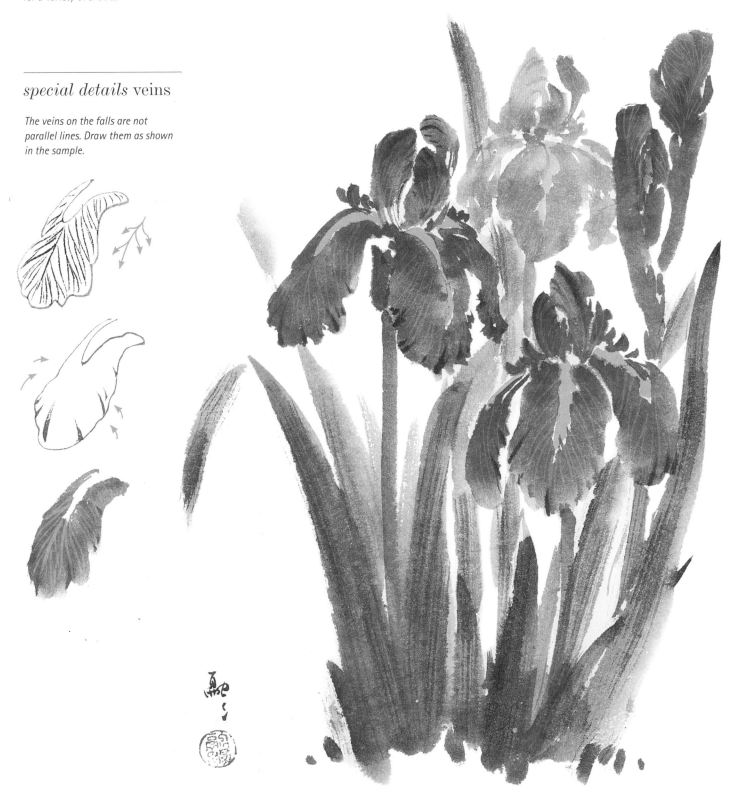

Helianthus Annuus
Sunflower

Palette

 Black Ink

 Yellow Ocher

 Vermilion

 Burnt Sienna

 Stone Green

 Gamboge Yellow

 Sap Green

Paper
Ma (semi-sized rice paper)

Brushes
Long Flow, medium combination
Mountain Horse, small hard

Sunflowers are large, beautiful flowers cultivated for their seeds and oil. The bold flower is actually a group of many flowers—in the center there are numerous florets crowded together. Many florets are of a deeper color, such as a velvety russet-brown or maroon. The outer florets bear large petals that come in shades of yellow, orange, red, and cream. The leaves are huge and bristly on the top and smooth on the bottom. The sunflower is the symbol of happiness and creates a striking focal point in any garden.

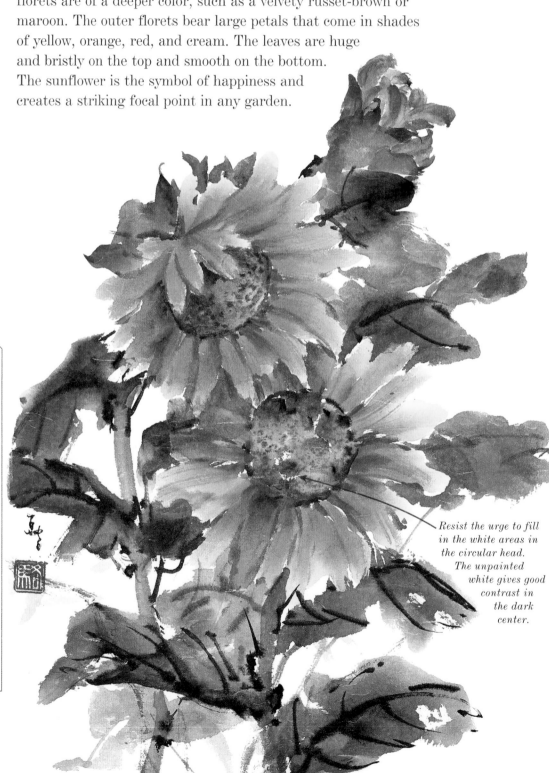

Resist the urge to fill in the white areas in the circular head. The unpainted white gives good contrast in the dark center.

sequence
start to finish

Draw the outline of the circular head of the sunflower in black ink. Fill in the head following the instructions opposite. Paint the petals with short center strokes. Add details in Burnt Sienna. Add the stems with center strokes in Sap Green and Yellow Ocher with a medium combination brush (Long Flow). Finally, paint the leaves with side strokes in combinations of Sap Green, Burnt Sienna, Yellow Ocher, and black ink. Add veins in black ink.

The flower heads

1 Load a small hard brush (Mountain Horse) with black ink and draw the outline of the circular head of the sunflower.

2 Now, load the brush with Gamboge Yellow and Vermilion. Roll the tip of the brush in short strokes inside the circular head.

3 Without washing the brush, add Burnt Sienna to the tip of the brush and roll it on the circular head of the sunflower.

4 Add Stone Green in the center for visual interest.

The petals

1 Load a medium combination brush (Long Flow) with two-thirds Gamboge Yellow and one-third Vermilion. Roll the brush on a plate to ensure a smooth color transition. Add a small amount of Alizarin Crimson at the tip. Paint the petals with short center strokes, from the center of the flower outward.

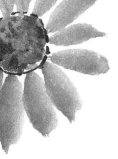

2 Move the paper to paint the petals surrounding the circular head.

3 Add details in Burnt Sienna with the tip of the brush.

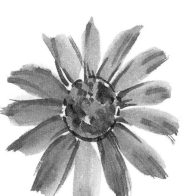 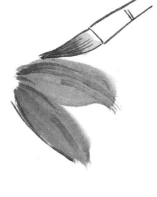

The leaves

1 Load a medium combination brush (Long Flow) with two-thirds Sap Green, one-third Burnt Sienna, and a small amount of black ink on the tip. Roll the brush on a plate to ensure a smooth color transition. Paint the leaves with side strokes.

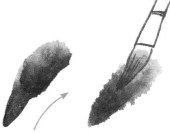

2 When loading the brush with colors to paint the leaves, vary the amount and intensity of the colors slightly by introducing more or less Sap Green, Burnt Sienna, Yellow Ocher, and black ink to the brush. This will create subtle color variations in the leaves, giving a more interesting result.

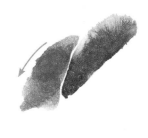

3 Add veins to the leaves in black ink with a small hard brush (Mountain Horse) while the colors are still damp.

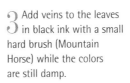

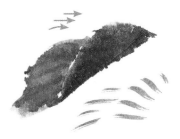

Palette

Green Gold

Sap Green

Black ink

Burnt Sienna

Stone Green

Opera Rose

Gamboge Yellow

White gouache

Begonia Begonia

The begonia is native to tropical and subtropical moist climates; in cooler climates many species are grown indoors as ornamental houseplants.
The flowers come in white, yellow, pink, and scarlet, and many have marked leaves with felt-like textures. Some have leaves that are dark green on top and bronze on the bottom. Begonia's showy flowers and marked leaves make it a highly cultivated flower with more than 1,400 species. We will paint one with pink flowers and marked leaves with contrasting top and bottom leaf colors. To capture the vibrant color of the begonia, we will use Opera Rose, a vivid, reddish-pink for the flowers. Although not found in traditional Chinese colors, this color is perfect for the dramatic fuchsia pink of the begonia.

Paper
Ma (semi-sized rice paper)

Brushes
Long Flow, medium combination
Leaf Vein, fine hard

Begonias are herbaceous so make sure the stems are curved and not straight, otherwise they will look stiff.

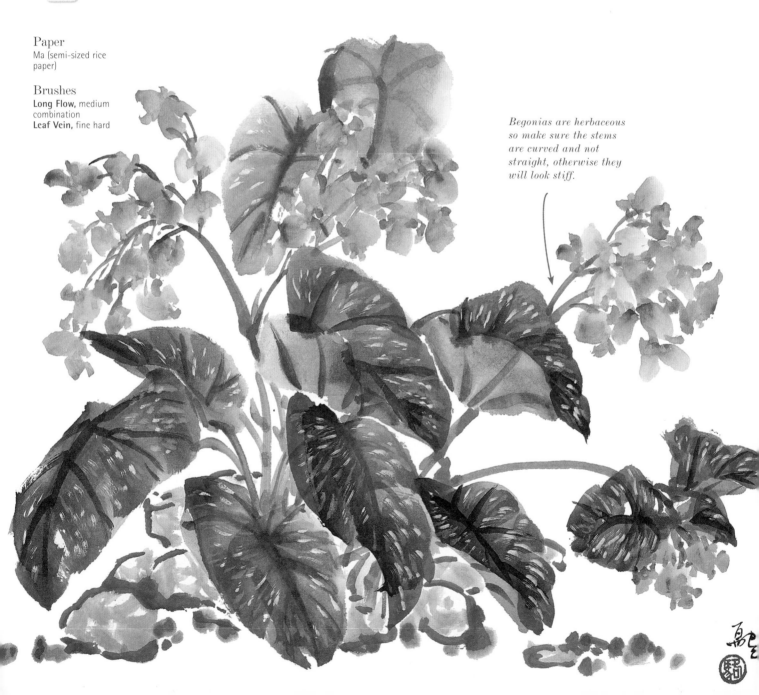

sequence start to finish

Start at the bottom of the page and paint the marked leaves with bold side strokes (see below). Add veins in black ink and Burnt Sienna and markings in white gouache and Stone Green

while the colors are still damp. Paint clusters of flowers following the instructions below. Load a medium combination brush (Long Flow) with Green Gold and connect the flowers and

leaves with stems in center strokes. Paint rocks and pebbles at the bottom in a mixture of Green Gold and black ink to complete the composition.

TIPS FOR FLOWER ARTISTS

The petals are generally in the shape of a cross with two wide petals and two narrow petals. However, because of the angles, you can draw them freely in a variety of shapes.

The leaves

1 Load a medium combination brush (Long Flow) with two-thirds Green Gold and one-third Burnt Sienna. Roll the brush on a plate to ensure smooth color transition. Start with the bottom side of the leaf, with a side stroke that captures all the colors on the brush.

2 Reload the brush with two-thirds Sap Green and one-third black ink. Roll the brush on a plate to ensure smooth color transition. Complete the top side of the leaf with a side stroke on top of the first stroke.

3 Load a fine hard brush (Leaf Vein) with black ink and draw the veins on the top portion while the colors are still wet.

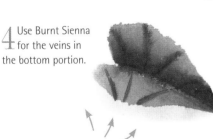

4 Use Burnt Sienna for the veins in the bottom portion.

5 Pick up a small amount of white gouache and put markings on the top side of the leaf.

6 Repeat with a small amount of Stone Green.

The flowers

1 Load a medium combination brush (Long Flow) with two-thirds white gouache and one-third Opera Rose. Roll the brush on a plate to ensure smooth color transition. Paint the first two petals that join in the middle.

2 Draw two smaller petals in Opera Rose with short tuck-in strokes.

3 Load a fine hard brush (Leaf Vein) brush with Gamboge Yellow and add two or three dots in the center.

Palette

Palette

Permanent
Violet

Alizarin
Crimson

Indigo

Gamboge
Yellow

Sap Green

Black ink

Yellow Ocher

White gouache

sequence start to finish

To begin, paint the fringed lip of the orchids in short tuck-in strokes. Add two rounded and three narrow petals (see opposite). Add the details of the veins and markings on the flower while the colors are still damp. Paint a backward-facing orchid if desired (see *Special Details*, below right). Using the instructions opposite, paint the leaves and stem in Sap Green and Indigo. Complete the texture on the leaves and stems in black ink and Yellow Ocher in dry strokes.

Paper
Double Shuen

Brushes
Long Flow, medium combination
Leaf Vein, fine hard
Mountain Horse, small hard
White Cloud, small soft

Orchidaceae Orchid

Orchid is one of the largest families of flowers in the plant kingdom. It is well-loved all over the world with 750 different genera, over 25,000 native species, and more than 30,000 cultivated hybrids. Orchids have a distinguished shape that is unique. Each flower has three outer sepals and three inner petals. One modified petal, called the lip, has fused stamens and carpels. Many orchids have dramatic color combinations and distinctive markings. Orchid leaves are generally long and slender with parallel veins.

The flower

1 Load a small soft brush (White Cloud) with two-thirds Permanent Violet and a small amount of Indigo at the tip. With short tuck-in strokes, paint the fringed lip.

2 Fill in the center of the lip with Gamboge Yellow.

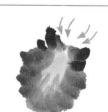

3 Load a medium combination brush (Long Flow) with two-thirds Permanent Violet and a small amount of Alizarin Crimson at the tip. Paint two petals starting with center strokes; apply increasing pressure to attain a rounded body.

4 Add three more outer sepals but decrease the pressure as you go to produce narrow endings.

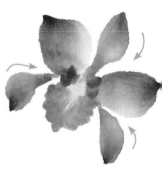

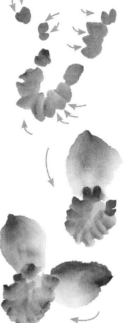

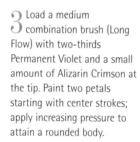

5 Add details in Permanent Violet with a fine hard brush (Leaf Vein). Flatten the tip of the brush with your fingers and add fine lines and dots while the petals are still damp.

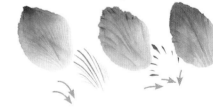

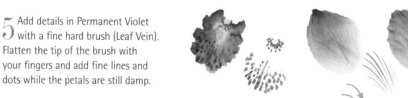

special details backward-facing flower

1. Mix equal parts of white gouache and Alizarin Crimson. Load a medium combination brush (Long Flow) with two-thirds of the mixture and a small amount of Permanent Violet at the tip. Pull three petals toward the middle in center strokes.

2. Add another two petals to complete the shape.

3. Add details in Permanent Violet. Since the orchid is facing away from the viewer, the ornamental lip is not shown. Add a stem with a center stroke.

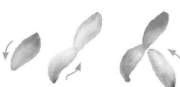

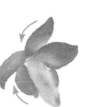

The leaves and stem

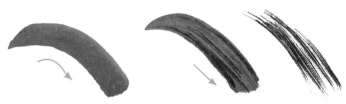

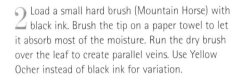

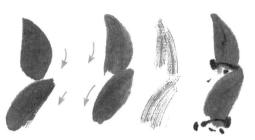

1 Load a medium combination brush (Long Flow) with two-thirds Sap Green and one-third Indigo. Roll the brush on the plate to ensure smooth color transition. Paint a leaf with a long side stroke.

2 Load a small hard brush (Mountain Horse) with black ink. Brush the tip on a paper towel to let it absorb most of the moisture. Run the dry brush over the leaf to create parallel veins. Use Yellow Ocher instead of black ink for variation.

3 For the stem, repeat the steps for the leaves, but in shorter successions.

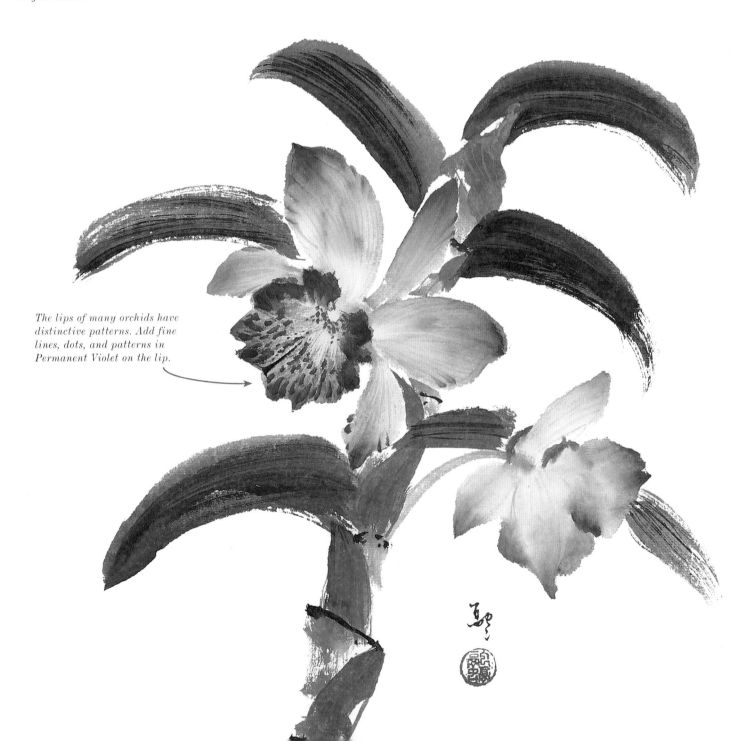

The lips of many orchids have distinctive patterns. Add fine lines, dots, and patterns in Permanent Violet on the lip.

Palette

 Alizarin Crimson

 Sap Green

 Black ink

 Stone Green

 Gamboge Yellow

Papaver Poppy

The poppy comes in a wide range of colors and has thin, overlapping petals, slender stems, and pale green leaves. When the flower withers, the poppy forms a capped seed pod. In China, a flaming red poppy is called "Yu the Beautiful" after a famous beauty who was the concubine of Xiang Yu. In 202 BC, Xiang was besieged in the Battle of Gaixia. In order not to distract Xiang, Yu committed suicide after performing a sword dance; red poppies grew from where she was buried. The love between Xiang and Yu exemplified eternal love and devotion, and is the subject of many paintings and plays in China. In this composition, we will paint the poppy with a Baltimore Oriole (see pages 82–83).

sequence start to finish

Create the flower and add details on the petals following the instructions on the opposite page. Paint the seed pods with short side strokes and add stems to each seed pod and flower. Add the furry details on the stems and seed pods with the tip of a fine hard brush. Paint the lobed poppy leaves in short side strokes. Each piece of leaf is composed of 5 to 7 short side strokes. Add vein details in black ink and markings in Stone Green to represent the furry texture of the leaves. When the colors of the petals are dry, add the seed pods and stamens of the flowers (see opposite). To finish, add a Baltimore Oriole to the composition (optional, see pages 82–83).

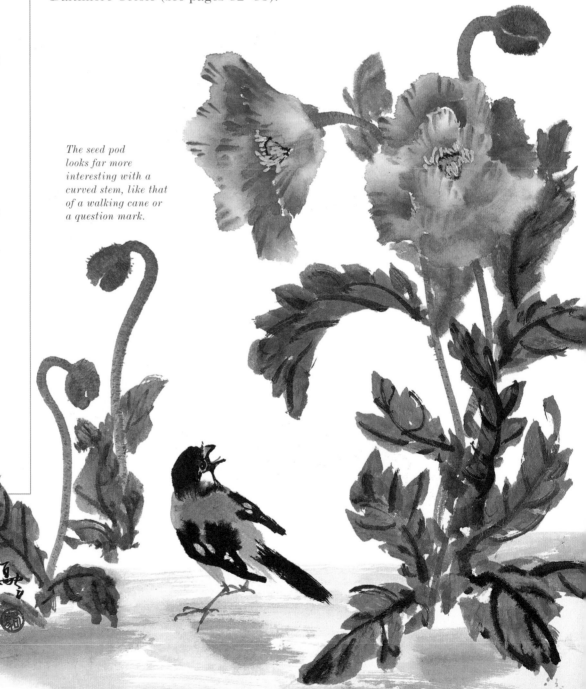

The seed pod looks far more interesting with a curved stem, like that of a walking cane or a question mark.

Paper
Ma (semi-sized rice paper)

Brushes
Long Flow, medium combination
Leaf Vein, fine hard
White Cloud, small soft

The seed pods

1 Load a medium combination brush (Long Flow) with two-thirds Gamboge Yellow and one-third Sap Green. Roll the brush on a plate to ensure a smooth color transition. Add a small amount of Alizarin Crimson to the tip of the brush. Paint the seed pod with two short side strokes and then paint the stem with a center stroke.

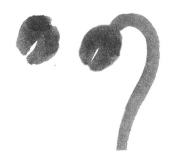

2 Flatten the tip of a fine hard brush (Leaf Vein) with your fingers and add the furry texture in Alizarin Crimson on the stems and seed pod.

The flowers

1 Prepare two dishes: one with one-part Alizarin Crimson and three-parts water to create a light Alizarin Crimson; and one with one-part Alizarin Crimson and one-part water to make dark Alizarin Crimson. Load a medium combination brush (Long Flow) with two-thirds light Alizarin Crimson and one-third dark Alizarin Crimson. Roll the brush on a plate to ensure a smooth gradation of color on the brush. In a side stroke position, move the brush in a small zigzag to form a petal.

2 Add additional petals to form the cup shape of the poppy.

3 Add more Alizarin Crimson to one-third of the brush and strengthen the colors in the inside of the cup shape.

4 Load a fine hard brush (Leaf Vein) with Alizarin Crimson and add short strokes for details on the petal.

5 When the petals are dry, mix Sap Green with black ink and add a small seed pod in the center of the flower.

6 Add Stone Green on the black seed pod.

7 With a fine hard brush (Leaf Vein), add stamens with short strokes in Gamboge Yellow.

The leaves

1 The poppy has lobed leaves with deeply indented margins. Load a medium combination brush (Long Flow) with Sap Green and paint them in short side strokes, as shown.

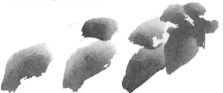

2 Add vein details in black ink and random markings in Stone Green to represent the furry texture.

3 Some poppy leaves are furry on the top side. Add Stone Green markings on the top to represent that texture.

Baltimore Oriole

Palette

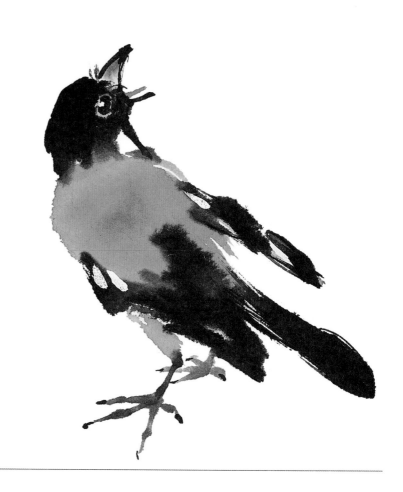

Gamboge Yellow

Vermilion

Black ink

Indigo

White gouache

Paper
Ma (semi-sized rice paper)

Brushes
Long Flow, medium combination
Mountain Horse, small hard
Leaf Vein, fine hard
White Cloud, small soft

The Baltimore Oriole is a medium-size bird (6½–8½ in./17–22 cm) and is a beautiful one to paint. The plumage of most species of Oriole ranges from pale yellow to bright orange and red. The male has deep, flaming orange plumage on its crest and shoulders. The head is black. It has fairly long legs and a long tail and the wings are usually black—some may have white markings. The female is yellowish brown. The Baltimore Oriole can be found in gardens in North America, and many birdwatchers attract them to their gardens by offering fruits, seeds, and berries in their backyard birdfeeders.

sequence start to finish

With a center stroke, draw an oval in Gamboge Yellow and Vermilion to create the body. Form the wings and tail in black ink in dry strokes (see below). Add the thigh in Gamboge Yellow and Indigo. Draw the legs and claws in Indigo. Form the head, starting with the bill, then the eyes, head, and face (see *Special Details*, opposite). When all the colors are dry, add markings to the wings in white gouache. Color the bill in Indigo and add the tongue and details of the eye (see opposite).

The body

1 Load a medium combination brush (Long Flow) with two-thirds Gamboge Yellow and one-third Vermilion. Draw an oval on the paper with a center stroke and pull the ending of the stroke to the right. This will be the body of the Oriole. Do not rinse the brush; set it aside.

2 Load a small hard brush (Mountain Horse) with black ink and draw the wings with two side strokes like a letter "y." Refine the shape with narrow center strokes for the pointed tip of the wing.

3 Paint the other wing with two center strokes using a dry brush.

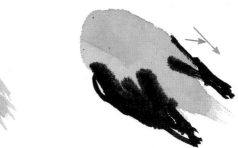

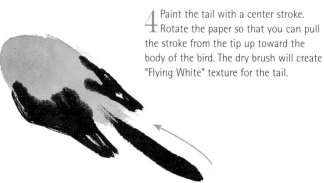

4 Paint the tail with a center stroke. Rotate the paper so that you can pull the stroke from the tip up toward the body of the bird. The dry brush will create "Flying White" texture for the tail.

5 Use the brush that you set aside in Step 1 to connect the tail to the body of the Oriole.

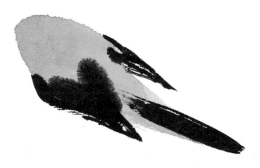

6 Continue to paint the thigh of the bird with a center stroke. If you paint this earlier, the black ink on the wings will run onto the thigh.

7 Load a small soft brush (White Cloud) with Indigo and paint the legs and claws in center strokes. (See *Special Details*, right.)

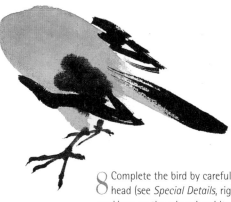

8 Complete the bird by carefully forming the head (see *Special Details*, right). Add white markings on the wings in white gouache and refine the head by coloring the bill and iris, and adding a tongue.

special details forming the head

1. Carefully draw the bill with the tip of a small soft brush (White Cloud) in black ink.

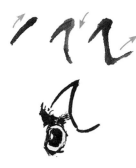

2. Add the eye behind the bill.

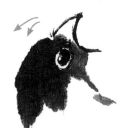

3. Load a small soft brush (White Cloud) with black ink and draw the head of the bird by pressing the tip of the brush with increasing pressure. Connect the head to the body.

4. Color the bill with Indigo and a small soft brush (White Cloud).

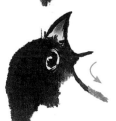

5. Refine the head with a fine hard brush (Leaf Vein) by adding a line of Vermilion for the tongue and filling the area surrounding the iris in Gamboge Yellow. Add a dot of white gouache in the pupil as a highlight.

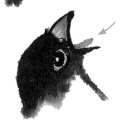

special details legs and claws

Practice drawing the legs and claws of the bird using center strokes. Each stroke becomes a segment of the leg. The claws look stronger with decisive brushwork, which comes with practice and confidence.

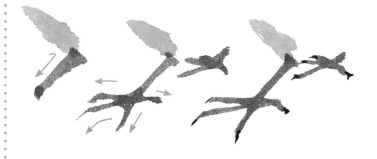

Palette

 Sap Green

 [Light ink] Black ink + water

 Black ink

 Burnt Sienna

 Olive Green

 Diluted Cadmium Yellow

 Diluted Vermilion

 White gouache

Narcissus Jonquil

The jonquil originated in Europe and came to China from the seventeenth century during the Tang Dynasty (AD 618–906). Its Chinese name is "Water Fairy" since it grows along ponds and is cultivated indoors in pots of shallow water. The flower has six petals and a corona in the middle. As many as ten flowers can grow from one bulb. The flower has yellow or white petals with orange, apricot, or pink coronas. The jonquil is a favorite subject of poets and artists because the flowers represent purity and elegance.

You may, if you wish, fill the petals with white gouache to enhance the whiteness of the jonquil. Use a small soft brush (White Cloud).

sequence
start to finish

Create knots of leaves in bold side strokes using the instructions opposite. Add vein details in black ink with a dry brush. Paint the flowers starting with the corona in black ink (see opposite). Draw the petals and flower buds in light black ink. Connect the flowers with stems and extend the stems to the bottom of each knot of leaves. Draw the bulbs in black ink in decisive brushwork (see *Special Details*, right). Finally, fill in the bulbs with Burnt Sienna and Olive Green once the black ink is dry.

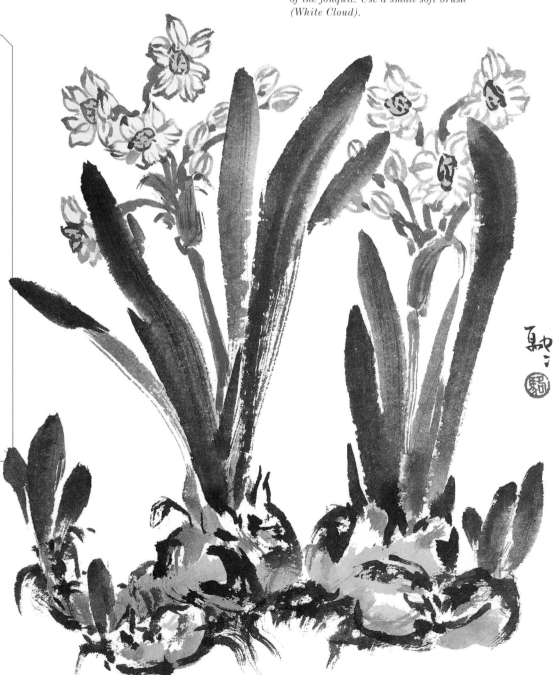

Paper
Ma (semi-sized rice paper)

Brushes
Long Flow, medium combination
Mountain Horse, small and medium hard
White Cloud, small soft

The flowers

1 Load a small hard brush (Mountain Horse) with black ink. Draw the corona in the middle with two nail strokes, which start with more pressure— the stroke will have a nail-like head that narrows to a pointed tip when it is done.

2 Add three dots inside. This completes the corona of the jonquil.

3 Mix black ink with water (1:5) to make light ink. Load a small hard brush (Mountain Horse) with light ink and draw six petals surrounding the corona.

4 When the drawing is dry, add diluted Cadmium Yellow over the corona and cover a bit of the surrounding petals.

5 Color the corona with diluted Vermilion. Optional: fill the petals with white gouache.

6 Use nail strokes to create the jonquil buds, as you did for the petals.

7 Load a medium combination brush (Long Flow) with two-thirds Olive Green and a small amount of Burnt Sienna at its tip. Connect the flowers and join them with the leaves and bulbs. Add parallel veins in Burnt Sienna with flattened tips.

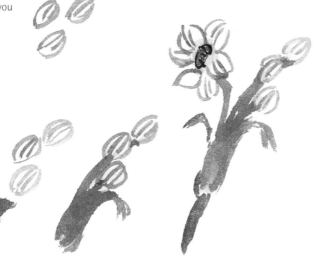

The leaves

1 Load a medium combination brush (Long Flow) with two-thirds Sap Green and one-third black ink. Roll the brush on a plate to ensure a smooth color transition. Paint with side strokes: one stroke for each leaf.

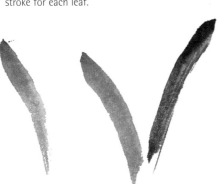

2 Flatten the tip of the brush with your fingers and pick up a small amount of black ink. Brush on a paper towel twice to let it absorb most of the ink. Run the dry brush over the leaves to create parallel veins on the leaves.

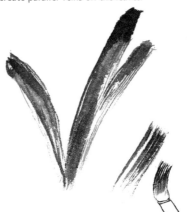

special details bulbs

1. Load a medium hard brush (Mountain Horse) with black ink. Brush on a paper towel twice to let it absorb most of the ink. Create quick, calligraphic marks on the paper with the dry brush for the bulbs. The speed will create a "Flying White" effect, adding texture to the bulb.

2. Load the brush with Burnt Sienna and Olive Green and complete the bulb with dry, quick strokes.

Palette

Gamboge Yellow

Vermilion

Alizarin Crimson

Green Gold

Sap Green

Black ink

Stone Green

Cadmium Yellow Pale

White gouache

sequence
start to finish

Paint a knot of leaves in bold side strokes in Sap Green using a medium combination brush (Long Flow). Add vein details in black ink with a small hard brush (Mountain Horse) in a dry brush (see Jonquil, page 85). Next, paint the petals in center strokes, see right. Rotate the paper if needed. Fill the center of the flower in Gold Green and add vein details. Create daylily buds (see opposite) and connect them with the flowers with Green Gold stem in a narrow center stroke. When the colors of the petals are dry, add the details of stigma and stamens.

Paper
Ma (semi-sized rice paper)

Brushes
Long Flow, medium combination
Leaf Vein, fine hard
Mountain Horse, small and large hard
White Cloud, small soft

Hemerocallis Daylily

Daylilies come in many colors. The buds open one at a time each day in graduation up the stem, and the plant blossoms for a long time in summer. The daylily follows the shape of a trumpet, with a narrow tube that widens into a flared mouth. The daylily usually has six petals, one stigma, and six stamens. Many varieties of daylily are edible, and the flower is used in Chinese cuisine, tea, and medicine. In ancient China, expectant mothers wore daylilies in their hair to wish for a healthy baby. The flower eventually became a symbol of maternal love.

The flowers

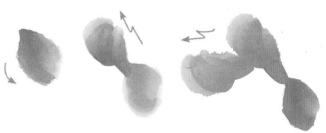

1 Start by painting the top three petals. Mix Gamboge Yellow and Vermilion to create Light Vermilion, and Vermilion and Alizarin Crimson to create Deep Vermilion. Load a medium combination brush (Long Flow) with two-thirds Light Vermilion and one-third Deep Vermilion. Paint the first petal with a center stroke but turn it to a side stroke position so the body of the petal will have all the colors in the brush.

2 Add two more petals on the top with similarly turned strokes—your brush should have sufficient paint without having to reload.

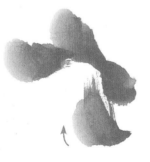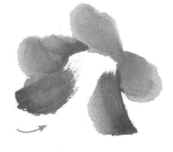

3 Reload the brush as in Step 1 and finish the remaining three bottom petals in center strokes. Start from the outside and brush toward the center of the trumpet. If the upward brush movement is hard for you, turn the paper by 45 degrees. The brush movement will be more left-to-right than bottom-to-top, making it easier for most artists.

4 Load a small soft brush (White Cloud) with two-thirds Gamboge Yellow and one-third Green Gold. Roll the tip of the brush in the center of the daylily's trumpet. Mix Cadmium Yellow Pale with a small amount of white gouache and draw a vein in the center of each petal. This helps emphasize the trumpet shape of the daylily. You can also add vein details in Alizarin Crimson.

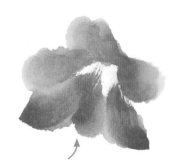

The stigma and stamens

1 When the colors of the petals are dry, load a fine hard brush (Leaf Vein) with Stone Green.

2 Paint three connected dots and draw a curved line toward the center of the flower for the stigma.

3 Mix black ink and Alizarin Crimson and draw six curved lines with a Leaf Vein brush for the stamens.

4 Complete the stamens with a long dot at the end of each curved line in the mixture of black ink and Alizarin Crimson with a Leaf Vein brush.

The buds

1 For the daylily buds, load a medium combination brush (Long Flow) with two-thirds Green Gold and a touch of Vermilion at the tip. Roll the brush on a plate to ensure a smooth color transition. Start the bud with a narrow center stroke.

2 Complete the shape of the bud with two or three narrow center strokes.

3 Connect the buds and flowers with stems in center strokes.

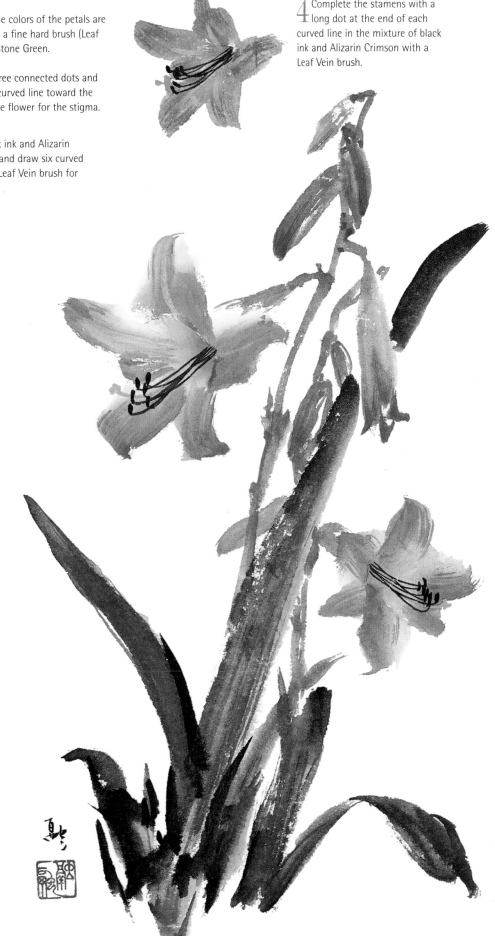

Rhododendron Azalea

Palette

 [Pink] Alizarin Crimson + white gouache

 Alizarin Crimson

 [Light indigo] Indigo + water

 Black ink

 Burnt Sienna

 Olive Green

 [Light yellow] Gamboge Yellow + white gouache

 White gouache

Azaleas are the gardener's favorite because they produce a vibrant display of colors with handsome foliage. The mass of showy flowers adds drama to striking landscape designs. The azalea flower has five petals, usually with five stamens. The flower has curved-in petals that are slightly fluting. Flowers develop individually or in a cluster. Azalea leaves are small, narrow, and pointed. Bright red azaleas are romantically linked to an ancient Chinese tale in which mountains covered with blooming white azaleas turned red to mourn the tragic passing of a beloved governor.

Pay attention to the markings of the azalea. Only three petals have markings: the center one has markings on both sides, while the two adjacent ones have markings only on one side of the petal.

TIP FOR FLOWER ARTISTS

You should be able to draw more than five leaves without reloading your brush. The water in the heel of the brush will continue to migrate to the tip of the brush, creating a subtle lightening of the leaves as you go.

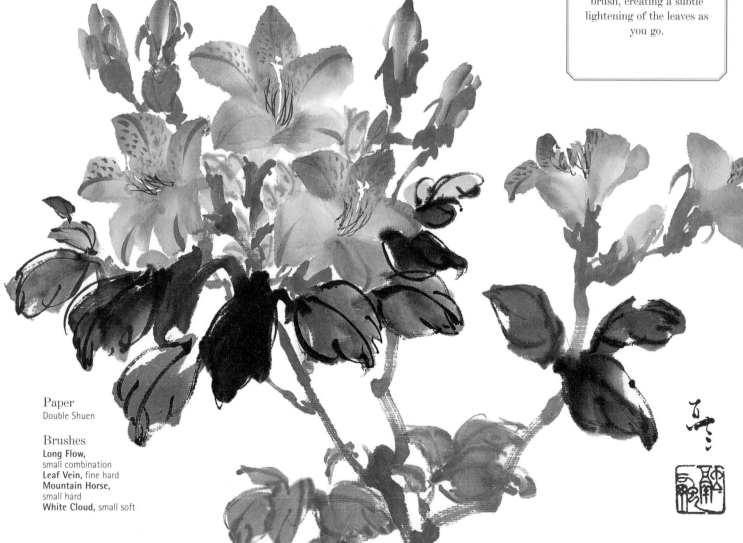

Paper
Double Shuen

Brushes
Long Flow, small combination
Leaf Vein, fine hard
Mountain Horse, small hard
White Cloud, small soft

sequence start to finish

Paint three azaleas each with five petals and add vein details when the colors are still damp (see below). Add buds in the same color as the flowers using a small combination brush (Long Flow) with two to three short center strokes for each bud (see *Special Details*, right). Load a medium combination brush (Long Flow) with two-thirds light indigo and one-third black ink. Paint leaves surrounding the flowers. Start with a center stroke and move to a side stroke as if writing a lower case "n." This is the same stroke as used to create the petals (see below). Draw the vein details on the leaves in black ink with a Leaf Vein brush while the colors of the leaves are still damp. Load a small hard brush (Mountain Horse) with two-thirds Burnt Sienna and one-third light indigo. Draw the stems and branches in quick, calligraphic center strokes connecting the leaves and stems (see Leaves, Stems, and Branches, page 21).

special details small blooms

1. For the side-view azalea, paint two petals with pink in side strokes.

2. Reload the brush with Alizarin Crimson and add three more petals on the top. Add vein details in Alizarin Crimson.

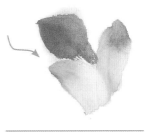

The flowers

1 Mix Alizarin Crimson with white gouache to create pink. Load a small combination brush (Long Flow) with two-thirds pink and one-third Alizarin Crimson. Roll the brush on a plate to ensure a smooth color transition. Start the first two bottom petals with center strokes and move to side strokes, as in writing a lower case "n."

2 Continue with three top petals with center strokes from the outside toward the middle.

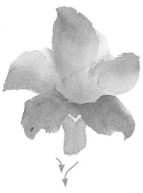

3 Load a small soft brush (White Cloud) with Olive Green and roll it in the middle of the azalea to enhance the funnel shape.

4 Load a fine hard brush (Leaf Vein) with Alizarin Crimson and add a vein in the middle of each petal while the petals are still damp. Add dotted markings on three of the petals as shown.

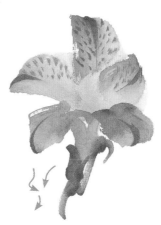

5 Draw the sepal in Olive Green using a small soft brush (White Cloud).

6 When the entire flower has dried, use a fine hard brush (Leaf Vein) and draw the stamens and stigma with white gouache and Burnt Sienna. Mix together Gamboge Yellow and white gouache and use to add the pollen.

buds

1. Load a small combination brush (Long Flow) with Olive Green and a small amount of Burnt Sienna at the tip. Paint the sepals in short center strokes.

2. Add tiny turned leaves with the top of the brush.

3. Load a small combination brush (Long Flow) with pink and a small amount of Alizarin Crimson at the tip. Paint the buds on top of the sepals in short center strokes.

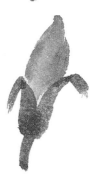

Palette

 Black ink

 [Light ink]
Black ink + water

 Green Gold

 Sap Green

 Burnt Sienna

 Gamboge Yellow

 White gouache

Paper
Ma (semi-sized rice paper)

Brushes
Long Flow, medium and large combination
Leaf Vein, fine hard
Mountain Horse, small hard
White Cloud, small soft

Magnolia Grandiflora
Southern Magnolia

Native to the southeastern United States, the southern magnolia is an evergreen tree with large, dark green leaves and big white flowers. The center has a spherical cone-like fruiting cluster that matures in fall. The leaves are glossy dark green on top and pale green to gray-brown beneath. Large white magnolia, with their leathery, two-toned dark green leaves, make a beautiful composition. The southern magnolia is painted with contour lines while the Mulan magnolia (pages 92–93) is painted without contour lines.

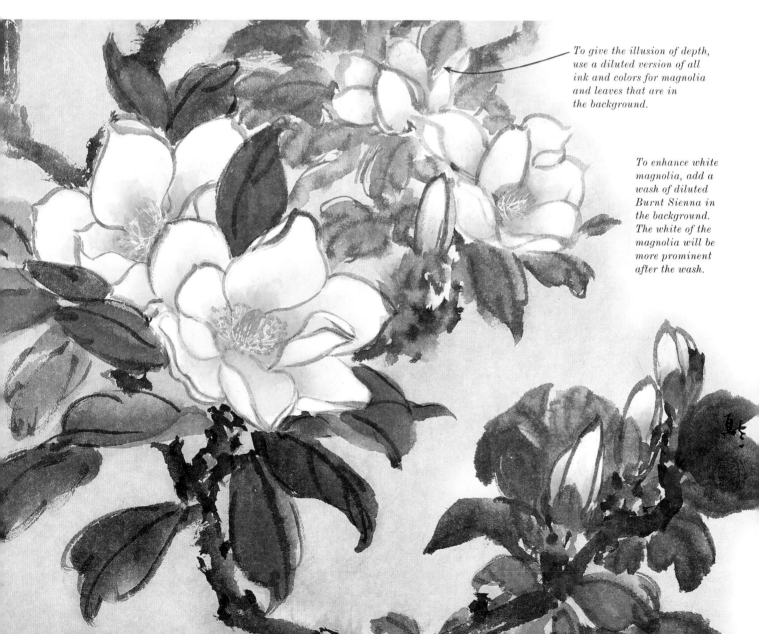

To give the illusion of depth, use a diluted version of all ink and colors for magnolia and leaves that are in the background.

To enhance white magnolia, add a wash of diluted Burnt Sienna in the background. The white of the magnolia will be more prominent after the wash.

sequence start to finish

Begin by forming the contours of the flower in light ink with nail strokes (see right). Add several buds also, if desired (see *Special Details*, below right). When the contours are dry, fill the center of the flower with Green Gold and the outer edges of the petals with white gouache. Paint the leaves in bold side strokes (see below). Add veins in black when the colors are still damp. Add stems and branches in quick calligraphic strokes using two-thirds Burnt Sienna and one-third black ink on a small combination brush (Mountain Horse). Go back to the flowers—by now the colors should be dry. Draw the cone in the middle and add stamen details in white gouache and Gamboge Yellow.

The flowers

1 Load a small hard brush (Mountain Horse) with light ink (1 part black ink diluted with 5 parts water). Start the petal from the tip with nail strokes as shown here. Pay attention so the curves are graceful. If needed, prepare a sketch ahead of time and follow the design as you draw on the rice paper.

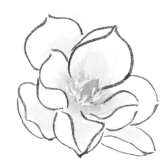

2 Use a small soft brush (White Cloud) to fill in the center of the flower with Green Gold. Fill in white gouache from the edge of the flower toward the center. Each layer should be thin. Repeat two to three times to build up the intensity of the white of the petal.

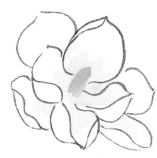

3 When the colors have dried, draw the cone with a center stroke with a small soft brush (White Cloud) with a mixture of white gouache and Sap Green.

4 Add details using a fine hard brush (Leaf Vein) in white gouache and Gamboge Yellow.

The leaves

1 Paint the leaves with a large combination brush (Long Flow) with two-thirds Green Gold, one-third Sap Green, and a small amount of Burnt Sienna at the tip.

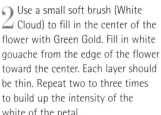

2 For two-toned leaves, load the brush with two-thirds Burnt Sienna and a touch of black ink. Add a side stroke of Burnt Sienna and black for the curved portion of the leaf.

3 Add veins in black ink with a fine hard brush (Leaf Vein).

special details buds and stems

1. For the buds, outline the bud in light ink with center strokes.

2. Load a medium combination brush (Long Flow) with two-thirds Green Gold and one-third Sap Green and paint the sepal.

3. Load a small hard brush (Mountain Horse) with two-thirds Burnt Sienna and one-third black ink and paint the stems and branches in quick, calligraphic strokes.

Palette

 Quinacridone Rose

 Permanent Violet

 Olive Green

 Stone Green

 Burnt Sienna

 Gamboge Yellow

 Black ink

 White gouache

Magnolia Liliiflora
Mulan Magnolia

The Mulan magnolia is native to Asia. Unlike the southern magnolia, it is not an evergreen. The flowers bloom before the leaves—in early spring, Mulan magnolia trees are full of buds covered in brown, furry leaves. When the trees bloom, the inside of the petals are white and the outside of the petals range from shades of pink to reddish purple, giving rise to an interesting contrast. The petals of Mulan magnolia are longer and narrower than those of the southern magnolia.

sequence
start to finish

Prepare the diluted white gouache and color mixture, and paint the petals and buds following the instructions opposite. Color the inside of the petals of the blooming flowers and add vein details on the petals of the flowers and buds with a Leaf Vein brush. Paint the sepals with two side strokes at the bottom of each bud and blooming flower (see opposite). Connect the flowers and buds with branches (see *Special Details*, right). Add textural details in black ink and Stone Green. Finish by drawing the cones in the blooming flowers and adding details to them.

Paper
Ma (semi-sized rice paper)

Brushes
Long Flow, medium combination
Leaf Vein, fine hard
Mountain Horse, small hard
White Cloud, small soft

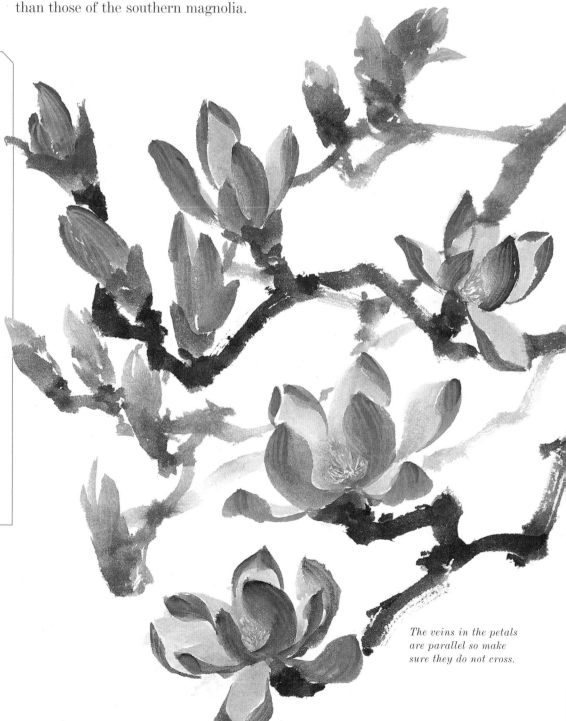

The veins in the petals are parallel so make sure they do not cross.

The flowers

1 Prepare a light wash of white gouache (2 parts water to 1 part gouache) and a mixture of Permanent Violet and Quinacridone Rose. Load a medium combination brush (Long Flow) with white gouache, then two-thirds with the violet and rose mixture. Use the tip of the brush to pick up a small amount of Permanent Violet. Paint the first petal by pressing the brush down at a 45-degree angle, but decrease the pressure and finish the stroke pulling up with a fine tail.

2 Repeat in a reverse direction to form the first two petals.

3 Build from the center of the flower, add more petals, and alternate the angle to form the shape of the flower.

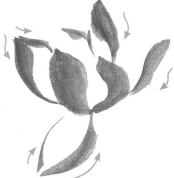

4 Load a medium combination brush (Long Flow) with a mixture of white gouache, Permanent Violet and Quinacridone Rose. Fill in the inside of the petals.

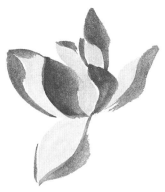

5 Load a small soft brush with water and two-thirds with a light wash of Olive Green, and fill in the center of the petals. Make sure the green fades into the white smoothly.

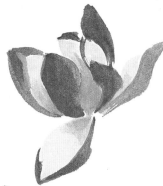

6 Load a fine hard brush (Leaf Vein) with white gouache and draw the parallel veins on the petals.

7 Load a medium combination brush (Long Flow) with Olive Green and a small amount of Burnt Sienna on the tip. Paint the sepals with two side strokes at the bottom of each bud and blooming flower.

8 After the color on the petals is dry, draw the cone in the center of the flower with a mixture of white gouache and Olive Green with a small soft brush (White Cloud).

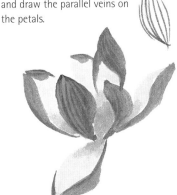

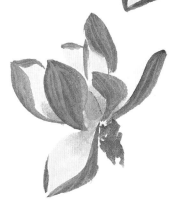

9 Add details with a Leaf Vein brush in white gouache and Gamboge Yellow.

special details buds

For buds, load a medium combination brush (Long Flow) as for Step 1 but draw the petals tighter, as they have not yet opened.

special details branches

1. For the branches, load a small hard brush (Mountain Horse) with two-thirds Burnt Sienna and one-third black ink, and paint the stems and branches in quick, calligraphic strokes.

2. After drawing the branches, add dots of black ink and Stone Green to add texture and visual interest.

Palette

 [Light ink] Black ink + water

 Black ink

 Alizarin Crimson

 Gamboge Yellow

 Olive Green

 White gouache

sequence
start to finish

Draw the contour of a lotus in the upper left of your paper following the instructions at right. Fill the petals with light colors of your choice and add vein details in white gouache (see right). Use a hake brush to paint large lotus leaves in bold brushwork. Add vein details. Load a medium combination brush (Long Flow) with Olive Green and add a stem to each flower and leaf. Add dots of light ink on the stems while the colors are still wet (see page 97).

Paper
Ma (semi-sized rice paper)

Brushes
Long Flow, medium combination
Leaf Vein, fine hard
Mountain Horse, small hard
White Cloud, small soft
Hake brush

Nelumbo Nucifera Lotus

The lotus is the national flower of both India and Vietnam. It symbolizes divinity, fertility, knowledge, and enlightenment as it rises above murky waters and blooms gloriously. The lotus is an aquatic perennial with large, round leaves and comes in white, shades of pink, and red. Some are white with a yellow or pink undertone. We will paint lotuses both with contour lines and in the Lingnan style.

Lotus with Contour Lines

Contour lines are often used for white or light-colored lotuses. The graceful lines create a dramatic contrast with the expressive brushwork used for the lotus leaves in black ink.

The flowers

1 Load a small hard brush (Mountain Horse) with light ink (1 part black ink to 5 parts water). Start with the outline of the seed pod in the center of the lotus and build from there.

2 Draw the petals from the tip with nail strokes. Lotus petals tend to be darker at the top. If desired, intensify the darkness of the tips of the petals with medium ink (1 part black ink to 3 parts water) while the brushwork is still wet.

3 The outline strokes of magnolia and lotus are very similar. The lotus petals are rounder than those of the magnolia, and the lotus has more petals than magnolia.

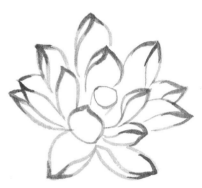

4 When the outline is dry, wet the area surrounding the tips of the petals with clear water. (Light blue is used in the demonstration.)

6 Add Gamboge Yellow to the lower end of the petals. Because of the ring of water, the colors will merge smoothly on the petals.

5 Load a small soft brush (White Cloud) with Alizarin Crimson and add the color to the tip of the petals.

7 Load a fine hard brush (Leaf Vein) with white gouache and add parallel veins on the petals.

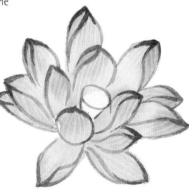

The leaves

1 For the lotus leaves, use a hake brush for a wide coverage. Prepare a dish of medium ink sufficient to cover the leaves of the whole artwork and load a hake brush. Use one side of the hake brush to pick up a small amount of black ink. Paint the bottom half of the lotus leaf with a quick zigzag movement.

2 Reload the hake brush with medium ink and complete the top of the lotus leaf.

3 Add the veins in black ink with a small hard brush (Mountain Horse).

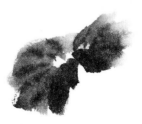

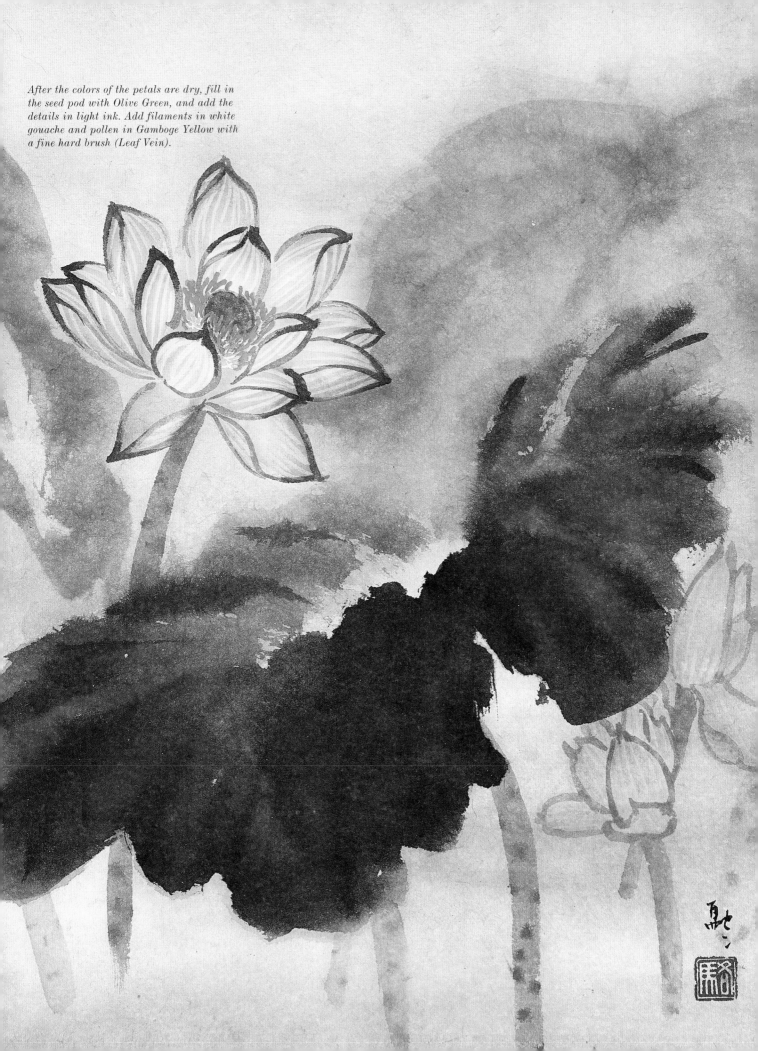

After the colors of the petals are dry, fill in the seed pod with Olive Green, and add the details in light ink. Add filaments in white gouache and pollen in Gamboge Yellow with a fine hard brush (Leaf Vein).

Palette

 Alizarin Crimson

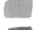 Olive Green

 Gamboge Yellow

 [Light green wash] Olive Green + Gamboge Yellow + water

 Vermilion

 [Light ink] Black ink + water

[Medium ink] Black ink + water

Black ink

White gouache

sequence start to finish

Begin by painting a lotus bloom off-center following the instructions at right. Add the seed pod and vein details. Paint a large lotus leaf with a hake brush to the right of the lotus. Add calligraphic marks to the leaf in black with dry strokes (see page 98). Return to the lotus and, when all of the colors are dry, add filament and pollen details. Add a stem to each flower and leaf with a Long Flow brush. Carefully position a dragonfly on top of a lotus petal (optional, see *Special Details*, page 98). Keep the dragonfly simple to match the stylistic expression of the Lingnan style.

Paper
Double Shuen

Brushes
Long Flow, medium combination
Leaf Vein, fine hard
Mountain Horse, small hard
White Cloud, small soft
Hake brush

Lotus in the Lingnan Style

The Mo-Ku (no bone) approach to painting flowers in the Lingnan style best expresses the elegance of the blooming lotus. Practice your brushwork carefully for best results.

The flower

1 Prepare a diluted white gouache in a dish (2 parts water to 1 part white gouache). Add a small amount of Alizarin Crimson to the diluted white gouache to create a semi-opaque light pink mixture. Load a medium combination brush (Long Flow) with two-thirds light pink and pick up a small amount of Alizarin Crimson on its tip. Paint the first petal with a side stroke at 45 degrees. Apply pressure to create the round body of the petal. If needed, use two strokes instead of one.

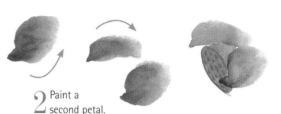

2 Paint a second petal.

3 Load a small soft brush (White Cloud) with Olive Green and paint the seed pod. Draw the details of the seed pod in light ink with a fine hard brush (Leaf Vein).

4 Continue to build the lotus from the center surrounding the seed pod. Paint three to four petals before reloading the brush. Since the water in the heel of the brush will continue to come down, the petals will be slightly lighter in color as you go. Always start from the tip of the petals toward the seed pod.

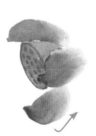
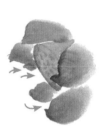
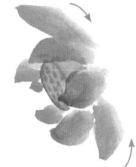

5 Mix equal amounts Olive Green and Gamboge Yellow and dilute the mixture with five parts water to form a light green wash. Apply this wash in the space between the petals at the base of the lotus to connect them.

6 When the colors of the petals are still damp, use a small hard brush (Leaf Vein) and add the veins to the petals in white gouache. Draw from the tip of the petals toward the seed pod.

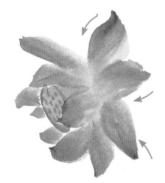
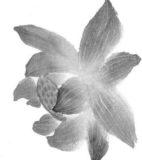
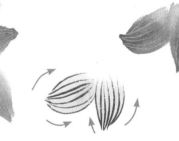

7 When all the colors are dry, draw the filaments with white gouache and add pollen in Gamboge Yellow and Vermilion with a fine hard brush (Leaf Vein).

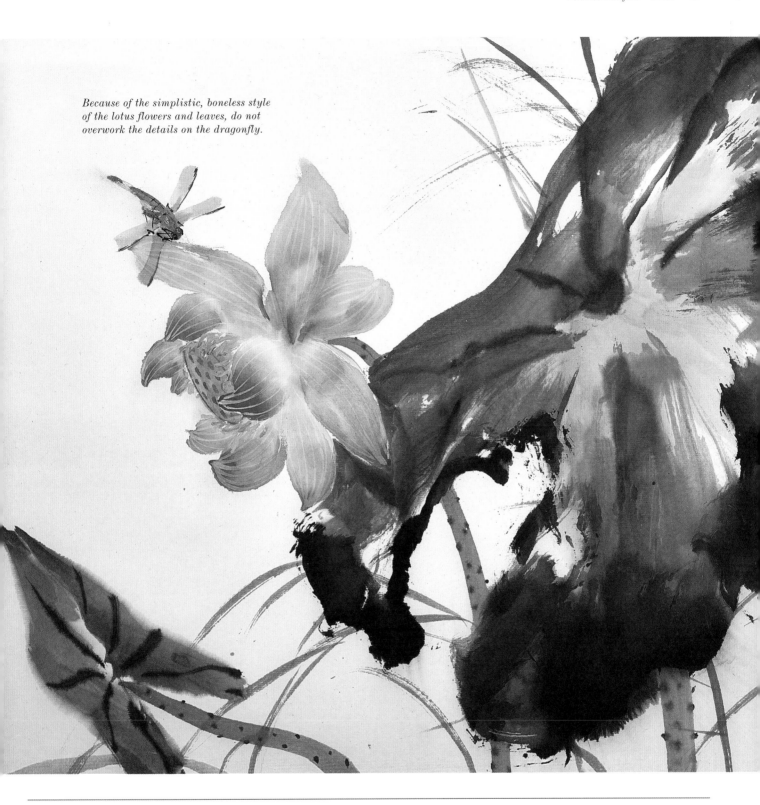

Because of the simplistic, boneless style of the lotus flowers and leaves, do not overwork the details on the dragonfly.

The stem

1 Load a medium combination brush (Long Flow) with Olive Green and add a stem to each lotus and leaf with a center stroke. Since the stems are herbaceous, draw them with a slight curve. They will look stiff if they are too straight.

2 Load a fine hard brush (Leaf Vein) with medium ink (3 parts water to 1 part black ink) and add tiny dots on the stems while the colors are still wet.

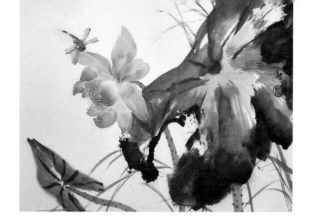

The leaves

1 Load a hake brush with light ink (5 parts water to 1 part black ink) on one end and medium ink on the other. Paint the lower portion of the leaf in broad strokes in a zigzag movement. The quick brushwork will create white gaps within the brushwork called "Flying White."

2 Add the upper portion of the leaf.

3 Mix equal amounts of Olive Green and Gamboge Yellow and dilute the mixture with five parts water to form a light green wash. Apply the light green wash to the center of the lotus leaf with a hake brush with quick brushwork. Some color will merge with the ink and some will not, leaving gaps on the leaf as "Flying White."

4 Load a small hard brush (Mountain Horse) with dark ink. Tap the brush on a piece of paper towel to absorb most of the ink. The brush now has black ink on it but is relatively dry. Strengthen the dark edges of the leaf and draw the veins with the brush in decisive strokes. Twist the tip of the brush as you go to create interesting shapes with the edges.

Palette

 Cobalt Blue

 [Very light ink] Black ink + water

 Black ink

 [Medium ink] Black ink + water

special details dragonfly

The dragonfly is a natural companion to aquatic plants like lotuses and water lilies. The insect has large compound eyes, two pairs of transparent wings, a long body, and three pairs of legs. There are many species of dragonfly in a variety of colors. Dragonflies are symbols of summer and are commonly found in Chinese and Japanese paintings and poems.

1. Load a small soft brush (White Cloud) with Cobalt Blue. Start the large compound eyes with two dots, and draw two squares to represent the thorax and the upper part of the segmented abdomen. Leave a spot in the middle of the square; this is the highlight of the thorax.

2. Continue with the segmented abdomen as the dragonfly has a long body.

3. Dilute 1 part black ink with 8 parts water to create very light ink. Use your fingers to shape the tip of the brush to resemble a small flat brush. Load it with very light ink and paint four wings connected to the thorax, one stroke for each wing.

4. Load a fine hard brush (Leaf Vein) with black ink and draw in the details of the eyes, segments, and tip of the wings.

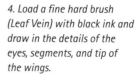

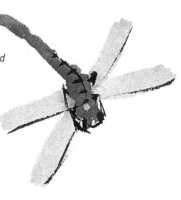

Ipomoea Purpurea
Morning Glory

Palette

	Permanent Violet
	Vermilion
	Sap Green
	Olive Green
	Permanent Alizarin Crimson
	Cadmium Yellow Pale
	Black ink
	[Light ink] Black ink + water

Regarded as one of the most beautiful climbers, the morning glory is popular in many gardens. The flower comes in many different colors, from white to shades of pink, blue, and purple. Many have contrasting colors, such as blue petals with yellow throats. Some have a single color, such as purple or rose that fades into white in the center. Morning glory is funnel-shaped and comes singly or in small clusters. Here butterflies have been added for visual interest and to balance the composition.

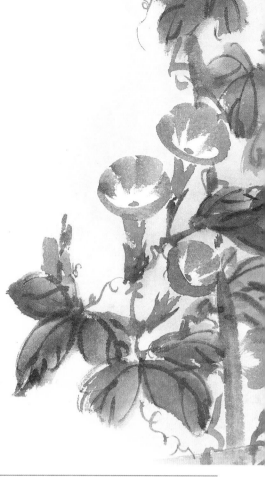

sequence start to finish

Beginning off-center, paint a cluster of flowers following the instructions at right. Add a few leaves (see page 100) near the flowers to set the general subject placement. Load a medium combination brush (Long Flow) with light ink and paint the bamboo fence with center strokes. Create more leaves and add flowers along the fence. Scribble tiny veins in Olive Green with a fine hard brush (Leaf Vein). Add butterflies to complete the composition, if you wish (see *Special Details*, page 100).

Paper
Ma (semi-sized rice paper)

Brushes
Long Flow, medium combination
Leaf Vein, fine hard

The flowers

1 Load a medium combination brush (Long Flow) with two-thirds Permanent Violet and one-third Permanent Alizarin Crimson. Draw a semicircle with center stroke. This will be the outer edge of the funnel shape.

2 Hold the brush horizontal to the paper and paint three to four side strokes downward toward the center of the semicircle. The strokes should be quick to purposely leave "Flying White" near the center of the funnel.

3 Draw the throat of the flower with two short center strokes in the shape of a letter "y."

4 Add a dot of Permanent Violet in the middle of the throat of the flower.

5 Load a combination brush (Long Flow) with Cadmium Yellow Pale and Sap Green. Draw the sepal with two short center strokes in the shape of a letter "y." Connect the sepals to the leaves.

The buds

1 With the same color as the flowers, press a medium combination brush (Long Flow) on its side to create pointed marks for the buds. Add the sepals in Sap Green and Cadmium Yellow Pale with short center strokes.

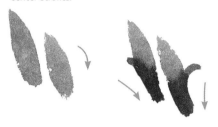

2 Load a fine hard brush (Leaf Vein) with Sap Green and Cadmium Yellow Pale and draw the veins with center strokes. Scribble tiny veins for visual interest.

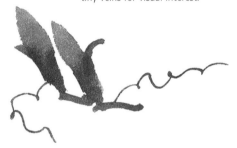

The leaves

1 Mix Sap Green and Cadmium Yellow Pale to make a light green. Load a medium combination brush (Long Flow) with two-thirds light green, one-third Sap Green, and a small touch of black ink at the tip. Draw a leaf with three side strokes.

2 Load a fine hard brush (Leaf Vein) with black ink. Draw the veins before the colors on the leaves are completely dry.

3 Load a fine hard brush (Leaf Vein) with Sap Green. Scribble the hanging vines with a circular brush movement.

special details butterfly

Butterflies come in many colors, but we have used Permanent Violet and Vermilion to match the morning glory.

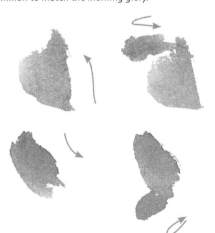

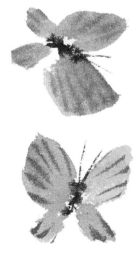

1. Load a soft brush (White Cloud) with your choice of color. For the wings closest to you, draw the forewing with a side stroke.

2. Draw the hind wing with a small loop with a side stroke.

3. For the forewing and hind wing farthest from you, draw it with two tuck-in strokes.

4. Depending on the style of the rest of the painting, you can add the details of the patterns on the wings. The markings on the butterflies should not be more complex than those on the flowers.

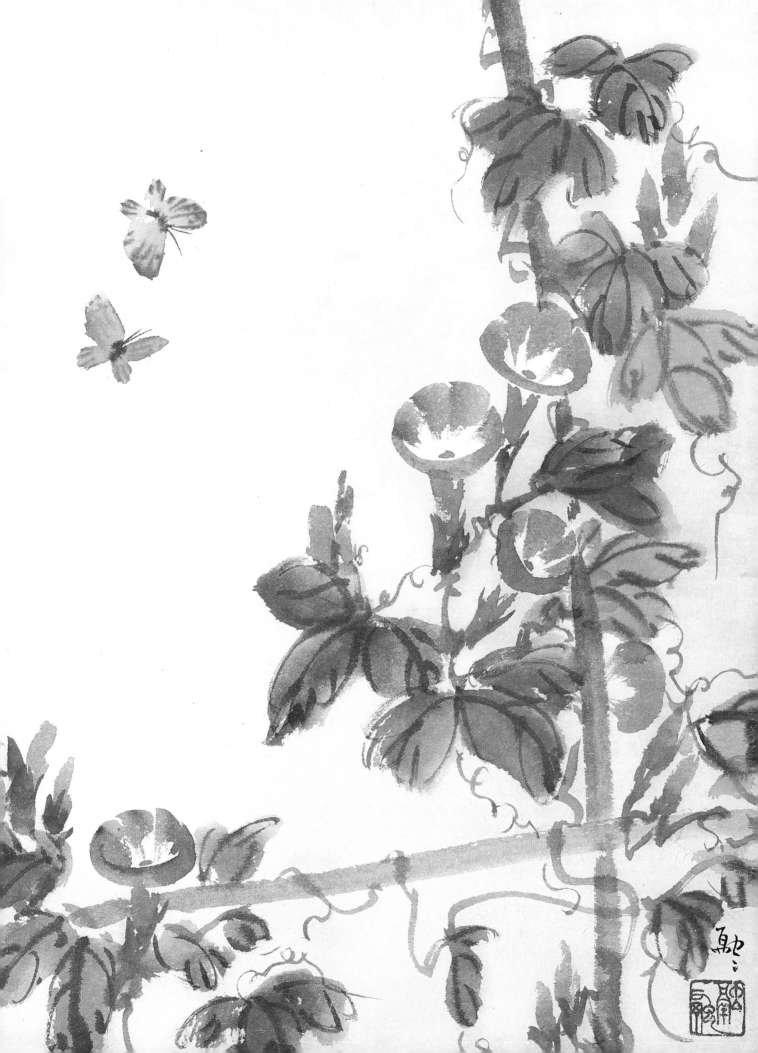

Palette

[Light ink] Black ink + water

Black ink

Cadmium Yellow Pale

Sap Green

Permanent Antique Violet

Vermilion

White gouache

Paper
Cicada Wing (sized rice paper)

Brushes
Leaf Vein, fine hard
White Cloud, small soft

Nymphaea Water Lily

Water lilies live in fresh water in tropical and temperate climates around the world. The leaves can be round with a radial notch or fully circular. Water lily flowers and leaves float on the water's surface while the roots are in the soil in the bottom of the pond. The water lilies commonly found in China are day-blooming ones, thus earning their Chinese name "Sleeping Lily," since the blooms close after dusk. Water lilies come in white, yellow, shades of red, and shades of purple.

Purple Water Lilies

Sized rice paper has a reduced immediate absorbency, allowing for the manipulation of water and colors for special art effects. For the purple water lilies, we will practice layering colors to achieve color intensity. The rich hues in this sample artwork were built up over eight color applications.

> **TIP FOR FLOWER ARTISTS**
>
> *The background of pond water is done in the same way as coloring the lily pads. Use only light and dark ink without any color for more contrast.*

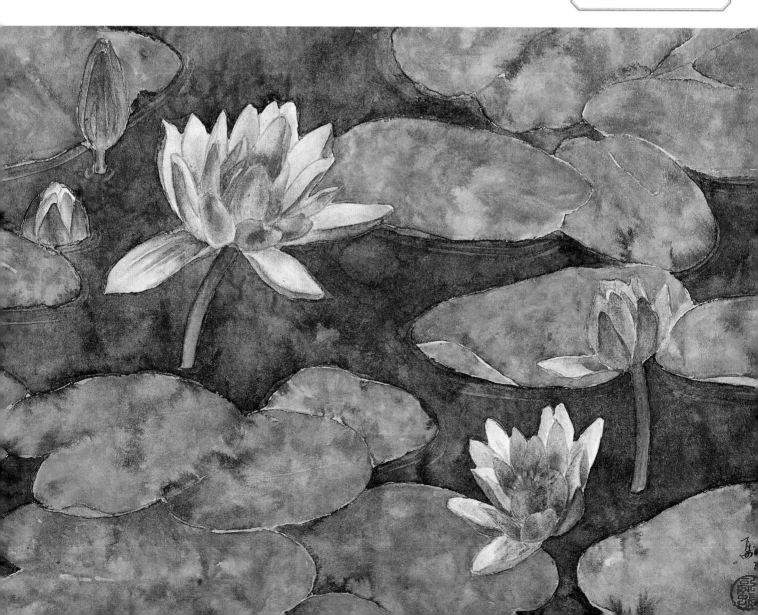

sequence start to finish

Draw the contours of the water lilies and lily pads in light ink with a fine hard brush (Leaf Vein). Beginners may sketch the design first, then lay the sketch underneath the thin rice paper to trace the contours. More advanced artists can try doing it freehand, building from the inner to the outer layers of the petals. When the contours are dry, apply color with a small soft brush (White Cloud), repeating multiple times to build color intensity (see below). When the petals are dry, add filaments and pollen, as below. Color the lily pads with a special blooming effect (see right). When all colors on the lily pads are dry, apply the blooming effect (see page 105) to the rest of the pond for dramatic contrast. Flood the background in light ink and touch the edges of the background with black ink. Lay flat to dry.

The flowers

1 Dilute one part black ink with five parts water to create light ink and use a fine hard brush (Leaf Vein) to draw the contours of the water lilies.

2 Load a small soft brush (White Cloud) with Cadmium Yellow Pale and fill in the center of the petals.

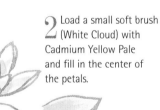

3 Use Permanent Antique Violet for the outer tips of the petals.

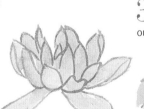

4 Repeat to build the color intensity. This piece took eight applications to build the potent color.

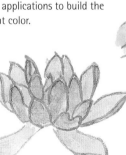
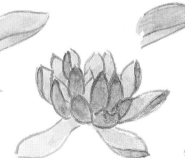

special details filaments and pollen

1. When the colors on the petals are dry, paint dots of white gouache in the middle with a fine hard brush (Leaf Vein). The dots set the base for the colors of the pollen.

2. Add dots of Vermilion on top of the white dots as pollen.

The lily pads

1 Draw the contours of the lily pads with a fine hard brush (Leaf Vein) in light ink.

2 Lay the paper on a flat surface. When the contours are dry, use a small soft brush (White Cloud) to flood the lily pad with light ink. The light ink will rest on top of the sized rice paper.

3 With the tip of a small soft brush (White Cloud) loaded with black ink, touch the pool of light ink on the edges of the lily pad. Let the ink flow into the pool.

4 You can also add other colors such as Sap Green and Cadmium Yellow Pale.

5 When painting overlapping lily pads, leave a fine gap between the pads so the pools of colors will not flood into each other.

Palette

[Light ink] Black ink
+ water

[Medium ink] Black
ink + water

Cadmium Yellow
Pale

Sap Green

Vermilion

Gamboge Yellow

White gouache

Paper
Cicada Wing (sized rice paper)

Brushes
Leaf Vein, fine hard
White Cloud, small soft

White Water Lilies

Besides building rich hues with multiple layers of colors, another approach in Detail style is to keep the colors simple to show the refined contours. We also use lighter colors in the blooming effect in order to achieve a different atmospheric result.

sequence start to finish

Draw the contours of the water lilies and lily pads in light ink with a fine hard brush (Leaf Vein). When the drawing is dry, apply a light green wash to the center of the lilies (see opposite). After the colors are dry, use a fine hard brush to add veins to the petals in white gouache and filaments in Vermilion and Gamboge Yellow. Color the lily pads with light ink, medium ink, Sap Green, and Cadmium Yellow Pale (see opposite). When all the colors of the lily pad are dry, apply the blooming effect (see *Special Details*, opposite) to the rest of the pond. Flood the background with water and touch the edges of the background with medium ink. Lay flat to dry.

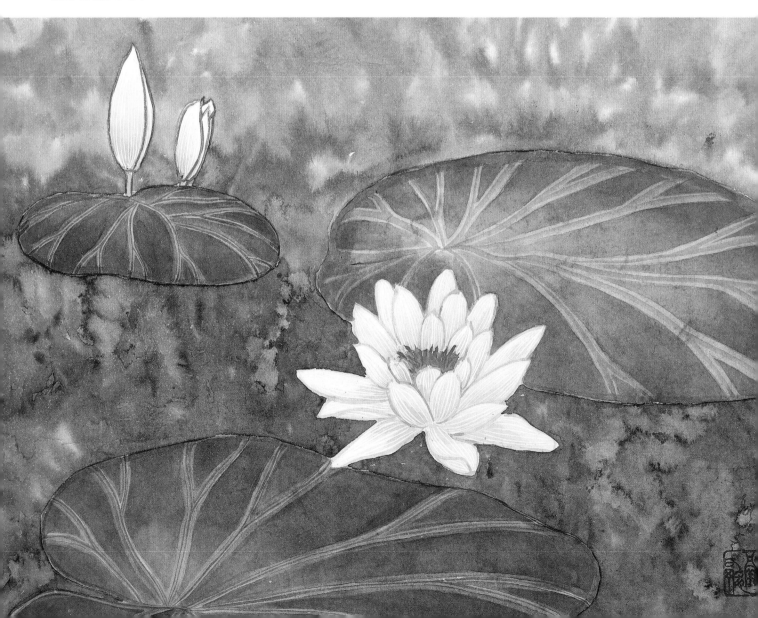

special details blooming effect

1. Because sized rice paper absorbs water and colors less readily than unsized paper, an excess amount of water and colors will create pools that will cause the "blooming" effect. The water and colors will backfill into the area and create outlines or edges of more intense colors. This effect creates a strong contrast with the highly controlled lines of the flowers.

2. Notice that the intensity of the blooms depends on the amount of water and the amount of the second color added to it. First create a pool in the area where you want the effect. This can be with clear water or a diluted color. The second color should be strong, such as dark ink. Do not just add the second layer of colors on top of the pool of water or diluted color; if you do that, it will

just create a pool of darker color to the area.

3. To make more blooms, load the tip of the brush with a stronger color, and touch the edges of the pool of water carefully with the tip of the brush. The stronger color will be drawn into the pool and create interesting patterns. Let the artwork lay flat to dry.

4. Examine the effect: you can add a third color if desired. Notice the difference between the white water lily and the purple water lily paintings. The value and darkness of the background depends on the amount of colors and water you use.

The flowers

1 Create the contours of the water lilies in light ink (one part black ink to five parts water) with a fine hard brush (Leaf Vein) in nail strokes (see page 20).

2 Load a small soft brush (White Cloud) with white gouache and fill in from the tip of the petals toward the base.

3 Mix equal amounts of Sap Green and Gamboge Yellow and dilute the mixture with five parts water to make a light green wash. Counter the white with light green from the center toward the tips of the petals.

4 After the colors are dry, add parallel veins on the petals in white gouache with a fine hard brush (Leaf Vein).

The lily pads

1 For large lily pads, the details of the veins are visible. Combine black ink and water to create a light ink (1 part black ink to 5 parts water). Fill the middle of the lily pad with light ink.

2 Dilute one part black ink with three parts water to make medium ink. Fill each segment of the lily pad from the outer edge and leave gaps between the veins.

3 When the ink wash is dry, apply Cadmium Yellow Pale from the center of the lily pad with a small soft brush (White Cloud).

4 Apply Sap Green from the outer edge of the lily pad with a small soft brush (White Cloud).

5 When the colors are dry, apply a final wash of Sap Green over the entire leaf to unify the hues.

Palette

Alizarin Crimson

Sap Green

Black ink

Permanent Violet

Green Gold

White gouache

Gladiolus Gladiolus

Gladiolus has spear-like flower spikes, earning its name since gladius means sword in Latin. Its Chinese name also means "sword." Each gladiolus stem bears a column of flowers, varying in size and opening from the bottom. The flowers have three dorsal petals that are large, and three outer petals that are narrower. They join at the base to form a funnel shape. Gladioli usually have one stigma and three stamens. Gladioli come in a wide range of colors, some with contrasting markings around the edges or at the throat. The leaves are dark green, and the stems are stiff and erect.

sequence start to finish

Start by forming the flowers at the bottom of your composition. Paint one to three blooming gladioli following the instructions opposite. Above the blooming flowers, draw the visible portions of the stem in Sap Green and black ink in center strokes using a medium combination brush (Long Flow). Add longer leaves too (see Jonquil, page 85). On top of each section of stem, add small blooms and buds (see opposite). They should decrease in size as they go up the stem. After all of the colors in the flower are dry, add stigma and stamen details (see *Special Details*, opposite).

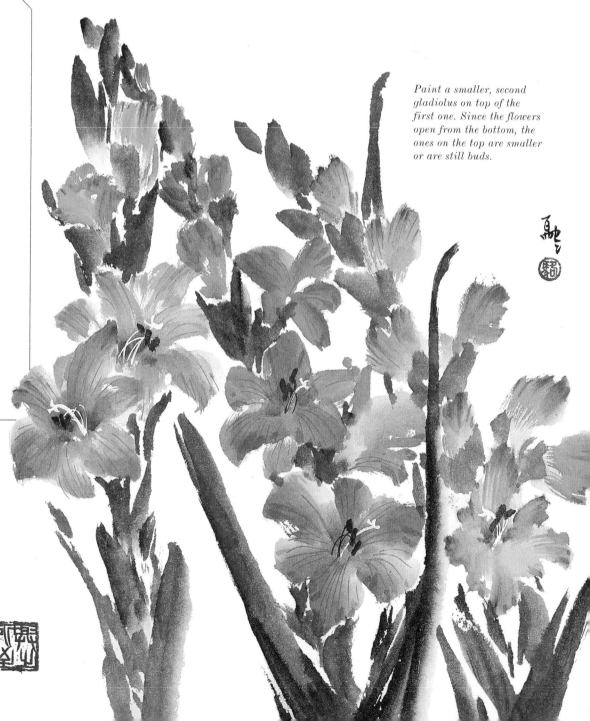

Paint a smaller, second gladiolus on top of the first one. Since the flowers open from the bottom, the ones on the top are smaller or are still buds.

Paper
Double Shuen

Brushes
Long Flow, medium combination
Leaf Vein, fine hard
White Cloud, small soft

The flowers

1 Load a medium combination brush (Long Flow) with two-thirds white gouache and one-third Alizarin Crimson. Roll it on a plate to ensure a smooth color transition. Starting at the center of the flower, press down with increased pressure to paint the first dorsal petal.

2 Without reloading the brush, add two more petals to the left and right.

 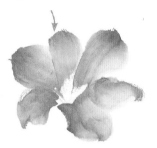

3 Reload as in Step 1 as needed. Draw the top three petals with side strokes from the tip toward the base of the flower.

4 Load a small soft brush (White Cloud) with Green Gold and fill in the middle of the flower funnel.

5 Load a fine hard brush (Leaf Vein) with Alizarin Crimson and add the veins on the petals. Begin with a longer vein in the middle of the petal and add short veins to the left and then to the right.

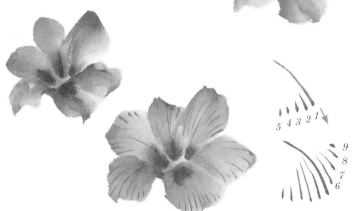

special details
stigma and stamens

1. After all of the colors on the flower petals are dry, draw three tiny dots in white gouache with a fine hard brush (Leaf Vein). Extend a thin line from the three dots to the center of the funnel of the gladiolus. This is the stigma.

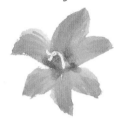

2. Draw three shorter thin white lines next to the stigma, also extending into the center of the funnel.

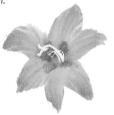

3. To create the stamens, add three long dots of Permanent Violet at the top of the three shorter white lines.

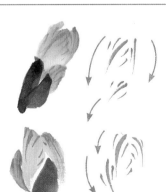

The buds and stems

1 Load a medium combination brush (Long Flow) with Sap Green and a small amount of black ink on the tip. Paint two short center strokes to represent the visible parts of the stem.

2 For the buds, load a medium combination brush (Long Flow) with two-thirds white gouache and one-third Alizarin Crimson. Roll it on a plate to ensure a smooth color transition.

3 Paint each bud with two to three short strokes.

4 Add vein details in Alizarin Crimson.

Hippeastrum Amaryllis

Palette

Gamboge Yellow

Vermilion

Alizarin Crimson

Sap Green

Burnt Sienna

Black ink

White gouache

Amaryllis bears bright, waxy flowers that bloom in clusters of three or four at the top of a long stem. Big and showy, the flowers come in red, scarlet, pink, orange, white, and sometimes striped in a combination of colors. The amaryllis has six petals, a straight stem, and strap-like leaves. It blooms most of the year and is a popular indoor plant.

sequence
start to finish

Practice the strokes for the petals before you start until you can form a petal with each stroke. Begin by painting two flowers, each with six petals, in Gamboge Yellow and Vermilion (see opposite). Add Sap Green to the middle of each flower to enhance the funnel shape, and add vein details to the petals in Alizarin Crimson. Amaryllis leaves are strap-like. Load a large combination brush (Long Flow) with Sap Green and touch the tip of the brush with Burnt Sienna. Paint each leaf with a side stroke, then add veins in black ink (see Jonquil, page 85). After all the colors in the flower are dry, add stigma and stamen details.

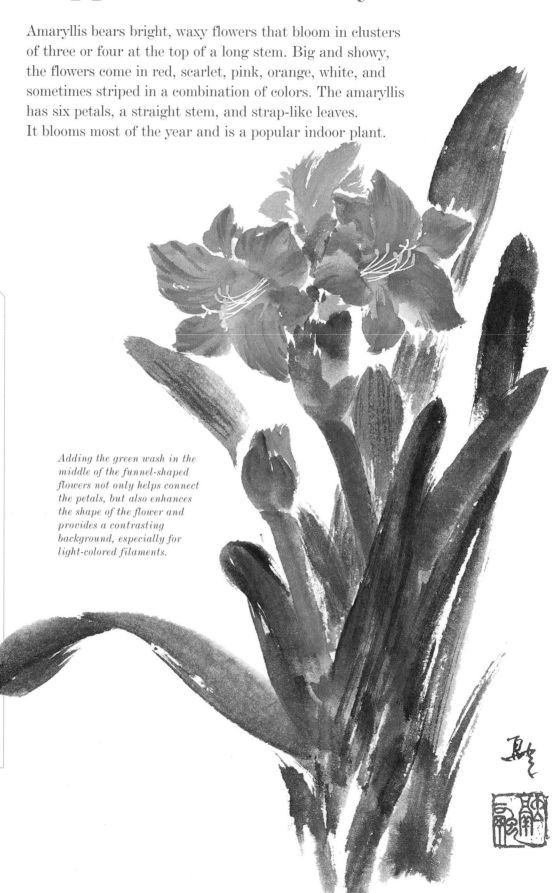

Adding the green wash in the middle of the funnel-shaped flowers not only helps connect the petals, but also enhances the shape of the flower and provides a contrasting background, especially for light-colored filaments.

Paper
Ma (semi-sized paper)

Brushes
Long Flow, medium and large combinations
Leaf Vein, fine hard
White Cloud, small soft

The flower

1 Load a medium combination brush (Long Flow) with two-thirds Gamboge Yellow and one-third Vermilion. Roll the brush on a plate to ensure a smooth color transition. Paint two side strokes slightly overlapping each other to make a wide petal.

2 Continue with the second and third petals, also with two side strokes.

3 Reload the brush and finish three more petals. Because this set of three is underneath the first set of three, each petal is painted with only one stroke.

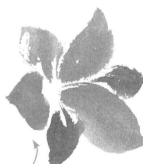

4 Add a diluted wash of Sap Green in the middle of the flower to enhance the depth of its funnel shape.

5 While the petals are still damp, load a fine hard brush (Leaf Vein) with Alizarin Crimson and add details on the petals. Start with a longer vein from the center, and add shorter ones to each side.

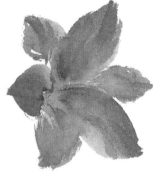

6 Pick up a thick amount of white gouache and draw the stigma in the middle. Add six more filaments. Top the end of the filament with Gamboge Yellow for the pollen.

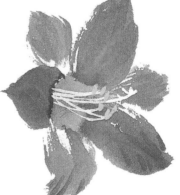

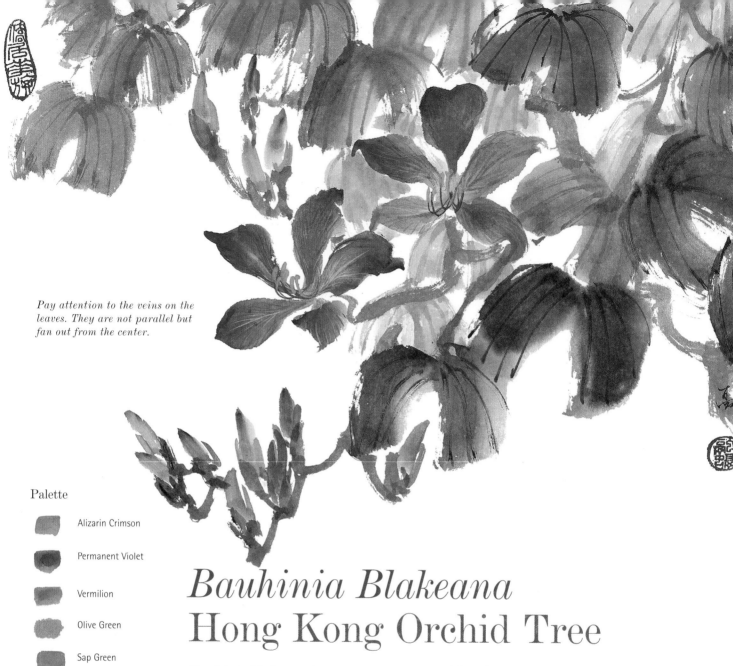

Pay attention to the veins on the leaves. They are not parallel but fan out from the center.

Palette

Alizarin Crimson

Permanent Violet

Vermilion

Olive Green

Sap Green

Gamboge Yellow

Black ink

[Medium ink] Black ink + water

White gouache

Paper
Double Shuen

Brushes
Long Flow, medium combination
Leaf Vein, fine hard
Mountain Horse, small hard
White Cloud, small soft

Bauhinia Blakeana
Hong Kong Orchid Tree

Bauhinia blakeana is an evergreen tree with thick leaves and reddish purple flowers. Because the flower has an orchid-like shape, it is also known as the Hong Kong orchid tree, although it is not an orchid. *Bauhinia blakeana* has five purplish red petals, one of which is usually a deeper red. The petals have purple veins. The leaf is double-loped with a deep cleft dividing the apex. *Bauhinia blakeana* is the floral emblem of Hong Kong and appears in its flag and coins.

sequence start to finish

Position two flowers in the center by painting each with five petals in a mixture of Alizarin Crimson and Permanent Violet (see opposite). Add Vermilion to one petal on each flower and add veins to all the petals while the colors are still damp. Paint the leaves in side strokes (see opposite) and add black veins while the colors are still damp. Add some clusters of buds (see *Special Details*, opposite) to the composition. Load a medium combination brush (Long Flow) with Olive Green and connect the flowers, buds, and leaves with stems in center strokes. When all of the colors in the flowers are dry, add stigma and filament details.

The flowers

1 Create a diluted white gouache (1 part white gouache to 2 parts water) in a dish. In another dish, mix a small amount of Alizarin Crimson and Permanent Violet to create a violet with a reddish tone. Load a medium combination brush (Long Flow) with one-third diluted white gouache and two-thirds reddish violet, and pick up a small amount of Permanent Violet on the tip. Paint the first petal with a side stroke at 45 degrees, letting the colors in the body of the brush touch the paper.

2 Add four more petals with side strokes, painting the tip of the petals toward the center of the flower. Join the petals together in the center.

3 Load a small soft brush (White Cloud) with a mixture of Alizarin Crimson and Vermilion. Add this color to one petal of each flower.

4 Load a fine hard brush (Leaf Vein) with Vermilion and paint the veins on this petal while the colors are still damp. Because the colors are still damp, the Vermilion veins and reddish colors will merge nicely with the rest of the petal, creating a subtle detail that is realistic to the *Bauhinia blakeana*.

5 When all the colors of the petals are dry, use a fine hard brush (Leaf Vein) and draw the stigma and filaments. Add Gamboge Yellow for the pollen.

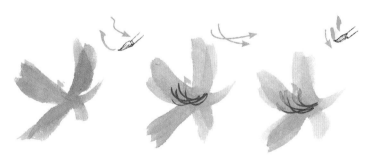

The leaves

1 For the leaves, load a medium combination brush (Long Flow) with two-thirds Olive Green and one-third Sap Green. Add a small amount of medium ink to the tip. Paint each leaf with two side strokes in the shape of a letter "c" and a reverse "c."

2 While the colors are still damp, use a fine hard brush (Leaf Vein) and add the veins in long curved lines forming a fan shape.

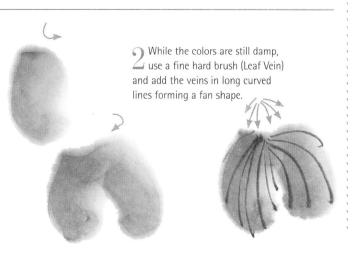

special details buds and stems

1. Load a medium combination brush (Long Flow) with diluted white gouache and two-thirds reddish violet, and pick up a small amount of Permanent Violet on the tip (see "The Flowers," Step 1). Paint the buds in two to three short center strokes.

2. Load a medium combination brush (Long Flow) with Olive Green. Draw the supporting sepals in two to three short center strokes below the buds.

3. Continue with the brush and connect the buds to the flowers and the leaves using center strokes.

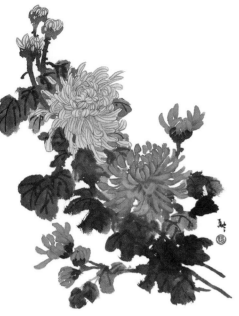

Chrysanthemum
Chrysanthemum

Chrysanthemum is the symbol of fall and represents loyalty and devotion. Since the flower defies the frost and blooms in early fall, long after most showy flowers have bloomed and faded, it symbolizes humbleness and righteousness. Thus, the chrysanthemum is honored as one of the "Four Gentlemen" in Chinese culture. There are many species of chrysanthemum, and they also come in a great variety of colors. The majestic crab claw chrysanthemum has exceedingly long ray florets that form curved hooks at the ends and cascade down from the center of the flower. Its complex petal arrangement presents an interesting opportunity to practice Contour style and Mo-Ku style in one artwork.

Palette

 [Purple] Indigo + Alizarin Crimson

 Cadmium Yellow Pale

 Cadmium Yellow Medium

 Black ink

 [Light ink] black ink + water

 White gouache

Paper
Ma (semi-sized rice paper)

Brushes
Long Flow, small and medium combination
Mountain Horse, small hard
White Cloud, small soft
Leaf Vein, fine hard

sequence start to finish

Begin with the yellow chrysanthemum in Contour style. Draw the contours of the flower using the instructions opposite. Add buds to the upper left of the flower (see *Special Details*, below, right). Switch to the purple chrysanthemum in Mo-Ku style. Paint the flower using the instructions opposite. Add purple buds and small blooms, too. Load a medium combination brush

(Long Flow) with two-thirds medium ink and one-third black ink and paint the leaves in side strokes. Using a medium combination brush (Long Flow) loaded with medium ink, connect the flowers, buds, and leaves with stems in center strokes. Load a small hard brush (Mountain Horse) with black ink and add small dots to the stems for visual interest. Add vein details to the leaves while

they are still damp. Go back to the Contour style flower—the contour drawing should be dry by now—and color all the petals and buds in Cadmium Yellow Pale. Add Cadmium Yellow Medium to the base of the petals while the colors on the petals are still wet to create the effect of depth in the center of the flower. Repeat this on the base of the petals in the buds.

special details avoiding mistakes

1. A common mistake in painting chrysanthemums is the lack of graceful curves in the long petals, making the flower appear unnatural.

2. Another common error is misjudging the center of the flower head, making the ends of the petals not gather at the same base.

3. The chrysanthemum should have naturally curved petals gathering at the center of the flower. The petals in back are shorter and those in front are longer to enhance the sense of perspective.

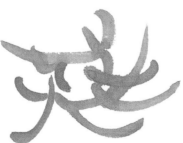

Yellow Chrysanthemum in Contour Style

Contour style emphasizes the use of graceful lines and is a wonderful way to present the complex petal arrangement of a crab claw chrysanthemum. We will color it in simple steps instead of using the more laborious coloring process of the Detail style.

The yellow flower

1 Dilute one part black ink with five parts water to make light ink. Load a fine hard brush (Leaf Vein) with the light ink. Draw each petal with two center strokes curving toward the center.

2 Add more petals to build the flower head. Be mindful of the overall spherical shape so the petals on the top are shorter and those closer to you are longer by comparison.

 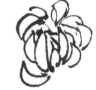

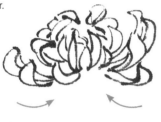

3 Continue to build the flower head. To create the hooked end of the petals, draw two long "c" shapes and add a line on the top of them.

4 For the petals cascading down from the flower head, draw two long curved lines from the center. Do not hesitate when drawing the lines or they will not appear smooth.

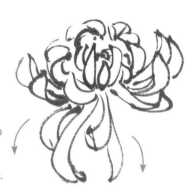

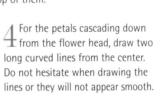

5 Repeat and add more petals—chrysanthemums typically have numerous petals.

6 When all the contour drawing is dry, use a small soft brush (White Cloud) and fill in a diluted layer of Cadmium Yellow Pale in the middle.

7 Add a stronger layer of Cadmium Yellow Medium in the center of the flower head and on selected petals to create the effect of light and shadow in the petals.

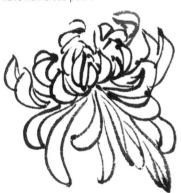 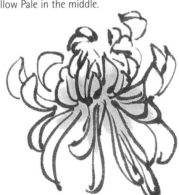 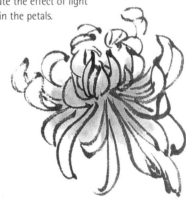

special details forming flower buds

If you do not add the cascading petals from the flower heads, they become flower buds in both the Mo-Ku style and the Contour style.

Contour style: Load a fine hard brush (Leaf Vein) with light ink and draw the buds in short center strokes, as shown. Color with Cadmium Yellow Pale as in Step 6, above.

Mo-Ku style: Load a small combination brush (Long Flow) in diluted white gouache and purple mixture (see Step 1 of the purple flower on page 114). Use short tuck-in strokes to create the buds.

Purple Chrysanthemum in Mo-Ku Style

Mo-Ku, meaning "no bone," is a style that uses expressive brushwork to denote surfaces instead of contours of the subject. We will use calligraphic brushwork in which each stroke becomes a petal of the crab claw chrysanthemum.

The purple flower

1 Prepare a dish of diluted white gouache (1 part white gouache to 1 part water). In another dish, mix 1 part Indigo to 2 parts Alizarin Crimson to make purple. Load a small combination brush (Long Flow) first with the diluted white gouache and then the purple mixture. Because white gouache does not merge completely with colors, it will create an interesting variation of colors in the brush. Use tuck-in strokes and paint the petals from the center of the flower.

2 Continue with more petals and build from the center to the outer layers. While the overall shape should be a sphere, be mindful to have variety by having some strokes higher or lower than the other ones. You should be able to paint at least six petals before reloading.

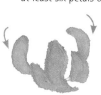

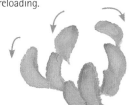

3 Reload the brush and build the outer petals that cascade down to the side of the flower. Start with the tuck-in stroke from the hooked end of the petal and spring the brush up toward the flower head.

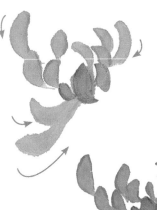

5 Load a small soft brush (White Cloud) with the purple mixture. Tighten the appearance of the flower by filling the gaps between the petals in the center of the flower. This will make the petals that were painted with purple and white gouache stand out.

4 Repeat and add more petals as chrysanthemums typically have many, many petals.

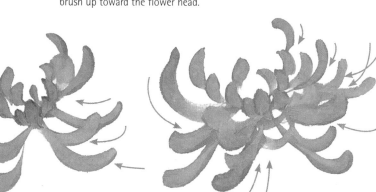

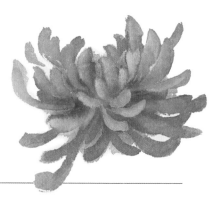

The leaves and stem

1 Mix one part black ink with three parts water to make medium ink. Load a medium combination brush (Long Flow) with two-thirds medium and one-third black ink. Paint the leaves in side strokes.

2 Add veins in black ink with a small hard brush (Mountain Horse) when the ink is still damp.

3 Load a medium combination brush (Long Flow) with medium ink. Connect the flowers and leaves with stems in center strokes.

4 Add dots of black ink with a small hard brush (Mountain Horse) on the stems for visual interest.

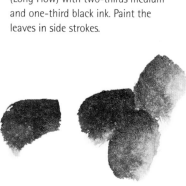

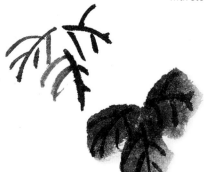

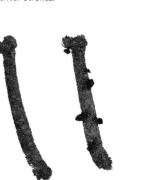

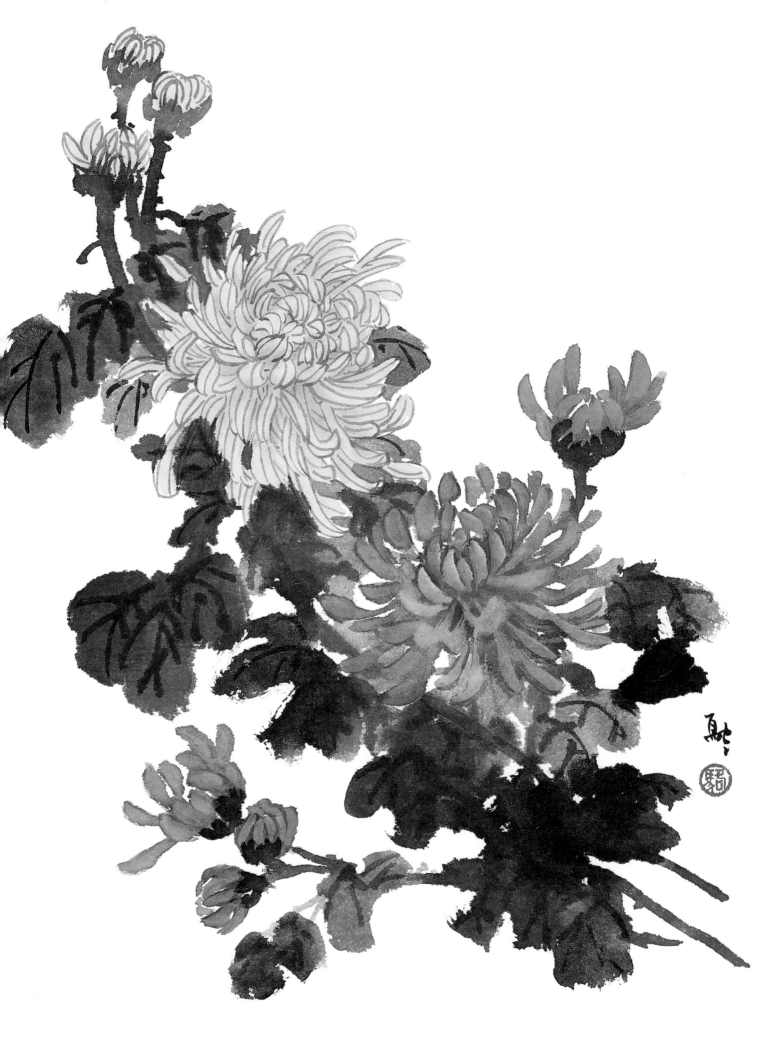

Rosa Rose

Roses represent love and admiration. They are highly cultivated, and new varieties are introduced every year. Roses bloom all year round in an enormous range of colors. Some come in single layers, but the most popular ones are double-layered, with curled and turned petals. The leaves are usually quite round with a pointed tip; some leaves have serration on the edges, while the stems have thorns. The Lingnan School of painting is famous for its expert use of white gouache to paint the turned petals of roses. We will use Cobalt Violet, which is not found in traditional Chinese colors, but is a gorgeous color for roses.

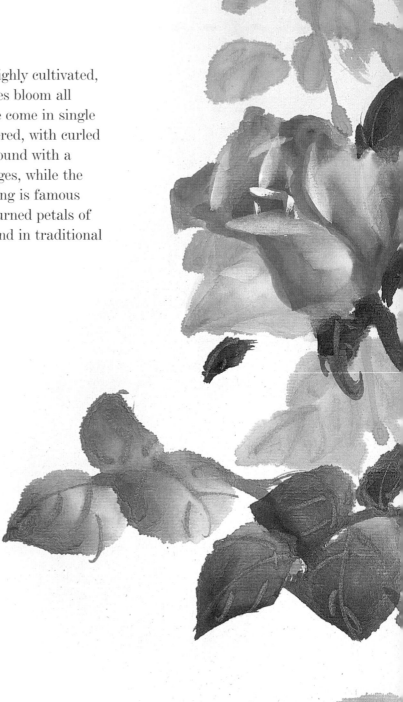

Palette

 Cobalt Violet

 [Green] Gamboge Yellow + Sap Green

 Sap Green

 Burnt Sienna

 Black ink

 Olive Green

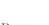 White gouache

Paper
Double Shuen

Brushes
Long Flow, medium combination
Leaf Vein, fine hard
White Cloud, small soft

sequence start to finish

Prepare dishes of diluted white gouache and Cobalt Violet and paint two roses in the upper left and center of your page following the instructions on the next page. Paint leaves in Sap Green and Yellow Gamboge (see pages 118–119). Vary the values of the leaves by reloading the brush with different intensities of black ink and Burnt Sienna on the tip of the brush. Add vein details to the leaves while the colors are still damp. Add stylistic rose buds to your composition following the instructions on page 119. Connect the flowers, buds, and leaves with stems using a medium combination brush (Long Flow) with Olive Green in center strokes. Add thorns with a fine hard brush (Leaf Vein) in Sap Green and Burnt Sienna (see *Special Details*, page 119).

The flowers

1 Prepare a dish of diluted Cobalt Violet (1 part Cobalt Violet to 1 part water). Prepare another dish of diluted white gouache (1 part white gouache to 1 part water). Load a medium combination brush (Long Flow) with two-thirds diluted white and one-third diluted violet. Roll the brush on a plate to ensure a smooth transition of colors. Paint the first two petals with two side strokes.

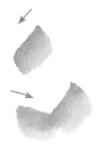

2 With the tip of the brush pointing toward the center of the rose, roll the brush on the paper for the inside center of the rose.

3 Continue to paint the outer layer of petals surrounding the center with side strokes.

4 Load a medium soft brush (White Cloud) with white gouache and draw the turned edge of the petals with long nail strokes, which are wide at the start and finish with a thin tail. The white gouache is used here at full strength. If it is diluted, it will not sit on top of the petals to represent the turned edges.

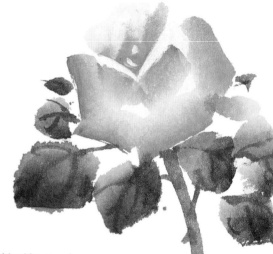

5 Continue with white gouache for all turned edges.

The leaves

1 For the leaves, mix together Gamboge Yellow and Sap Green to create green. Load a medium combination brush (Long Flow) with two-thirds green and one-third Sap Green. Paint each leaf with a side stroke.

2 While the leaves are still damp, load a fine hard brush (Leaf Vein) with Burnt Sienna and draw the veins.

3 For variation, each time you need to reload the brush with color, alternate the amount of colors added to the two-thirds Sap Green base. At the tip, add a different intensity of black ink or Burnt Sienna. This subtle variation will create different values for the leaves.

The buds

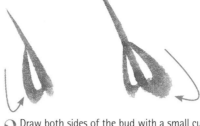

1 The flower buds of roses are done in a stylistic and calligraphic manner. Load a small combination brush (Long Flow) with Olive Green and start with the middle of the bud with a long center stroke, ending with the heel of the brush.

2 Draw both sides of the bud with a small curve, as in the letter "c."

3 Load the brush with two-thirds white gouache and one-third Cobalt Violet and fill in the space on both sides of the buds.

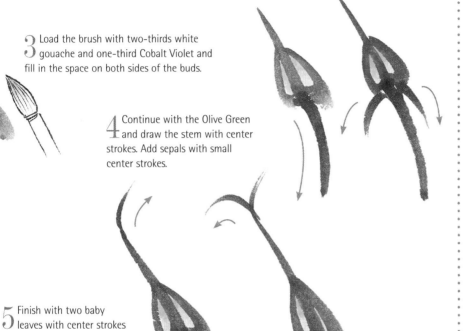

4 Continue with the Olive Green and draw the stem with center strokes. Add sepals with small center strokes.

5 Finish with two baby leaves with center strokes on the top of the bud.

special details thorns

Load a fine hard brush (Leaf Vein) with a mixture of Sap Green and Burnt Sienna. Rest the tip of the brush sideways on the paper where the stems are so the entire portion of the brush hair touches the paper. Gently pull the brush sideways and upward. The lifting motion will create the thorns of the stems.

4 Roses have compound leaves. After painting several leaflets with side strokes, connect them with a common stem and add veins in Burnt Sienna.

5 Some rose leaves have serration on the edges. You can add dots on the edge of the leaves while they are still damp to stylistically represent the serration. Do not overdo it or the details will take away from the focus on the flowers.

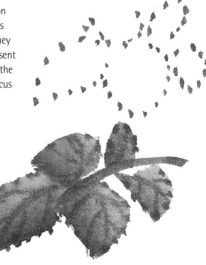

Wisteria Sinensis
Chinese Wisteria

Palette

 Sap Green

 Black ink

 Stone Green

 Cobalt Violet

 Permanent Violet

 Cadmium Yellow Medium

 Burnt Sienna

 White gouache

Paper
Double Shuen

Brushes
Long Flow, medium combination
Leaf Vein, fine hard
Mountain Horse, small and large hard
White Cloud, small soft

Relaxing in a garden underneath a cascade of exotic wisteria is the perfect way to enjoy the beauty of spring. The ornamental vines bear showy blooms in pendulous clusters that hang gracefully from the twining stems. Wisteria comes in different shades of lavender, from white to pink and purple. Chinese wisteria bears blue-violet flowers and opens in one big splash in spring, the blossoms dancing gracefully in the gentle breeze.

sequence start to finish

First paint a thick vine in a dry stroke (see page 20) in black ink. Add dots of Stone Green while the black ink is still wet. Scribble tiny vines with a small hard brush in Sap Green randomly throughout the plant. Form groups of overarching leaves in Sap Green by the vine on the top of the paper (see right). Turn the paper upsidedown and create a group of florets following the instructions below. Add a chain of buds at the tip and connect the buds and florets into a chain by joining them with a spine (see *Special Details,* opposite). Turn the paper back to its normal position and, once the petals are dry, add two dots of Cadmium Yellow Medium on each floret.

The leaves

1 Load a medium combination brush (Long Flow) with Sap Green. Start the first leaf with a center stroke in a downward motion.

2 Loop up and create a second leaf and repeat for a third and fourth. The motion of the brush is similar to writing the letter "m" in cursive.

The florets

Wisteria hangs down from the vines, so it can be a lot easier to paint if you turn the paper upsidedown. This technique produces a smoother stroke than trying to move your brush upward to draw the buds.

1 Load a medium combination brush (Long Flow) with two-thirds white gouache and one-third Cobalt Violet, and a small amount of Permanent Violet on the tip. Start the florets with two short side strokes.

2 Without washing the brush, add Permanent Violet to the tip of the brush and draw two small petals with two short tuck-in strokes.

3 Add a light touch of diluted Cadmium Yellow in the middle of the floret.

4 When the petals are dry, add two dots of Cadmium Yellow Medium on each floret to represent the stamens. Painting the stamens better defines each floret and adds visual interest.

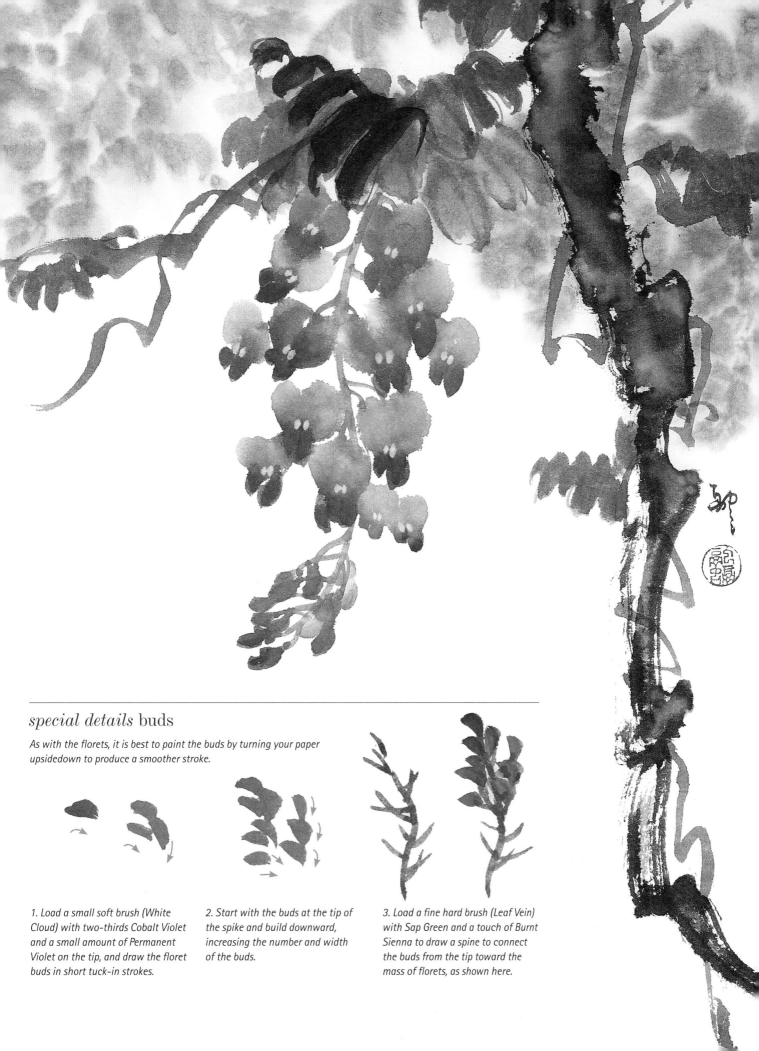

special details buds

As with the florets, it is best to paint the buds by turning your paper upsidedown to produce a smoother stroke.

1. Load a small soft brush (White Cloud) with two-thirds Cobalt Violet and a small amount of Permanent Violet on the tip, and draw the floret buds in short tuck-in strokes.

2. Start with the buds at the tip of the spike and build downward, increasing the number and width of the buds.

3. Load a fine hard brush (Leaf Vein) with Sap Green and a touch of Burnt Sienna to draw a spine to connect the buds from the tip toward the mass of florets, as shown here.

Palette

 [Light ink] Black ink + water

 Alizarin Crimson

 Sap Green

 Indigo

 Cadmium Yellow Pale

 Burnt Sienna

White gouache

Paper
Cicada Wing (sized rice paper)

Brushes
Leaf Vein, fine hard
White Cloud, small soft

Paeonia Lactiflora
Herbaceous Peony

Herbaceous peonies are very fragrant and come in a variety of colors. The showy flower has soft, silky petals that form a bowl shape. Tree peonies have woody stems that stand in winter while the entire stem of the herbaceous peony wanes to the ground and regrows in spring. We will paint the herbaceous peony in Detail style, building strong color intensity with multiple applications and unifying the hues with a final color application.

sequence start to finish

This flower involves complex contours, so start by sketching it to resolve all design issues. Practice the graceful turns of the lines before drawing on the sized rice paper. Draw the contours of the flower and leaves in light ink (see opposite). Draw a stem to connect the elements. When the contours

are dry, prepare two dishes of light and medium Alizarin Crimson, and following the instructions opposite, use two brushes to alternately apply the colors to the petals to build intensity. Alternately apply Sap Green, Indigo, and Cadmium Yellow Pale to the leaves to build rich hues. Build color in

the stems and young leaves by applying alternate applications of Sap Green and Burnt Sienna (see page 124). Finally, when the colors are dry, add stamen details in the center of the flower in Cadmium Yellow Pale using a fine hard brush (Leaf Vein).

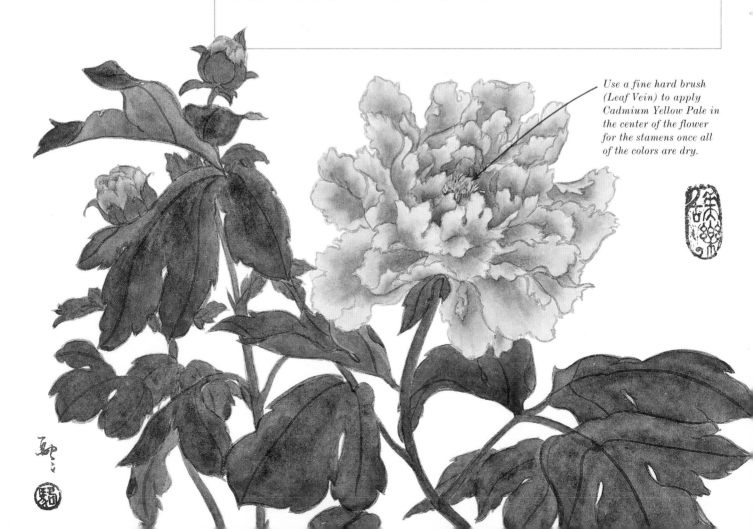

Use a fine hard brush (Leaf Vein) to apply Cadmium Yellow Pale in the center of the flower for the stamens once all of the colors are dry.

The flower

1 Dilute one part black ink with five parts water to make light ink. With a fine hard brush (Leaf Vein) and light ink, start from the center of the flower and draw each petal with care. The lines should be fluid and smooth. You may prepare a pencil sketch of the composition and place it underneath the rice paper as a guide.

2 Build from the center and continue by adding more petals to build up the center of the flower. Play attention to the graceful twist and turn of the lines. (See *Special Details*, page 124.)

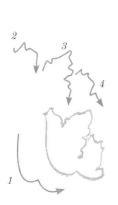

3 Prepare two dishes, one with light Alizarin Crimson (1 part Alizarin Crimson to 2 parts water) and one with medium Alizarin Crimson (equal parts Alizarin Crimson and water). Use two medium soft brushes (White Cloud) alternately. One brush is loaded with light Alizarin Crimson, and the other with medium Alizarin Crimson. Color one petal at a time. Start with light Alizarin Crimson on the outer edge, then switch to the brush with medium Alizarin Crimson on the inner petal. The quick succession of two brushes will ensure the merging of light and medium Alizarin Crimsons in each petal.

4 After the entire peony is colored, repeat the coloring with light and medium Alizarin Crimson on the petals.

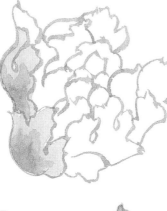
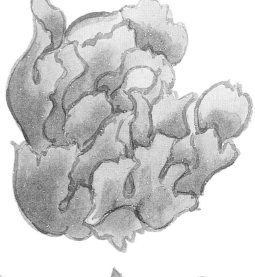

5 You may need to repeat the process four or five times to achieve the intensity of the peony.

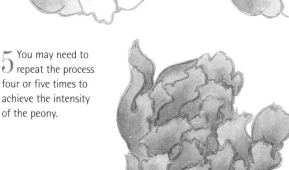
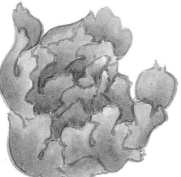

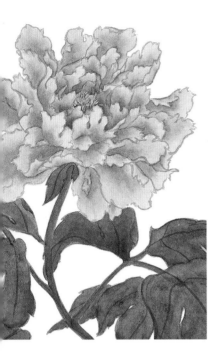

The leaves

1 Draw the contours of the leaves with a fine hard brush (Leaf Vein) in light ink. Prepare three dishes, each with one part color to two parts water, of Sap Green, Indigo, and Cadmium Yellow Pale. Start with the light Sap Green and use a small soft brush (White Cloud) to color the entire leaf. This is the base color of the leaf. Use small soft brushes (White Cloud) for each of the colors.

2 Color the top of the leaf with light Indigo with stronger color application on the top-most edges.

3 Apply light Cadmium Yellow Pale to the bottom of the leaf. Repeat Steps 2 and 3 three or more times to build up color intensity.

4 When you are satisfied with the color intensity, apply light Sap Green over the entire leaf to unify the hues.

The stems and young leaves

1 The stems and young leaves have red hues, especially at the edges. Draw the contours with a fine hard brush (Leaf Vein) in light ink. Prepare two dishes, each with one part color to two parts water, of Sap Green and Burnt Sienna. Use a small soft brush (White Cloud) for each color. Color the entire stem and young leaves in light Sap Green.

2 Apply light Burnt Sienna on the outer edges of the stems and young leaves.

3 Repeat Steps 1 and 2 three or more times to build up the color intensity.

4 Finally, when you are satisfied, apply light Sap Green over the entire stem and young leaves to unify the hues.

special details mastering graceful lines

The success of a painting in the Detail style depends on its graceful lines and vibrant coloring.

1. When drawing the lines, apply varying pressure but do not overdo it, otherwise you will create too much contrast between the thick and thin lines.

2. Pay attention to the smoothness of the lines. Avoid too many sharp angles.

3. Use continuous lines and do not draw in short, broken strokes.

4. Practice graceful turns of the lines by writing varieties of the small letter "r" in calligraphy, as shown. The movement will eventually become natural to you and you will be able to make smooth turns in the contour of a petal and a leaf.

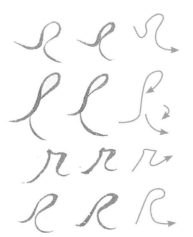

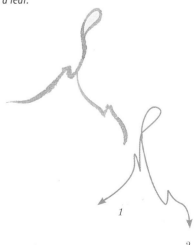

Paeonia Suffruticosa
Tree Peony

The peony is one of the most beloved flowers in the Chinese culture. Known as the "Kings of Flowers," peonies represent wealth and prosperity. Peonies have been the subjects of numerous poems and literature for many centuries, and there are countless tales from folklore and mythology related to the flower's irresistible beauty. Images and motifs of peonies can be found on exotic silk robes, delicate porcelain, and intricate woodcarvings. With their beautiful showy petals, it is easy to understand why this sumptuous bloom is a favorite subject in Chinese brush painting.

Palette

 Alizarin Crimson

 Alizarin Crimson + Cadmium Yellow + water

 Indigo + black ink

 [Green] Indigo and Cadmium Yellow

 Burnt Sienna + black ink

 Black ink

 Burnt Sienna + Vermilion

Paper
Double Shuen

Brushes
Long Flow, medium combination
Mountain Horse, large hard
Leaf Vein, small hard
Happy Dot, small soft

sequence start to finish

Beginning in the center, create the center petals of the flower in Alizarin Crimson, and continue to build to the outer layers, following the instructions below and on page 126. Fill in the gaps between the center petals with Alizarin Crimson and Cadmium Yellow and add petal markings while the petals are still damp. With a medium combination brush (Long Flow), paint the stem from the center of the bloom in Indigo and Cadmium Yellow with a center stroke. Add leaves in a mixture of Indigo and black ink following the technique in Leaves, Stems, and Branches (pages 21–23) but don't overwhelm the composition by adding too many leaves. Add the woody branch with a large hard brush (Mountain Horse) in a mixture of Burnt Sienna and black ink. Add several dots of black ink along the branch for visual interest. Complete the composition by painting new budding stems in a mixture of Burnt Sienna and Vermilion (see page 127).

The flowers

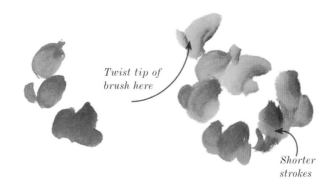

Twist tip of brush here

Shorter strokes

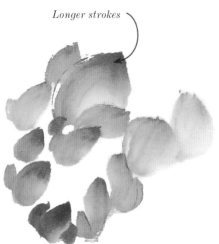

Longer strokes

1 Load a medium combination brush (Long Flow) with two-thirds diluted Alizarin Crimson and some full-strength Alizarin Crimson at the tip. Start from the center and paint the first few petals with short tuck-in strokes.

2 Continue to build additional petals, twisting the tip of the brush slightly to attain the natural curve of the petals.

3 Keep in mind where the center of the flower is. The strokes used should be slightly longer to denote outer petals.

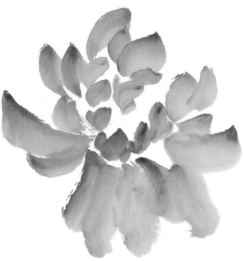

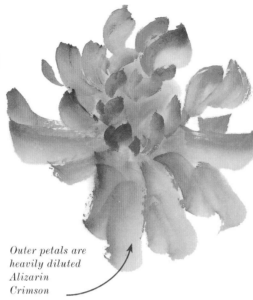

4 Dip the brush in the diluted Alizarin Crimson again. Allow a bit more water in the brush to attain a slightly lighter shade of crimson for the outer petals. Continue to add more outer petals. Pay special attention to the overall shape of the bloom. Even though the flower is in globular form, avoid painting a perfectly circular shape, as this would look unnatural.

Outer petals are heavily diluted Alizarin Crimson

5 After painting all the petals, mix Cadmium Yellow and Alizarin Crimson. Fill in the center of the bloom while the petals are still wet. The color will blend together to create a natural look.

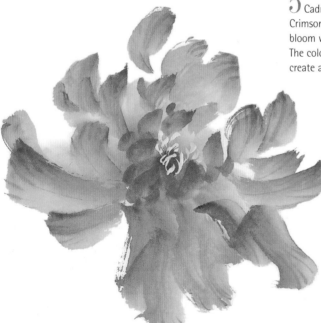

6 Complete the bloom by adding details (see *Special Details*, below).

special details carpels, filaments, and stamens

1. Using a small soft hair brush (Happy Dot) with green mix (Indigo and Cadmium Yellow), paint the carpel with two downward strokes.

2. Draw the filaments using white gouache.

3. Mix an equal amount of Cadmium Yellow and white gouache and draw the stamens with short strokes. The movement of each stroke resembles drawing an open semicircle, similar to writing a small letter "c" or reverse letter "c."

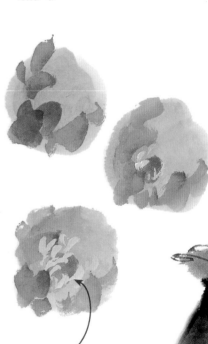

Each stroke, a letter "c" or a reversed letter "c"

special details petal markings

1. Load a small hard brush (Leaf Vein) with Alizarin Crimson. Paint the markings with a long center stroke, pulling the brush up with decreasing pressure to create a thin end to the line.

2. Start with a longer line in the center. Add one or two shorter lines to denote the darker pink markings on the petal.

Don't overwork the markings. Let the colors bleed into each other slightly

3. Don't overwork the petals with too many strokes. Use just enough to give the suggestion of delicate veining.

The budding stems

1 Load a small soft brush (Happy Dot) with a mixture of Burnt Sienna and Vermilion. Begin with a tuck-in stroke and press down to make a round beginning to the brush work.

2 With the brush still touching the paper, pull the brush up to create a thin stem.

3 Paint the budding new stems at the knots of the woody branch.

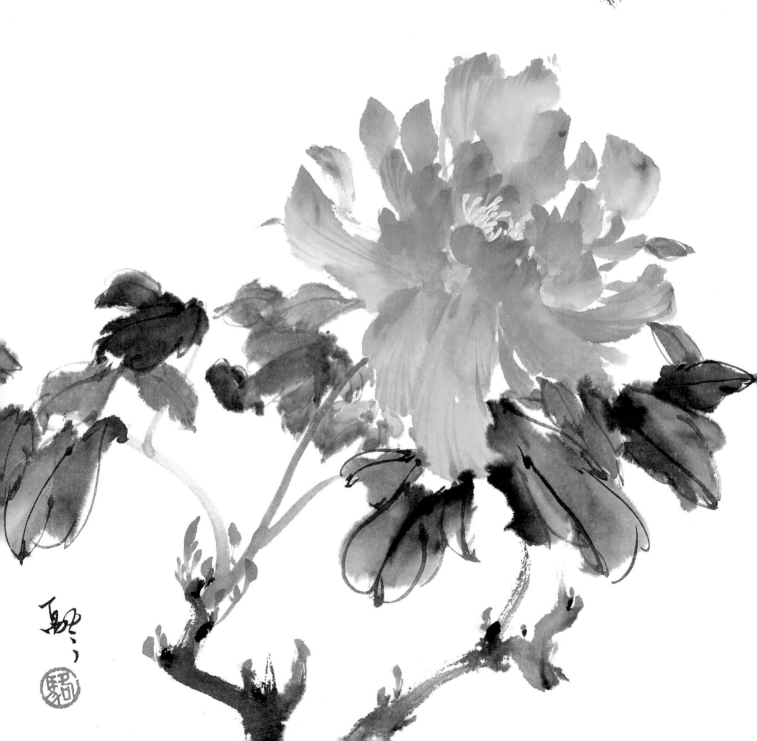

Index

Credits

Quarto would like to thank Sidewinder Studios for kindly supplying tools and equipment for photography.

All photographs and illustrations are the copyright of Quarto Publishing plc.

Acknowledgments

I constantly ride on the shoulders of giants, predecessors and pioneers of Chinese brush paintings whose contributions have improved and renewed the appreciation of Eastern art in the world. My gratitude to Professor Cheng-Khee Chee, international watercolor master, for writing the Foreword; my mentor Mr. Fong Yuen Ng, founder of the Lingnan Art Association of America, for generously guiding me for over 30 years, and botanists Dr. and Mrs. James and Peggy Duke for their help. I am grateful to the National Board and the members of the Sumi-e Society of America for their encouragement, and all my patrons and students for their continuous support in my artistic journey. To my husband David and my sons, Wesley and Gary, my deepest appreciation for your sacrifice to help me realize my dreams and fulfill my aspiration. I am indebted to all of you.